Surrealism and Modernism

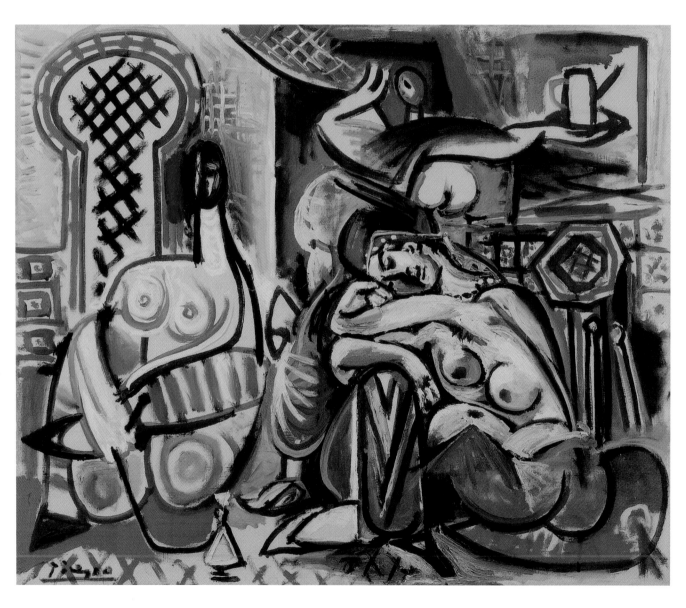

Pablo Picasso, *The Women of Algiers*, 1954
Oil on canvas, 25 ⅝ × 28 ⅝ in. Checklist no. 45

Surrealism and Modernism

from the Collection of the Wadsworth Atheneum

Eric Zafran

and Paul Paret

Wadsworth Atheneum Museum of Art
in association with
Yale University Press
New Haven and London

Editing, design, and production: Sally Salvesen and Emily Winter
Index by Indexing Partners, Annandale, VA
Typeset in Monotype Walbaum
Printed in Singapore

Library of Congress Cataloging-in-Publication Data

Surrealism and modernism : from the collection of the Wadsworth
Atheneum / edited by Eric Zafran.
 p. cm.
Catalog of a traveling exhibition organized by the Wadsworth
Atheneum.
Includes bibliographical references and index.
 ISBN 0-300-10203-8 (cl : alk. paper)
1. Modernism (Art)—Exhibitions. 2. Art—Connecticut—Hartford—
Exhibitions. 3. Wadsworth Atheneum Museum of Art—Exhibitions.
I. Zafran, Eric. II. Wadsworth Atheneum Museum of Art.
N6494.M64S87 2004
709'.04'00747463—DC21

 2003009654

Published in conjunction with the exhibition organized by the Wadsworth
Atheneum and shown at:

The Phillips Collection, Washington, DC
October 6, 2003 – January 18, 2004

Orange County Museum of Art, Newport Beach, CA
February 15 – April 25, 2004

Kimbell Art Museum, Fort Worth, TX
May 23 – September 5, 2004

The John and Mable Ringling Museum of Art, Sarasota, FL
October 14, 2004 – January 9, 2005

NOTE TO THE READER

All works of art illustrated in this publication are in the collection of
the Wadsworth Atheneum. Checklist numbers given at the end of
captions indicate works in the exhibition and refer the reader to the
checklist at the back of the book

ILLUSTRATION

Halftitle page: detail from Fig. 20, Giorgio de Chirico, *The General's
Illness*

CONTENTS

Acknowledgments

9

Foreword

11

PAUL PARET *Destination Unknown: Pathways to Modernism*

13

ERIC ZAFRAN *Springtime in the Museum: Modern Art comes to Hartford*

61

Checklist of works exhibited

135

Works illustrated from the Wadsworth Atheneum Collection

143

Index

147

Picture Acknowledgments

152

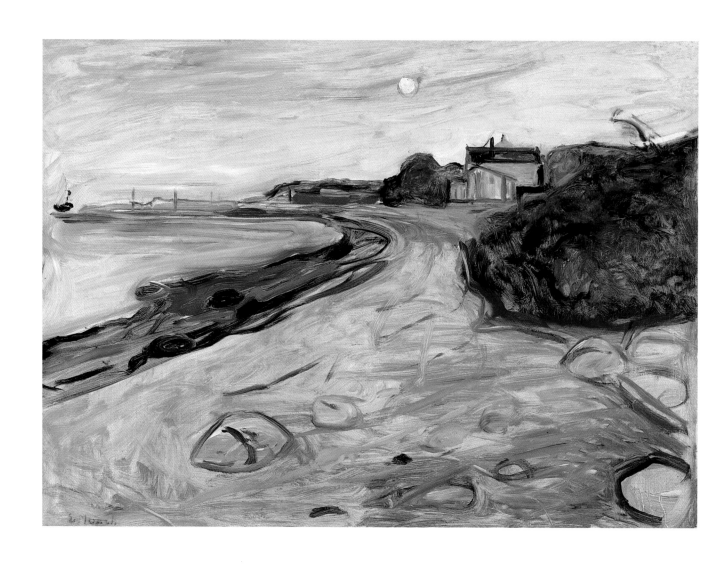

Edvard Munch
Winter Landscape at Hvitsten, c. 1918
Oil on canvas, 23 ½ × 29 in.
Checklist no. 39

ACKNOWLEDGMENTS

No history of the Atheneum's collections, especially one regarding the Austin era, could be written without the help of the Atheneum's brilliant Archivist, Eugene Gaddis. He and his assistant, Ann Brandwein, placed all their accumulated wisdom and resources at my disposal and have helped verify many details and locate the appropriate photographs – most especially the previously unpublished portrait of Chick Austin by Lee Miller. Also at the Atheneum I am, as always, most grateful to the former Associate Curator for European Art, Dr. Cynthia Roman, for her good advice and timely assistance. Our Department of Collection Imaging – Allen Phillips, Natalie Russo, and Daniella Mann – all contributed to providing a set of beautiful new transparencies for this publication. The registrar, Mary Schroeder, and Director of Exhibitions, Maura Heffner, both worked diligently to make sure that all the arrangements for the traveling aspects of the exhibition were in place and carried out efficiently. Likewise our conservators, Stephen Kornhauser, Ulrich Birkmaier, and Zenon Gansziniec, expertly prepared all the paintings, drawings, sculptures, and frames for their long voyage. We were fortunate that living in Hartford, there was such a serious scholar and talented author as Professor Paret, who knows our collection well and could write a truly insightful essay about it. Thanks are also due to the staffs at the archives of the Getty Research Institute, The Museum of Modern Art, and the J. P. Morgan Library, who assisted in locating relevant material on the Atheneum's history and collections. Finally I am most pleased to again have had the opportunity to work with Yale University Press, London, and its most sympathetic and talented editor-designer, Sally Salvesen, to produce a book, which will serve so well not just as a record of an ephemeral exhibition, but also as a long-lasting document of a unique and wonderful era in the history of American museum collecting.

Eric M. Zafran
Curator of European
Painting and Sculpture

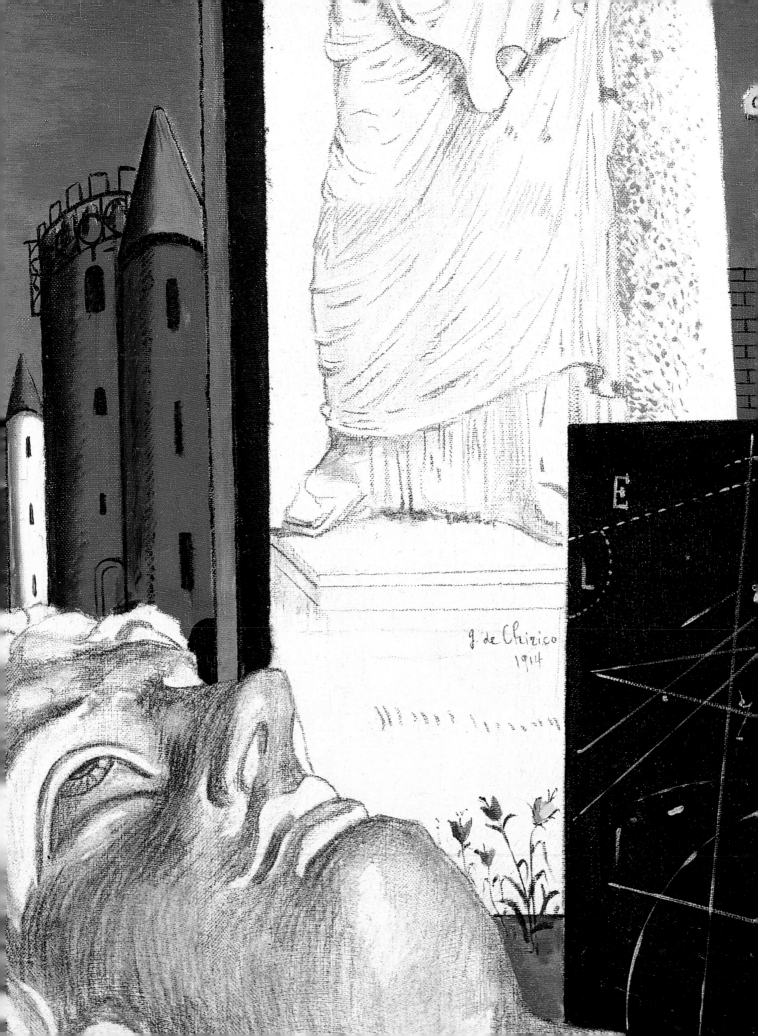

g. de Chirico
1914

Although America's oldest art museum, the Atheneum has had a long and lively relationship with new art, beginning with Daniel Wadsworth commissioning works from Frederic Church in 1826 and continuing to our most recent patronage and presentation of a variety of contemporary artists in the ongoing Matrix program, founded at the Wadsworth Atheneum in 1975 and soon to celebrate its thirtieth anniversary of uninterrupted exhibitions. As Eric Zafran, Curator of European Painting and Sculpture, shows in his essay, the foundation of the museum's collection and support of modern European art of the twentieth century was established with the arrival of Chick Austin as Director of the Atheneum in 1927. Within three years Austin mounted the first American exhibition of the Surrealist group, and acquired the first Salvador Dalí painting owned by an American Museum, *La Solitude*. Four years later the Atheneum was again at the forefront of support for the most advanced art of the day with an exhibition of abstract art including works by Mondrian, Gabo, Pevsner and others. It is both a professional honor and enormous personal pleasure for me that the first publication to appear as I assume the post of Director of the Wadsworth Atheneum almost seventy years later is the one accompanying this traveling exhibition devoted to the museum's remarkable collection of modern art.

The impetus for the organization and circulation of this exhibition and two others drawn from our deep resources has been the Atheneum's plans for a significant renovation and expansion that will not only reflect the marvelous history of collecting and exhibiting here, but will also allow the Atheneum to continue to occupy a position at the forefront of artistic risk-taking. As we move ahead with our plans we believe that these remarkable works are the best possible ambassadors for the Atheneum's ambitions. By sharing the genius of the artists gathered together in our collection and these individual exhibitions with audiences around the country it is our hope to also inspire many future visits to the Wadsworth Atheneum.

Willard Holmes
Director, The Wadsworth Atheneum Museum of Art

Detail from Fig. 21, Giorgio de Chirico
The Endless Voyage, 1914

Destination Unknown: Pathways to Modernism

PAUL PARET

Ernst Ludwig Kirchner's seemingly straightforward painting of 1912, *Suburb of Berlin* (Fig. 2) opens a window onto the modernist imagination. In the middle of this bird's-eye-view filled with lush green trees and massive civic buildings, two women, their heads thrust forward and legs kicking out from beneath their long coats, walk down a pathway at the edge of one of the great cities of the modern age. The ostensible subject of this tranquil cityscape is unremarkable, as Kirchner depicts no action beyond the strolling couple. Yet his treatment of the scene and of its psychic undertones is revealing.

Suburb of Berlin is built up of short, distinct, almost frenetic brushstrokes, a combination of bold colors and deep natural earth tones characteristic of German Expressionism, of which Kirchner is a key representative. The composition of the image is structured by the pathways slicing diagonally through the center of the canvas, bound on one side by a dense jungle of trees, and on the others by massive buildings, several cut off by the edges of the canvas. Perhaps most dramatically, the bird's-eye perspective, which should be commanding and all-knowing, radically warps our vision, destabilizing the landscape and buildings pulsating at its edge.

At the center of the painting is the strolling couple, destination unknown, undisturbed, yet visually and materially overwhelmed. The agitated brushstrokes, disorienting perspective, and particularly the isolation of the figures, create an impression of intense instability and even approaching doom. The primitive energy of the world around them, both natural and manmade, seems on the verge of exploding, having reached a level of dynamism and anxiety that is just barely contained by the frame of the painting and the conventions of art and perception.

Like much of the best modernist art, Kirchner's painting is self-conscious about its own processes and techniques (the loose, sketchy brushwork and the artifice of its compositional structure) and casts a critical eye, whether explicitly or implicitly, on the contemporary world. Of particular interest is the social identity of the two strolling women.

1
Detail from Fig. 2, Ernst Ludwig Kirchner
Suburb of Berlin, 1912

The elegant women who populate Kirchner's many other images of Berlin in the early 1910s – for instance, *The Street (Berlin)* 1913, (The Museum of Modern Art, New York) – are often regarded as prostitutes, potent symbols of the eroticism and social instability of modernity.[1] Whether or not the figures in *Suburb of Berlin*, a more spacious scene at the margins rather than center of the city, represent prostitutes, they signal the sexual allure as well as the unsettling dangers that accompany urban anonymity.

When Kirchner painted *Suburb of Berlin*, he belonged to the group of German artists known as *Die Brücke* or *The Bridge*, which had been founded in Dresden in 1905 as an anti-academic and anti-realist movement committed to the expression of subjective experience beyond the confines of bourgeois conventions. Although rooted in the particular concerns and context of German Expressionism, *Suburb of Berlin* suggests broad questions about the relation of individuals to the material, social and psychological conditions of modernity.

Kirchner's figures proceed down one path, but modernism moves in many directions. Modern art is not a single story; it develops along linked and often opposing paths, driven by divergent interests and obsessions. The selection of works from the collection of the Wadsworth Atheneum in the present exhibition reflects this diversity and the unreconciled energy at the heart of modernism.

It may be the connections between the visually dissimilar works that best illuminate the intensely varied practices of modernism. The barren, distorted, cityscape of *Suburb of Berlin*, for instance, finds a disturbing echo in Giorgio de Chirico's *The General's Illness* of 1914 (Fig. 20), a work whose precise lines and clean forms are far removed from Kirchner's agitated surfaces. The isolation and insignificance of the two figures in the center of their teeming surroundings reappears as the total loss of human agency in Paul Klee's 1929 *Marionettes in a Storm* (Fig. 59), where the hapless puppets flail in the wind, their movements no longer controlled by even their own strings.

It would be going too far to say that Kirchner points directly to such an apocalyptic vision as Max Ernst's *Europe after the Rain*, 1940–42 (Fig. 32); yet Ernst's painting, begun in Europe and completed after his emigration to America, fulfills in the extreme something of the underlying anxiety and unease that permeates Kirchner's canvas. In Ernst's nightmare scene of the destruction of European culture and civilization, the landscape is now a corroded tangle of devoured architectural and natural elements populated by monstrous apparitions, half human and half animal. Kirchner's strolling couple has been replaced by the post-apocalyptic central pairing of a woman and a mysterious flag-bearing creature with a man's body and the head of a bird. Standing back to back with each other, these figures are surrounded not by the pulsating, if ominous, energy of the early twentieth-century city, but by the traces and ruins of European civilization. Kirchner's

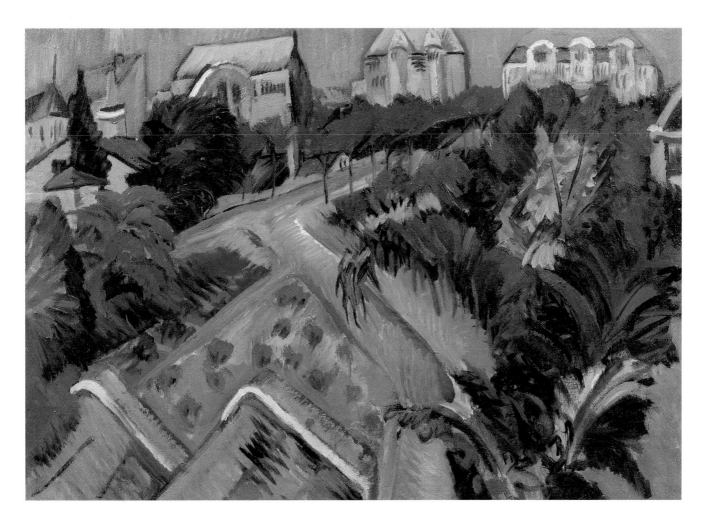

expressionist fervor and quick brush strokes have given way to Ernst's surreal textures and patterns. By pressing glass or paper on wet paint, a technique for which he appropriated the word "decalcomania," Ernst evades the deliberate action of the human hand and creates forms that appear made of mysterious substances and by unknown forces.

Despite the overwhelming devastation of the scene, Ernst's figures, like Kirchner's, remain highly sexualized. At the very center of the painting, a large greenish rock pillar transforms at the top into the nude torso of a woman; the dress of the woman just to the right is open in the back to reveal her buttocks. Elsewhere, a small naked torso stands between two pillars of the destroyed structure on the right, and the two small figures near the lower left are all but defined by their exposed breasts. Eroticism remains as a primal force, as powerful and destructive as those that physically devastated this landscape.

Kirchner's *Suburb of Berlin* evokes something of the primal energy of the city as jungle, the anxiety of anonymity, the ambiguity of narrative, and the materiality of paint as an applied substance. In Ernst's panorama, these elements now all take center stage. In the intervening

2
Ernst Ludwig Kirchner
Suburb of Berlin, 1912
Checklist no. 22

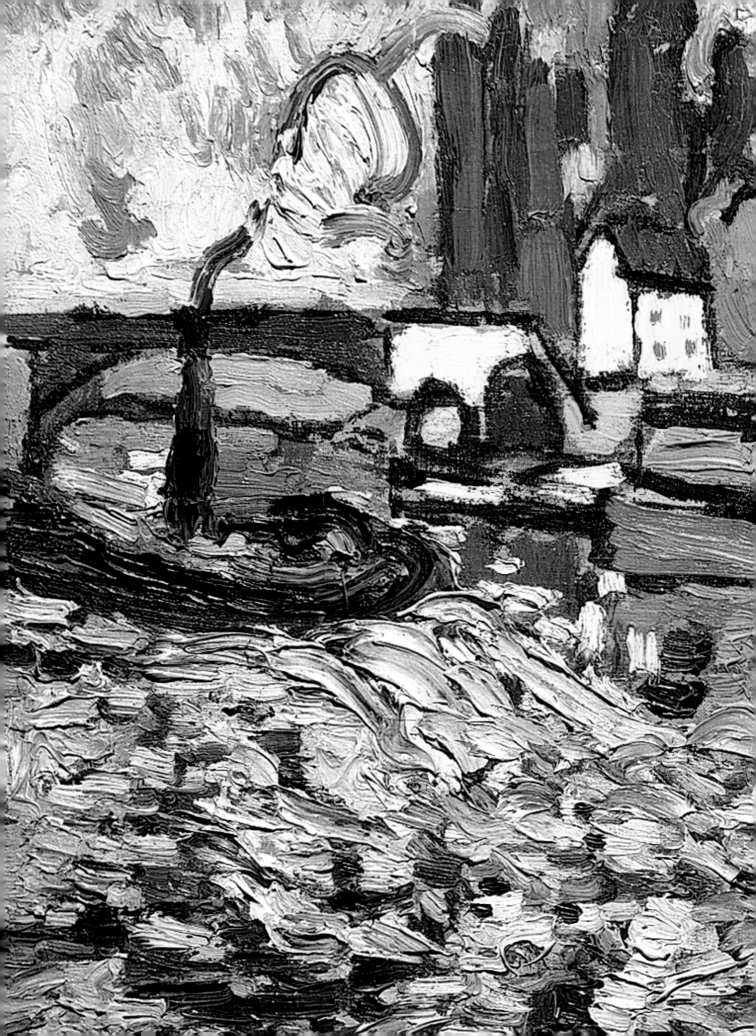

4
Henri Rousseau
Landscape at Pontoise, 1906
Checklist no. 51

decades, it was not just "Europe" that had changed, but the very idea
of how paintings work: how figuration relates to abstraction, pattern
and materiality; and the privileged status given to the subconscious in
image making. Though separated by two world wars and artistic inno-
vations including both radical abstraction and figurative returns, the
paintings by Kirchner and Ernst suggest the terms of creation and
destruction, desire and trauma, the primitive and the modern, and the
individual and the absolute that circulate with powerful, inventive
force within the modernist imagination.

MODERNITY AND THE PRIMITIVE
If Kirchner's painting offers one pathway to modernism, another is
presented by Henri Rousseau's 1906 *Landscape at Pontoise* (Fig. 4), an
image of pre-industrial French village life. In Rousseau's crude per-
spective, the width of the road stretches across the entire foreground
on the picture's lower edge, then rapidly narrows as it leads out of the

3
Detail from Fig. 6, Maurice de Vlaminck
River Scene with Bridge, c. 1905

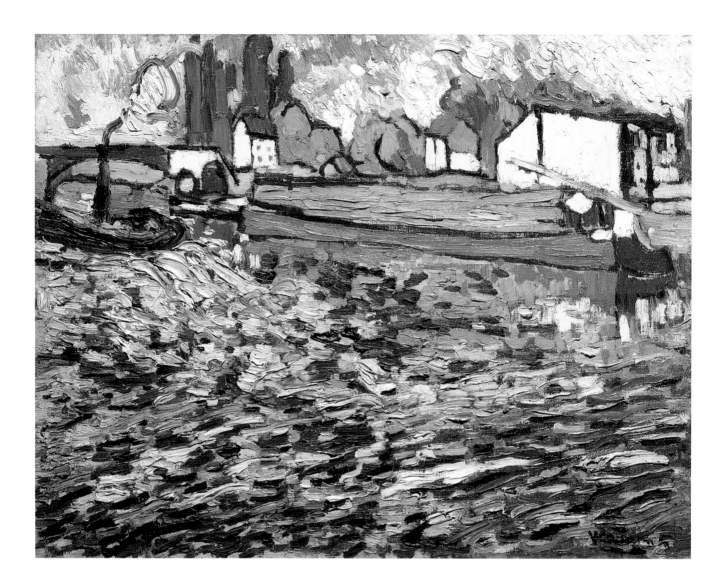

5
Maurice de Vlaminck
River Scene with Bridge, c. 1905
Checklist no. 63

village past several tiny figures. The fascination of Rousseau's image belongs in good part to its radical shifts in scale. The diminutive figures do not correspond to the enormity of the bordering walls and the height of the house and trees. The lamp-post, which in any case seems out of place in this rural scene, absurdly towers over the adjacent figure, barely more than a speck. It is the eerie banality and irrational scale of Rousseau's paintings that made them particularly interesting to the Surrealists in the 1920s.

Known as *Le Douanier*, or customs officer, because he had worked for years in the Paris customs service, Rousseau was a self-taught artist. The direct, frontal simplicity of his naïve style belongs to an anti-academic tendency that contrasted with the highly trained, precise illusionism of much official state-sponsored painting of the late-nineteenth century. A modernist reaction against academic artistic training can be recognised in paintings as different as Kirchner's *Suburb of*

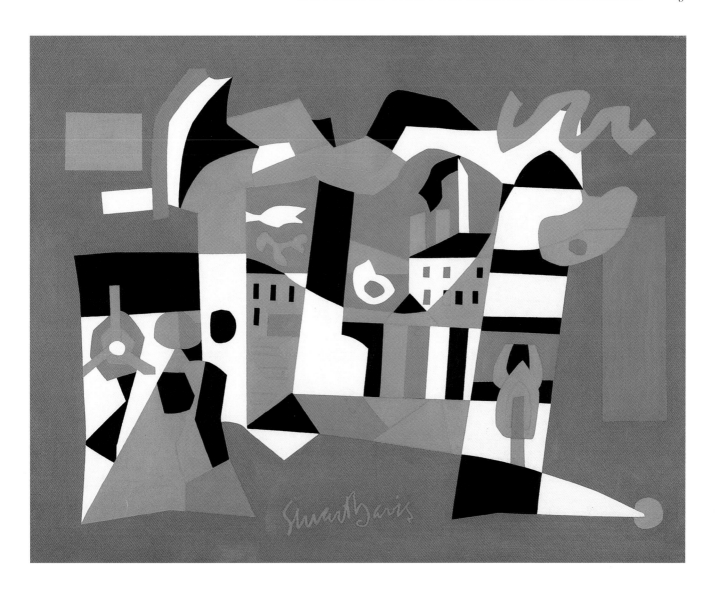

6
Stuart Davis
Midi, 1943
Checklist no. 17

Berlin, with its loose brushstrokes and distorted perspective, and the interest in children's drawing evident in the scratchy linearity of Paul Klee's *Architecture*, 1924 (Fig. 22). All belong to the modernist fascination with the Primitive, understood not only as the art of non-Western cultures, but also as Europe's own pre-industrial folk traditions and art of children and the insane.

Implicit in these interests is a certain critique of contemporary culture as overly refined and excessively inhibited, yet the allure of the "primitive" also works hand in hand with an opposite fascination with the technology and industry of modern life. Maurice de Vlaminck's *River Scene with Bridge, c.* 1905 (Fig. 3 and 5), far from a bucolic idyll, depicts a modern rail bridge, a red barge and a tugboat spewing smoke. One of Vlaminck's many paintings of the Seine at the Parisian suburb of Chatou near his home, the aggressive technique and bold colors, which he often applied unmixed directly from the tube, are typical of

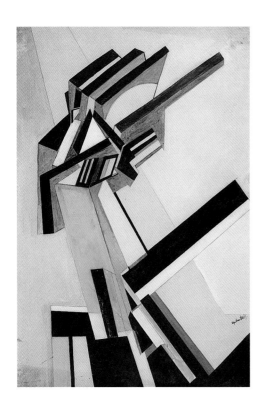

7
Wyndham Lewis
Portrait of an English Woman, 1913–14

8
Detail from Fig. 9, Pablo Picasso
Still Life with Fish, 1923

Fauvism in the first decade of the century, a grouping that at the time also included Henri Matisse. Signs of industrial modernity were found as easily in this type of suburban location as in the heart of the great urban centers. Decades later and in a different context, Stuart Davis's 1943 *Midi* (Fig. 6) attends to industrial motifs of smokestacks and propellers based on an impression of the waterfront of Gloucester, Massachusetts, north of Boston. Vlaminck's composition is still related to Impressionist landscapes such as those by Monet at Argenteuil in the 1870s; Davis's arrangement of flat planes of solid color is dependent on the formal innovations of Cubism and abstract art at the beginning of the new century.

CUBISM AND PICASSO

Nowhere is the nature of pictorial representation in modernism so profoundly explored as in the pioneering development of Cubism by Pablo Picasso and Georges Braque between 1907 and 1914. The so-called Analytic phase of Cubism during these early years involved the radical breakdown of pictorial space into dense, fragmentary, and near monochrome, compositions of shifting lines and planes. Picasso and Braque's collages of 1912–14 combine more traditional drawing with fragments of popular printed matter (such as wallpaper, newspapers and sheet music) that function both as literal material and pictorial description within a complex play of surface and depth, reality and representation. For the art that followed, a crucial aspect of Cubism was a new emphasis on the formal integrity and coherence of a picture's surface determined by its own compositional logic rather than the appearance of the external world.

Albert Gleizes, who belonged to the group known as the Puteaux Cubists had been an early advocate for the broader movement of Cubist artists outside of Picasso and Braque. In 1912, Gleizes together with the artist Jean Metzinger, published a pamphlet "Cubism" in which, perhaps surprisingly, they placed the movement within the legacy of nineteenth-century Realism: "For the partial liberties conquered by Courbet, Manet, Cézanne, and the Impressionists, Cubism substitutes an indefinite liberty."[2]

Already by the early 1910s a number of artists in different countries were working in modes closely related and indebted to Cubism's fragmentary abstraction. In England, for instance, Vorticism was developed by the artist and writer Wyndham Lewis, whose *Portrait of an English Woman*, 1913–14, (Fig. 7) presents an architectonic vision of humanity at once mechanized and fragmented.

During and after the First World War, Cubist painting became characterized by a greater stability and hierarchical order, as well as the reintroduction of color. This Synthetic Cubism includes such works as Picasso's 1923 *Still Life with Fish* (Fig. 9) and Albert Gleize's *Imaginary Still Life, Green* of 1924 (Fig. 10). In Gleizes's work, a dense

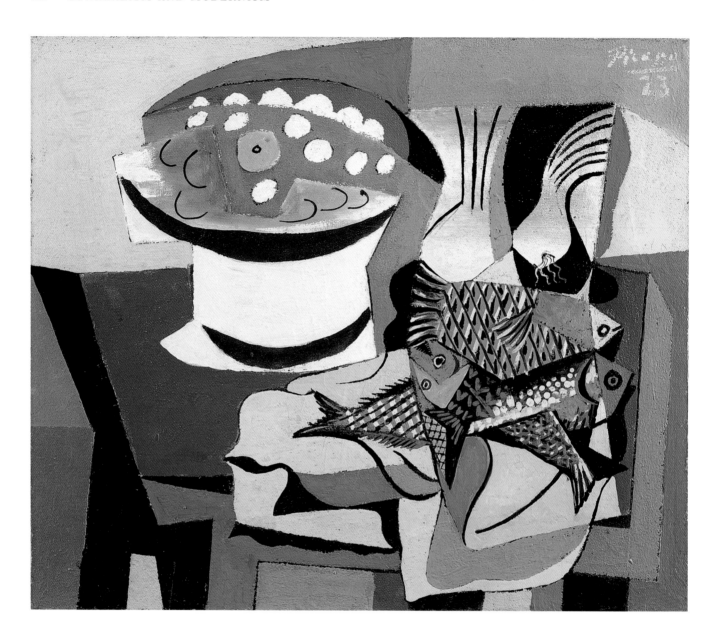

9
Pablo Picasso
Still Life with Fish, 1923
Checklist no. 43

10
Albert Gleizes
Imaginary Still Life, Green, 1924
Checklist no. 21

central core opens to large flat planes at outer edges. The word "imaginary" in the title refers to Gleizes's claim of creating this and similar still lifes without immediate physical models; the integrity of the decorated surface, not the depiction of any external object, is decisive for the work's pictorial value.

Picasso constructs *Still Life with Fish* with overlapping flat planes of broad color. Yet space is not entirely evacuated, and the segments of descriptive drawing (e.g. the fishwrap) and the suggestion of spatial recession along the table's edge hint that by this time Picasso felt no binding commitment either for or against perspectival space and more naturalist description. Indeed one of the hallmarks of Picasso's prodigious activity in the 1920s is a sometimes baffling desire to switch between naturalistic and cubist modes of paintings.

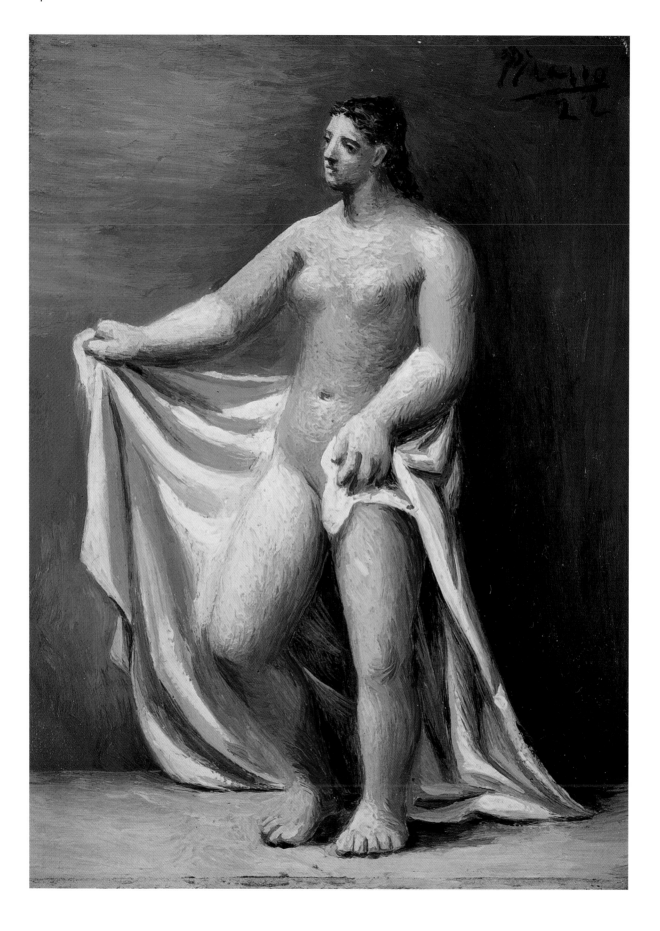

12
Maurice B. Prendergast
Red-Headed Nude, c. 1902
Checklist no. 48

RETURN TO ORDER?

Two years before *Still Life with Fish*, Picasso began a striking series of figurative paintings on classic motifs, using a naturalistic technique to set his fully modeled figures within a more conventional spatial framework. In works like the 1922 *The Bather* (Fig. 11), Picasso clearly refers to antique sculptures and reliefs, but he distorts their proportional systems to create peculiarly idiosyncratic figures. Here, the nude's massive limbs and feet support an undersized, and therefore all the more fragile, head. Picasso, in effect, makes the figure too big for her space, her shrunken head conforming to the restrictions of the canvas's edge. Thus, even in returning to naturalistic figuration, Picasso continues to assert the primacy of the picture plane, to which we are directed again by the cloth stretched out from the figure's body toward the edge of the canvas.[3]

In addition to these idiosyncratic compositions, Picasso complicates the figure's sexual identity with the distinctly phallic shape of the

11
Pablo Picasso
The Bather, 1922
Checklist no. 42

13
Max Ernst
The Kiss in the Night, 1927
Checklist no. 20

cloth she holds in front of her. Sexual duality and the misplaced phallus permeate much of modern art, reappearing notably in works as varied as Maurice Prendergast's *Red-Headed Nude*, c. 1910–13 (Fig. 12) and Picasso's *The Artist*, 1963 (Fig. 16); they assume an especially central role in Surrealism, as in Joan Miró's *Composition*, 1924 (Fig. 24), and Max Ernst's 1927 *The Kiss in the Night* (Fig. 13), both of which incorporate peculiarly prominent and ambiguous phallic imagery.

Picasso's return to classical themes and motifs was part of a more general tendency in the 1920s involving artists with divergent aims.[4] In contrast to Picasso, Aristide Maillol, in his bronze sculpture of the Roman goddess *Pomona*, 1925 (Fig. 14), conforms to classical proportions and stresses the static and monumental qualities of the human figure. With her prominent plume of curly hair, Maillol's *Pomona* stands with her weight on one leg in classical *contraposto* as she holds out an apple in each hand. Both the subject and aesthetics of *Pomona* can be linked to the supposed Latin lineage of France and the push for increased fertility rates that were mainstays of conservative rhetoric in France between the wars. Yet with her simple offering, *Pomona* presents an almost farcical parallel of apples and breasts as symbols of agricultural and sexual fertility. The lightly veiled eroticism of this vaguely nationalist rhetoric is precisely the type of repressed sexual desire that the Surrealists would seek to make explicit, a subject to mine and exploit as a generative, even revolutionary, cultural force.

For Picasso, meanwhile, the identification of sexuality with his own artistic practice could be almost overwhelming. In *The Painter*, 1934, (Fig. 15), a theme of the artist in his studio to which Picasso would

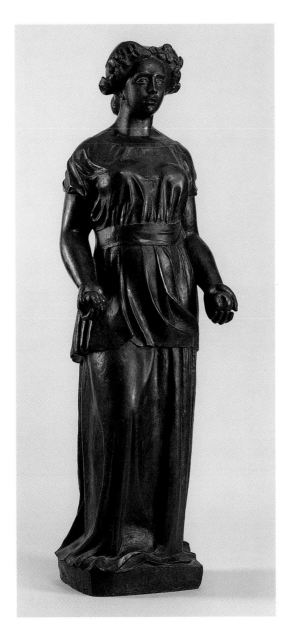

14
Aristide Maillol
Pomona, 1925
Checklist no. 27

return repeatedly (Fig. 16), presents a writhing orgiastic image of the model (Marie-Thérèse Walter), whose sweeping curves and repetitive forms spiral up and end in the plant-like hands of a modern day Daphne.[5] A powerful opposition is created between the simple, detached observation of the painter on the left before his blank canvas and the swirling prismatic environment of his model. Behind the model in the upper right is another canvas painted with the date and the abbreviated name of Boisgeloup, the châtaeau in Gisors northwest of Paris where Picasso lived in the early 1930s. Picasso's rapid-fire rendering of a blank canvas, painted surfaces and spatial depth points to a central problem, and indeed subject, of modernist painting: the tension between the image of space and the decorated flat surface.

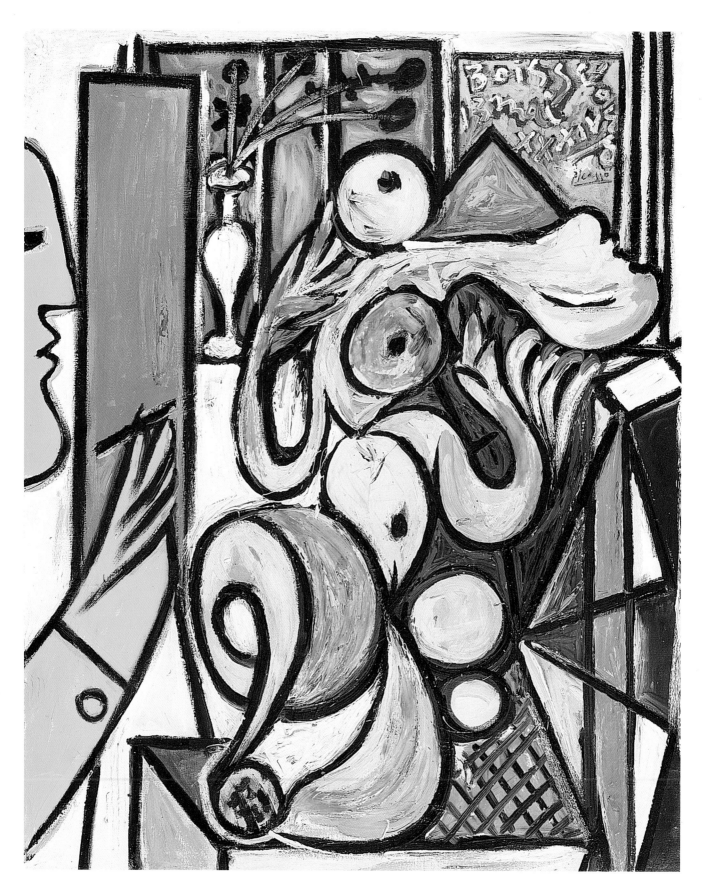

15 Pablo Picasso, *The Painter*, 1934. Checklist no. 44

16 Pablo Picasso, *The Artist*, 1963. Checklist no. 46

ABSTRACTION, REPRESENTATION & THE DECORATED SURFACE

Modernist artists took different approaches to the surface of the canvas. In a work like Henri Matisse's *Ostrich-Feather Hat*, 1918, (Fig. 17) the unity of space is held in a lively tension with the materiality of the flat canvas. The portrait shows Matisse's daughter Marguerite, then twenty-four, with a reserved expression seated in a chair with her hands gently clasped. While Marguerite's face is carefully modeled and her body (save for the flat, squiggly left arm) is set within the shallow space of the chair, Matisse exploits the various fabrics and textures depicted to call attention to the painting's material surface and the artifice of representation. He uses broad, splotchy brushstrokes for the chair and pillow, and thinner, more regular lines for the texture of the purple hat. Most striking, the checked pattern of the blouse is literally scratched into the paint, redirecting attention away from Marguerite and back to the surface of the canvas as its own material reality. It is the process of representation itself as much as the identity of his daughter that preoccupies Matisse in this image.

A very different example is the potent image of space in Georgia O'Keeffe's *The Lawrence Tree*, 1929, (Fig. 18). Painted while at the ranch of the author D.H. Lawrence during the first of O'Keeffe's many extended stays in New Mexico, the motif of an earthbound tree soaring into the night sky reflects something of the physical vigor and spiritual ambition that characterizes both O'Keeffe and Lawrence. Much later O'Keeffe offered an anecdotal explanation for both the subject and her unusual perspective:

> I spent several weeks up at the [D. H.] Lawrence ranch that summer. There was a long weathered carpenter's bench under the tall tree in front of the little old house that Lawrence lived in there. I often lay on that bench looking up into the tree — past the trunk and up into the branches. It was particularly fine at night with the stars above the tree.[6]

Yet the disorienting effect of O'Keeffe's upside-down and backwards point of view is also one of the now classic tropes of modernist painting and, particularly, photography of the 1920s. The dramatic skyward view may draw specifically on her husband Alfred Stieglitz's recent series of *Equivalents*, photographs of sky and clouds that formed abstractions often without clear spatial referents and with trees sometimes similarly intruding from the top or sides to announce that the picture's orientation is *not* the same as that of the viewer. In *The Lawrence Tree*, this disorienting perspective is made extreme by the emphatically flat areas of broad, unmodulated color. O'Keeffe thus acknowledges the decorated surface, yet the modernity of her canvas lies in its visual and symbolic representation of an earthly soaring into infinite space.

17
Henri Matisse
The Ostrich-Feather Hat, 1918
Checklist no. 33

18
Georgia O'Keeffe
The Lawrence Tree, 1929
Checklist no. 41

19
Piet Mondrian
Composition in Blue and White, 1935
Checklist no. 37

To varying degrees both Matisse and O'Keeffe tempered their observation of the external world with an attentiveness to the essential flatness of painting as a decorated surface. Another painter, Piet Mondrian, stands out for his singular commitment to the total exclusion of representational space. Mondrian called for a pure plastic art detached from all reference to the external world. Throughout the twentieth century, the desire for new origins, a blank slate, has been a driving force of Modernism, a fantasy of renewal that involved a utopian vision of the future. Mondrian suggested this kind of equation in his 1926 statement *General Principles of Neo-Plasticism*: "Equilibrium, through a contrasting and neutralizing opposition, annihilates individuals as particular personalities and thus creates the future society as real unity."[7] Yet Mondrian's visual force comes from his radical commitment to the autonomy of his aesthetic system.

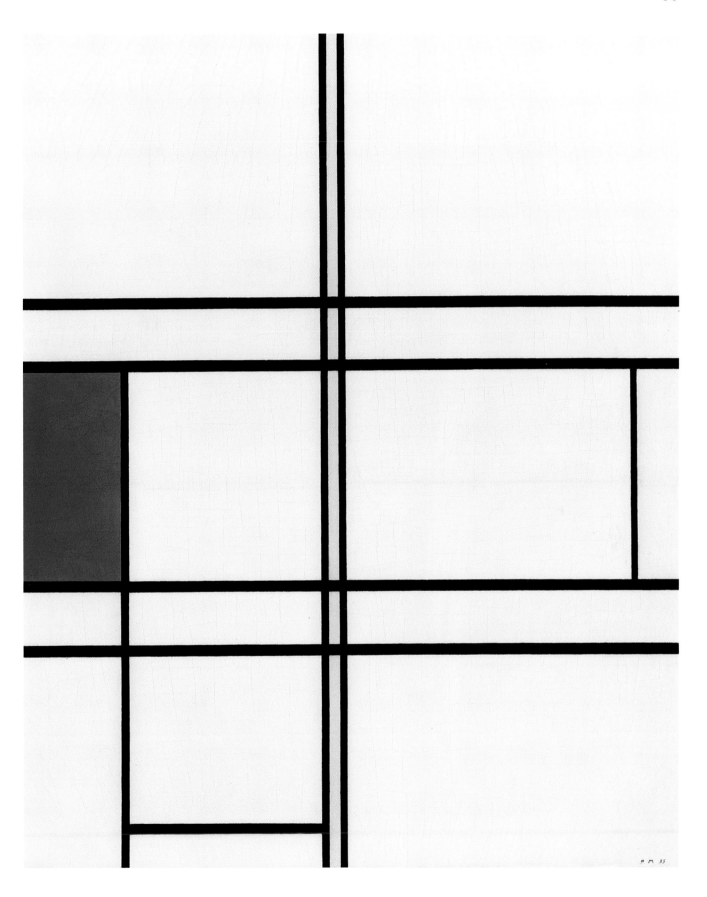

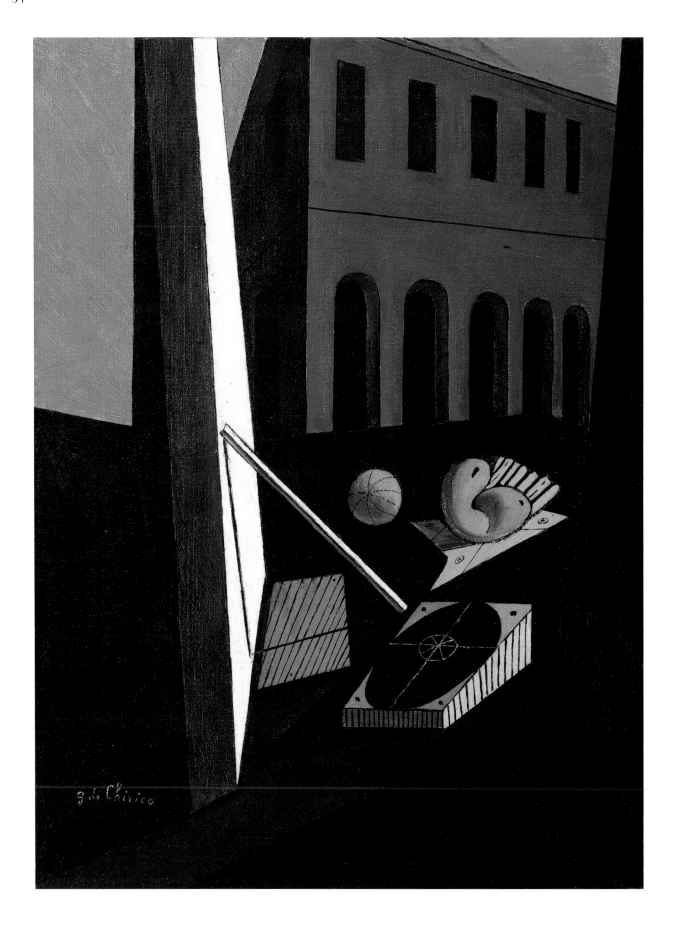

Painted in Paris, Mondrian's *Composition in Blue and White* of 1935 (Fig. 19) belongs to a group of paintings in which a single area of primary color punctuates the irregular grid of black lines on white ground. The deceptive simplicity of Mondrian's compositions – their geometry corresponding fundamentally to the rectilinear format of the canvas – gives way to complexities of detail: the area of blue sits directly against the edge of the canvas, bordered by black lines on only three sides; the entire grid is formed by three sets of parallel lines extending fully from edge to edge (one vertically and two, more widely spaced, horizontally) plus three shorter line segments; not only the length, but the width of the black lines varies as well, with the horizontal lines thicker than the four vertical ones. The effect of this asymmetrical grid is to insist on the most subtle compositional relations, which repeatedly hold us to the surface without allowing for the slightest suggestion of depth.

THE RATIONAL AND IRRATIONAL: SURREALIST BEGINNINGS

Among the modernist practices – including the naïve style of Henri Rousseau and Picasso's disjunctions – that would soon attract the Surrealists, Giorgio de Chirico's *Pittura Metafisica* or metaphysical paintings from the 1910s are particularly important. Painted in a crisp illusionistic style, de Chirico's perplexing pictures incorporate disjunctive perspectives and a relatively small inventory of recurring objects, buildings and figures into intensely cryptic compositions. In *The General's Illness*, 1914 (Fig. 20), de Chirico presents a strikingly barren landscape dominated by an empty building and an array of enigmatic objects – including a large wall that tilts away from a rod leaning against it, a ball, a biomorphic shape sometimes identified as a shuttlecock, and a variety of wedges, one of which presents a basic chart or graph. These elements all reappear in various other works by de Chirico.[8]

The confusion of spatial relations is particularly intense in *The Endless Voyage*, 1914 (Fig. 21). In the foreground of this deceptively complex painting are partial views of a large head of antique statuary (the *Apollo Belvedere*) and a mathematical graph supported by a yellow staff. Behind them is a tall drawing of a toga-clad classical figure whose torso becomes an armless mannequin-like form, one of the first of the mannequin images that de Chirico frequently included in his later paintings. Presented as a canvas within a canvas, the image of the classical figure bears de Chirico's signature and the date on its base. Behind this figure, a red brick wall on the right fails to correspond to the castle-like building on the left, which is itself presented as either a view through a window or the scene of yet another framed painting.

De Chirico offered few clues on how to make sense of his combination of pseudo-academic realism with narrative illegibility. His link of the temporal present to the nostalgic allure of antiquity, and the everyday object with the technically specific device, seems

20
Giorgio de Chirico
The General's Illness, 1914–15
Checklist no. 7

21
Giorgio de Chirico
The Endless Voyage, 1914
Checklist no. 8

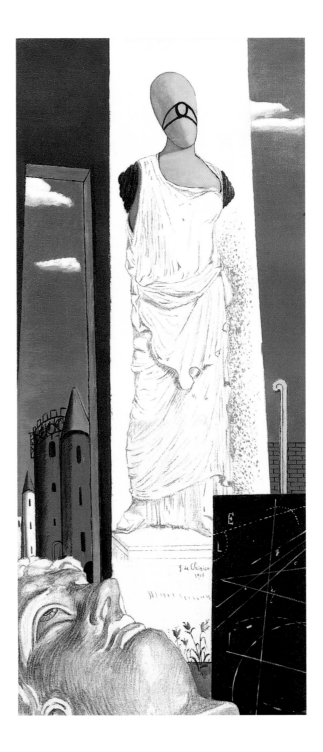

to render each element strange, and the absence of people makes these fantasy-scenes evocative of a both personal and cultural loss. It is the dreamlike suggestion of the presence of the irrational in the everyday objects as well as the intellectual traditions of Western culture that brought de Chirico recognition as a forerunner of Surrealism, although he was never formally associated with the group.

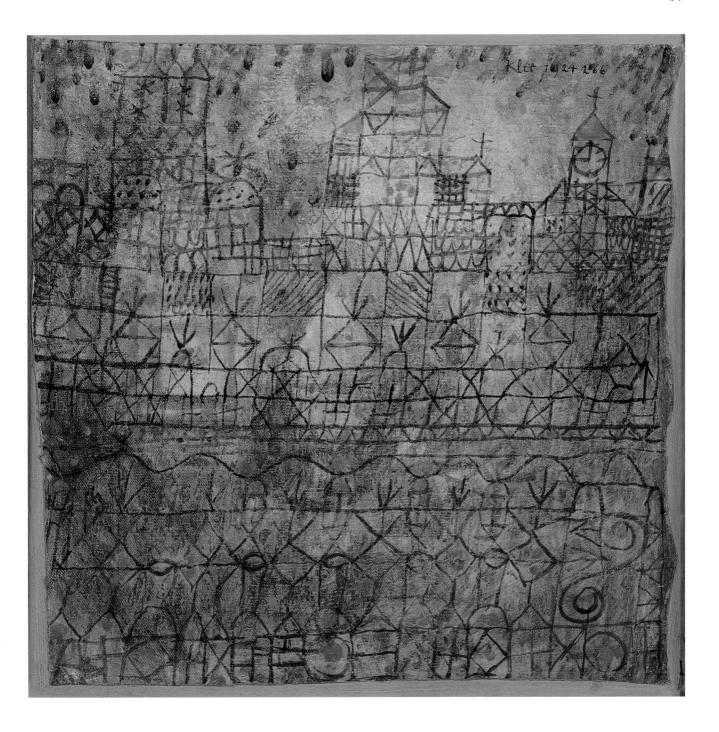

The Swiss artist Paul Klee is another figure at the edges of Surrealism. Like de Chirico, his work caught the attention of the Surrealists, who included him in their first exhibition in Paris in 1925. In *Architecture*, 1924 (Fig. 22), a dense network of graphic markings stretches across the canvas to evoke a mysterious city that is both child-like and Kafkaesque.

22
Paul Klee
Architecture, 1924
Checklist no. 23

SURREALISM: PATHWAYS TO THE UNCONSCIOUS

In 1924 a group of writers led by André Breton launched Surrealism as a movement committed to political revolt and the liberation of irrational and socially repressed desires. Never monolithic, Surrealism from the beginning revealed aesthetic and political divisions, some leading to important dissident groupings. It was Breton, however, who emerged as the dominant theorist of the official Surrealists and who offered the following definition in the *Surrealist Manifesto* published in October 1924:

> SURREALISM, *n.* Psychic automatism in its pure state, by which one proposes to express — verbally, by means of the written work, or in any other manner — the actual functioning of thought. Dictated by thought, in the absence of any control exercised by reason, exempt from any aesthetic or moral concern.

> ENCYCLOPEDIA. *Philosophy.* Surrealism is based on the belief in the superior reality of certain forms of previously neglected associations, in the omnipotence of dream, in the disinterested play of thought. It tends to ruin once and for all all other psychic mechanisms and to substitute itself for them in solving all the principal problems of life.[9]

The Surrealist idea of automatism derived from the psychoanalytic theories of Sigmund Freud, who argued that the seemingly incoherent associations people made in unconscious states — dreaming or under hypnosis — reveal clues to their conscious behavior. Unlike the ultimately scientific and instrumental ambitions of psychoanalysis, however, the Surrealists valued the poetics of the irrational as a pure expression of "the marvelous." The poet Louis Aragon, in an essay titled "A Wave of Dreams" synthesized the ambitions of Surrealism into the following definition:

> The essence of things is in no way linked to their reality, there are relations other than reality that the mind may grasp and that come first, such as chance, illusion, the fantastic, the dream. These various species are reunited and reconciled in a genus, which is surreality.[10]

Dreams offered a particularly promising avenue to this surreality of psychic mechanisms beyond rational thought. Other areas of intense interest to the Surrealists were the "logic" of insanity and the fantasy life of children, both of which served as counterpoints to the supposed rationalism of modern society's cultural and political institutions. The question remained, however, how these interests

23
Detail from Fig. 56, Salvador Dalí
La Solitude, 1931

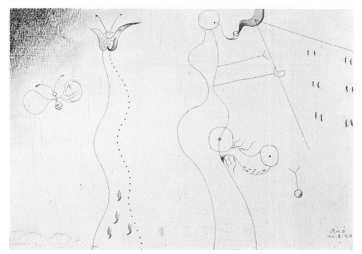
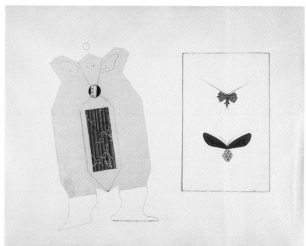

could be realized in visual art. Surrealist painters show two general tendencies: those like Max Ernst, and to some extent Joan Miró, interested in automatic and chance procedures to provoke unconscious associations; and the imagistic Surrealists, like Salvador Dalí and René Magritte, who use the deliberate, academic techniques of illusionism in the service of surreal imagery.

A good example of automatic procedures as a source for imagery is Max Ernst's 1927 canvas *The Kiss in the Night* (Fig. 13). Ernst, who had first emerged in Cologne as part of the international group of Dada artists during and after the First World War, settled in Paris in 1921 and became a founding member of the Surrealist group. For *Kiss in the Night* (and other related works from 1927), Ernst based the composition on lines formed by dropping rope dripped in paint on the flat canvas. The eroticism of the shifting, ambiguous body parts that can be read in numerous ways, is linked here to technical procedures of Surrealism.

Other quasi-automatic techniques developed by the richly inventive artist include *grattage*, a process that involved scraping wet paint from a canvas with a rough surface and using the resulting forms to provoke the imagination; and *frottage*, pencil rubbings on paper laid on rough board or other textured surfaces. Since his Dada days Ernst had also worked with collage. His 1932 collage *Loplop with Butterflies* (Fig. 25), part of the series *Loplop Presents*, constructs Ernst's alter ego, Loplop, out of an easel for the body and the head of an elephant. Within the image, Loplop presents his own collage of glued and painted butterflies on a sheet of cardboard to the right.

Joan Miró, who had first come to Paris from Spain in 1919, was an early member of the Surrealist movement. In the same year that

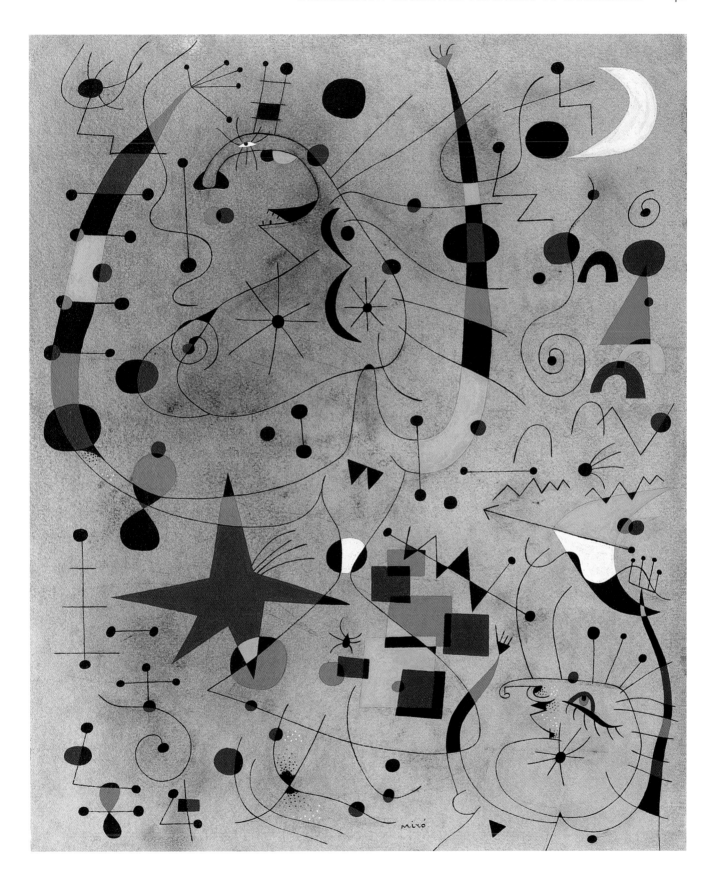

27
Jean Arp
Objects Placed on Three Planes like Writing,
1928
Checklist no. 1

Breton's *Surrealist Manifesto* appeared, he completed *Composition,* 1924, (Fig. 24), one of a series of small works using graphite and patches of tempera on wood panel. In *Composition,* Miró sketches the bare curvy outlines of two figures. The figure on the left has a plant or insect-like head, the other, with an enormous root-like protrusion in place of genitals, smokes a pipe dispelling red and yellow flame to which the figure holds up a large angled form.

Though not truly spontaneous, Miró suggested that the compositions in this series of works were derived in part from the forms and grains of their wood support. In a letter to the Surrealist writer Michel Leiris, Miró explained that "Using an artificial thing as a point of departure like this, I feel, is parallel to what writers can obtain by starting with an arbitrary sound."[11] Typical of Miró, the playful openness of his highly personalized imagery belies a tension between structure and spontaneity that also characterizes works like the 1925 *Dream Painting* and the 1940 watercolor *Acrobatic Dancers* (Fig. 26).

Something similar is at work in Jean Arp's relief *Object Placed on Three Planes Like Writing,* 1928 (Fig. 27). Like Ernst, Arp had been involved with Dada during the First World War. Reliefs like *Object Placed on Three Planes Like Writing* carry a suggestion of random order, even though chance played no role in the composition. Arp arranged the biomorphic shapes carefully along the three planes of black blue and grey, a background that no longer indicates a landscape so much as a lined surface for a musical score or written language.

DREAM LANDSCAPES: DALÍ AND SURREALIST ILLUSIONISM
Unlike Ernst or Miró, who at least to a certain degree explored auto-
matic and chance procedures to passively access the irrational and the
unconscious, other Surrealist painters, including Dalí and Magritte,
used more precise illusionistic techniques to actively and consciously
produce destabilizing, irrational imagery. Paradoxically, this mode of
"imagistic" Surrealism relied on the legibility of academic techniques
of modeling, foreshortening, etc, to convincingly represent the irra-
tional dream-world of the unconscious. In *The Tempest*, 1931 (Fig. 28),
Magritte displays his now classic strategy for disrupting expectations.
Instead of looking out the window to the space beyond – a classic trope
of Romantic iconography – Magritte redirects our attention to an inte-
rior space through which clouds drift and blue-gray blocks simultane-
ously suggest architecture and an eerily solidified geometric sky.
Rather than gazing out into the world, we are directed to the psychic
spaces of our own interiors.

28
René Magritte
The Tempest, 1931
Checklist no. 25

29
Salvador Dalí
Paranoiac-astral Image, 1934
Checklist no. 14

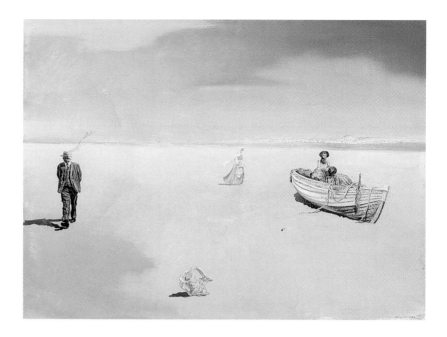

The master of illusionistic Surrealism was Salvador Dalí, who joined the group in 1929 and soon became their most publicly recognizable figure. Dalí's major theoretical contribution to Surrealism was what he termed the "paranoiac-critical method" that involved trying to objectively depict the illusions and fantasies produced by delirium and paranoia. Dalí called this a form of "irrational knowledge."

In the tiny *Paranoiac-astral Image* of 1934 (Fig. 29), Dalí presents in minute detail a barren seascape with four almost evenly-spaced elements, each unrelated and contextually out of place. At the left a man in a suit walks towards us, on the right a woman and boy sit in a wooden boat on the sand. The top of a broken amphora lies in the foreground, a washed up fragment of antiquity standing in place of the expected seashell. In the background a young woman seems to move off to the right. The boat rests only on the sand, its dangling ropes tied to no pier, and Dalí adds to the incongruity of the scene by varying the length of the shadows, and thus the time of day depicted, so that the shadow cast by the man is far longer than that of the boat or woman in the background. This kind of temporal disjunction was a favored device among Dalí and other Surrealist painters.

It has been suggested that the woman in the boat may represent Dalí's partner and future wife, Gala, and the boy in sailor suit Dalí himself as a child. The painting as a whole thus becomes a meditation on memory and a "nostalgia for the past" formed by "the irrational resurgence of individual experience" and "inscribed within the deep history of the Mediterranean coast, allegorized by the amphora."[12]

The same amphora fragment reappears (just left of center) in *Apparition of Face and Fruit Dish on a Beach*, 1938–39, (Fig. 30) a work that in contrast to the sparse poetic melancholy of *Paranoiac-*

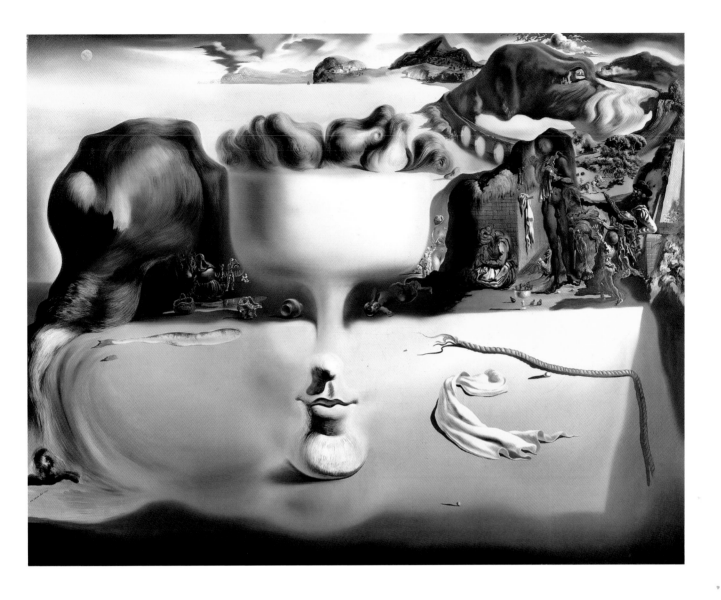

astral Image is an explosive accumulation of oscillating images, disjunctive scenes and ruptured scales. *Apparition of Face and Fruit Dish on a Beach* exemplifies the idea of the double image, simultaneously present in a single painting, that was an important part of Dalí's paranoiac-critical method. The presentation of alternative visual realities seemed to suggest that the notion of reality itself was unfixed and derived from the mind of the individual.

 In *Apparition of Face and Fruit Dish on a Beach*, three images predominate: a still life centered on the white fruit bowl at center, a landscape encompassing the beach and distant mountains, and the side of a dog across the length of the canvas. As Dawn Ades writes, "the whole spatial frame of the painting is doubled, to read as both the restricted arena of a still life and the more expansive space of a landscape."[13] At the center is a large white fruit bowl bearing pears that help form a head and face, probably Dalí's friend, the poet Federico García Lorca,

30
Salvador Dalí
Apparition of Face and Fruit Dish on a Beach,
1938–39
Checklist no. 15

who was murdered by Fascists in September 1936 at the beginning of the Spanish Civil War. The pears become a head of hair, and the eyes are formed by a fallen amphora and the head of a sleeping, or possibly dead, child. At the same time, the fruit bowl, which reappears in miniature on the table to the right, morphs into the front body and legs of the dog whose head becomes a part of the distant mountains and whose collar doubles as a ancient aqueduct. The dog's eye is also a hole through its head, a tunnel through the mountain. Each illusion is convincing yet tenuous, disrupted by the incursion of the other. Even within the framework of the still-life image, the white expanse of the table cloth across the lower half of the canvas functions in two mutually exclusive ways: it is the flat surface supporting the narrow base of the fruit bowl, the yellow cloth and the rope (which dangles over the right edge); simultaneously and incongruously, the same expanse of cloth reads as the folded area hanging down in relation to the numerous small figures and vessels resting on the flat of the shaded area above.

By 1939, the year Dalí completed this painting, he had a final break with André Breton, who several years earlier had become deeply suspicious of Dalí's fascination with Adolf Hitler. Breton now ridiculed the paranoiac-critical method, arguing that Dalí's continued commitment to its visual refinements "has reduced him to concocting entertainments on the level of *crossword puzzles*."[14] Surrealism was torn by fractious aesthetic and political differences, but it was the outbreak of World War II—whose prologue in the Spanish Civil War was such an important part of Dalí's work in the late 1930s – that finally ruptured the Parisian nucleus of Surrealism and sent many artists into exile, especially to the United States, where some had a significant impact on modern art in America.

SURREALISM IN EXILE

Emblematic of Surrealism's exile is the exhibition of Miró's *Constellations* at the Pierre Matisse Gallery in New York in January 1945. This series of works on paper, which includes the watercolor *Acrobatic Dancers*, 1940, (Fig. 26), was made between January 1940 and September 1941, a period after the beginning of the Second World War when Miró and his family left France and returned to the relative safety of Spain. For many of the European artists in exile in New York, this exhibition was, as André Breton recalled in a 1958 essay, "the first message of an artistic kind to reach America from Europe since the onset of war ... It was to be the wide-open window on all that the distant squall might have spared of trees in blossom."[15] Miró's *Constellations* caused a small sensation not just among the exiled Surrealists, but also for young American painters in New York, particularly Jackson Pollock, for whom the "all-over articulation" of Miró's surfaces, and the suspension of his imagery between figuration and abstraction, was said to be exemplary.[16]

31
Detail from Fig. 32, Max Ernst,
Europe after the Rain, 1940–42

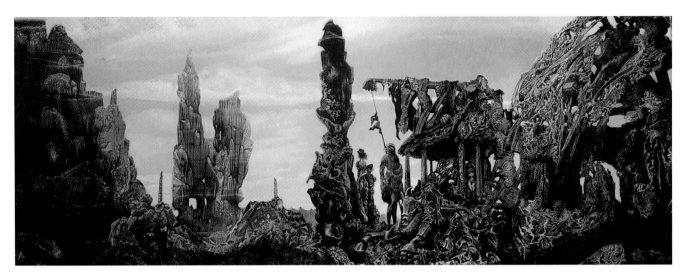

32
Max Ernst, *Europe after the Rain*, 1940–42
Checklist no. 19

33
Roberto Matta, *Prescience*, 1939
Checklist no. 34

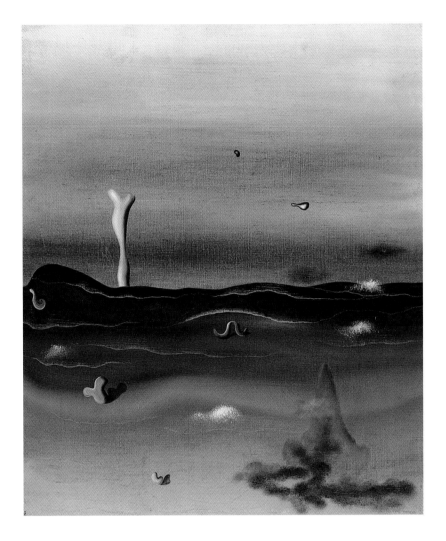

34
Yves Tanguy
Sans Titre, 1929
Checklist no. 62

It was only after Max Ernst arrived in America in 1942, it will be recalled, that he completed *Europe after the Rain* (Fig. 32), a painting begun two years earlier. Drawing on both dream imagery and a continued interest in automatic procedures – here his "decalcomania" of pressing glass on wet paint – Ernst creates a nightmare scene, part reality and part prophecy, of the destruction of European culture and civilization. Other artists had arrived earlier. In late 1939 Yves Tanguy, who since around 1927 had been painting subaquatic dreamscapes such as *Sans Titre*, 1929 (Fig. 34), arrived in New York with his American wife, the painter Kay Sage, and the Chilean-born painter Roberto Matta. Several years earlier Matta had abandoned his ambitions as an architect and begun to paint spatially ambiguous biomorphic abstractions like *Prescience*, 1939 (Fig. 33), a work that combines rapidly applied, occasionally dripped, paint with thin, translucent washes. Matta played an important role in familiarizing American artists, particularly Robert Motherwell, with Surrealist ideas of automatism.

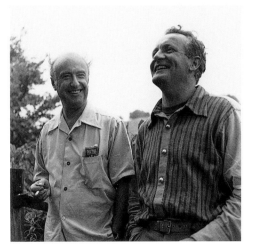

35
From left to right: Yves Tanguy and Peter Blume at Woodburg, CT, 1949
Photograph by James Thrall Soby

36
Marsden Hartley
Military, 1913

37
John Marin
Movement No. 3, Downtown, New York, 1926

AMERICAN MODERNISM AND ABSTRACT EXPRESSIONISM

Surrealism was hardly the first wave of European modernism to have a dramatic impact on American artists. Since the early part of the century, a vigorous transatlantic exchange of art and ideas was taking place. Works like Max Weber's *Three Figures*, 1910 (Fig. 38) and Marsden Hartley's *Military*, 1913 (Fig. 36) were inspired early on by the example of Expressionism and other modernist styles. As in Europe, the exploration of modernist themes in America oscillated between the city – like John Marin's 1926 *Movement No. 3, Downtown, New York* (Fig. 37) – and rural landscapes, ranging from Arthur Dove's 1934 *Approaching Snow Storm* (Fig. 39) in upstate New York to Georgia O'Keeffe's many paintings of the American Southwest, such as *The Lawrence Tree*, 1929 (Fig. 18). These artists, all part of the circle around the photographer and gallery director, Alfred Stieglitz, reconciled diverse strains of European modernism with nativist and self-consciously American interests.[17]

During and immediately after the Second World War, the emerging group of Abstract Expressionists – as Willem de Kooning, Mark Rothko, Jackson Pollock and their colleagues came to be labeled – were all to some degree affected by Surrealist ideas of automatism. They wrestled with a seemingly contradictory commitment to radical indi-

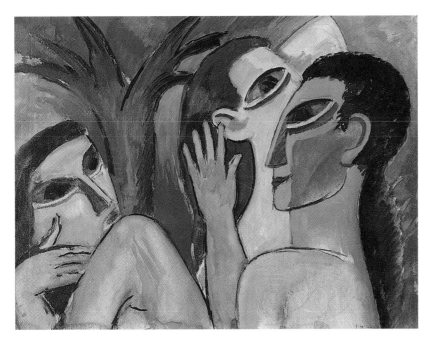

38
Max Weber
Three Figures, 1910

39
Arthur Dove
Approaching Snow Storm, 1934
Checklist no. 18

40
Willem de Kooning
Standing Man, c. 1942
Checklist no. 24

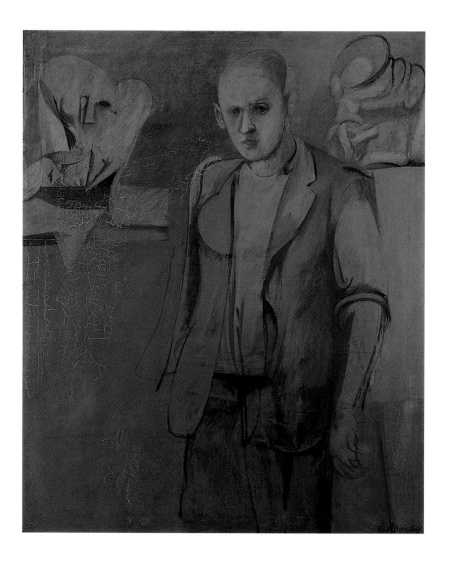

vidualism and the expression of universal subject matter. Although stylistically different, their works share an intensely self-conscious attention to the procedures of painting, the reinvention of which seemed to hold the best hope for the continued relevance of painting.

De Kooning painted *Standing Man, c.* 1942, (Fig. 40) some eight years before developing his aggressive gestural style that would engender the term "Action Painting."[18] Probably a self-portrait, the nearly monochrome painting shows an artist standing in his studio flanked by a still-life on the left and what might be a sculpture on the right. Only sketchy, partial outlines and slight variations of color distinguish the figure, who remains in a haze, half-present and staring out bleakly through a single eye. This image of an isolated and uncertain artist — far removed from the notoriously rowdy senior statesman of the New York School that de Kooning would become — may epitomize the position in which these young American artists found themselves in the early 1940s. The colors of *Standing Man* have suffered from age, but

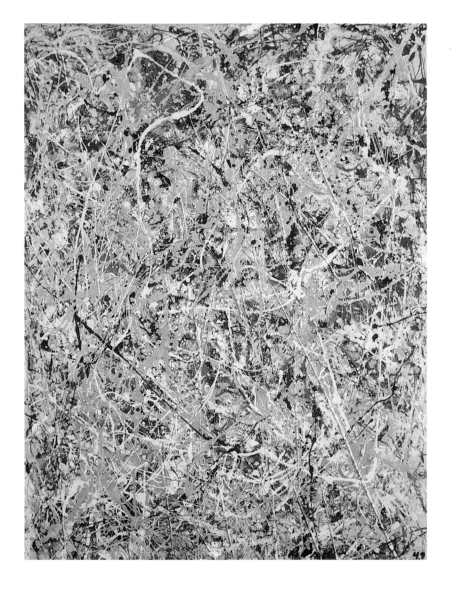

41
Jackson Pollock
Number 9, 1949
Checklist no. 47

its unfinished quality and many reworked areas are hallmarks of de Kooning's emphasis on process and the materiality of painting.

The Abstract Expressionists' interest in spontaneity reaches its apogee in Jackson Pollock's "drip paintings" such as *Number 9, 1949* (Fig. 41). For these paintings, the earliest of which date from late 1946 or early 1947, Pollock laid swathes of unstretched canvas (*Number 9, 1949* is atypically small) horizontally on the floor and, moving about all four sides, dripped and poured paint from above without directly touching brush to canvas. Beyond their powerful evocation of spontaneity, these paintings are as graphically dense as Klee's *Architecture* (Fig. 22) or Miró's *Acrobatic Dancers* (Fig. 26), and as formally rigorous as Mondrian's *Composition in Blue and White* (Fig. 19). Pollock's dense network of lines contains a carefully orchestrated structure and a visible layering of colors, from the more open framework of the blue and yellow, to the increasingly impenetrable skeins of black, silver and white that partially conceal the work's compositional origins.

42
Mark Rothko
Untitled, 1949
Checklist no. 50

Each drip and splotch of paint could be understood as an indexical record of Pollock's spontaneous gestures and physical movement around the canvas. His paintings were thus invested with a sense of his entire being and a new conception of the relation of artist to canvas. At the same time, the faith in direct unmediated artistic expression embedded in works like *Number 9, 1949* also marks the pinnacle of an early nineteenth-century Romantic concept of creativity. In the art that followed, the expressive theories and compositional strategies of Abstract Expressionism would be extended and reinforced, but also radically challenged.

FIGURATION IN POSTWAR ART

Alternatives to Abstract Expressionism could be found in a variety of contemporaneous modernist practices. A continuity of realism in the early 1950s is indicated by the work of two artists far outside the orbit of Abstract Expressionism: Peter Blume's 1952 *The Italian Straw Hat* (Fig. 43) and Stanley Spencer's 1951 *Silent Prayer* (Fig. 44). The contemplative realism of these two artists, respectively American and British, is inflected by highly personalized imagery, which disturbs the ordinariness of their interior scenes. The straw hat of Blume's title is found not at the center of the room, but appears like a spiraling pinwheel on the back wall behind an exaggerated and warped rendering of an Alexander Calder mobile Blume owned. Each object in the room is animated and the interior is oddly discontinuous with the exterior spaces beyond.

In contrast to Blume's unpeopled scene, Stanley Spencer's *Silent Prayer* presents a crowded communal interior: a Christian Science Reading Room in which each figure is intently absorbed in his or her own private activity. Spencer was a painter of contemporary religious

43
Peter Blume
The Italian Straw Hat, 1952
Checklist no. 4

44
Stanley Spencer
Silent Prayer, 1951
Checklist no. 55

scenes, and in this image his ex-wife Hilda, a devout Christian Scientist, who had died the previous year, is pictured on the face of the vase on the central table. The vase and its flowers dominate the painting, their size and bursting colors all but push back the figures at the table and overwhelm the everyday, somewhat drab routine of silent reading and private contemplation. "I think to myself it's possibly too personal," Spencer commented of his work trying to understand its mixed public reception, "and yet when I do a painting like that Reading Room painting [*Silent Prayer*] I can hardly bear to show anyone... it is greatly liked. And nothing could be more introspective than that painting."[19] The "introspection" of *Silent Prayer* involves not only its personal subject matter, but also Spencer's own hypnotic absorption (mirroring that of his figures) in rendering the minute repetitive patterns of tweed coats, wicker chairs, and tile flooring – a methodical trance-like patterning that seems the opposite of Pollock's dense networks of expressive lines or the calligraphic markings of Miró's *Constellations*. If Spencer and Blume are ultimately compelling

as modern painters, it is the result of the slight distortions and irregularities that make their mundane ordinariness redolent with unknown private meanings and link their studied, even academic, realism with the tensions of works by Kirchner, Dalí or Ernst.

The difference between these two paintings and the works of Abstract Expressionism could hardly be greater: realism versus abstraction; anecdotal versus universal; narrative space versus all-over composition. Yet such oppositions are inherently unstable, and it is their shifting constellation that helps make up the always provisional matrix of modernist positions and practices. Modern art moves in many directions and draws as much from the richness of repetitions and returns as from the heroism of innovation and originality.

Notes

For their thoughtful comments on this text, I would like to thank Peter Paret, Joel Smith and Eric Zafran.

1. See for instance, Charles W. Haxthausen, "'A New Beauty': Ernst Ludwig Kirchner's Images of Berlin," in Charles W. Haxthausen and Heidrun Suhr, eds., *Berlin: Culture and Metropolis*, Minneapolis, 1990, pp. 58–94; and Sherwin Simmons, "Ernst Kichner's Streetwalkers: Art, Luxury, and immorality in Berlin, 1913–16," *The Art Bulletin*, 82:1, March 2000, pp. 117–48.

2. Albert Gleizes and Jean Metzinger, *Du Cubism*, Paris, 1912; reprinted in translation in Charles Harrison and Paul Wood, eds., *Art in Theory 1900–1990: An Anthology of Changing Ideas*, Oxford and Cambridge, MA, 1992, p. 195.

3. A similar phenomenon in Picasso's related works of the early 1920s is discussed in Briony Fer, David Batchelor and Paul Wood, *Realism, Rationalism and Surrealism: Art between the Wars*, New Haven and London, 1993, pp. 71–72.

4. On this turn toward naturalistic and classically oriented paintings among modernist artists, see Benjamin H.D. Buchloh, "Figures of Authority, Ciphers of Regression: Notes on the Return of Representation in European Painting," *October* 16, Spring 1981, pp. 39–68. Elizabeth Cowling and Jennifer Mundy, *On Classic Ground: Picasso, Léger, de Chirico and the New Classicism 1910–1930*, London, 1990; and Kenneth E. Silver, *Esprit de Corps: The Art of the Parisian Avant-Garde and the First World War, 1914–1925*, Princeton, NJ, 1989.

5. On the studio as a theme in Picasso's work, see Michael Fitzgerald, *Picasso: The Artist's Studio* New Haven and London, 2001.

6. Georgia O'Keeffe, quoted in Elizabeth Mankin Kornhauser, *American paintings before 1945 in the Wadsworth Atheneum*, New Haven and London, 1996, p. 578.

7. Piet Mondrian, "General Principles of Neo-Plasticism," (1926), in *The New Art – The New Life: The Collected Writings of Piet Mondrian*, edited and translated by Harry Holtzman and Martin S. James, Boston, 1986, pp. 214–5.

8. *The General's Illness* is closely related to two other paintings from 1914 – *The Sailors' Barracks* and *The Evil Genius of a King* – that also include the leaning wall and variations of the colonnaded building.

9. André Breton, *First Surrealist Manifesto*, Paris, 1924; reprinted in Charles Harrison and Paul Wood, eds., *Art in Theory 1900–1990: An Anthology of Changing Ideas*, Oxford and Cambridge, MA, 1992, p. 438.

10. Louis Aragon, "A Wave of Dreams," 1924, quoted in Matthew Gale, *Dada & Surrealism*, London, 1997, p. 222.

11. Joan Miró, letter to Michel Leiris, August 10, 1924, reproduced in Margit Rowell, ed., *Joan Miró: Selected Writings and Interviews*. translations from the French by Paul Auster; translations from the Spanish and Catalan by Patricia

Matthews, Boston, 1986, p. 86.

12. Dawn Ades, ed., *Dalí's Optical Illusions*, New Haven and London, 2000, p. 98.

13. Ibid., p. 132.

14. André Breton, "The Most Recent Tendencies in Surrealist Painting," (1939), reprinted in Breton, *Surrealism and Painting*. translated by Simon Watson Taylor, New York, 1972, 147. On Dalí's break with Breton, see Dawn Ades, *Dalí*, London and New York, 1995, p. 106–09 and passim.

15. André Breton, "Constellations of Joan Miró," translated by Paul Hammond, in Hammond, *Constellations of Miró, Breton*, San Francisco, 2000, pp. 193–94.

16. Carolyn Lanchner, *Joan Miró*, New York, 1993, p. 71, citing William Rubin, *Miró in the Collection of the Museum of Moderrn Art*, New York, 1973, p. 81.

17. For a compelling study on the question of the "Americanness" of these and other artists, see Wanda Corn, *The Great American Thing: Art and National Identity, 1915–1935*, Berkeley, 1999.

18. The term "action painting" was coined by the critic Harold Rosenberg in his 1952 essay "The American Action Painters," reprinted in Rosenberg, *The Tradition of the New*, New York, 1994.

19. Stanley Spencer, letter to Unity Spencer, the artist's daughter, *c.* January, 1958, in Stanley Spencer, *Letters and Writings*, selected and edited by Adrian Glew, London, 2001, p. 249.

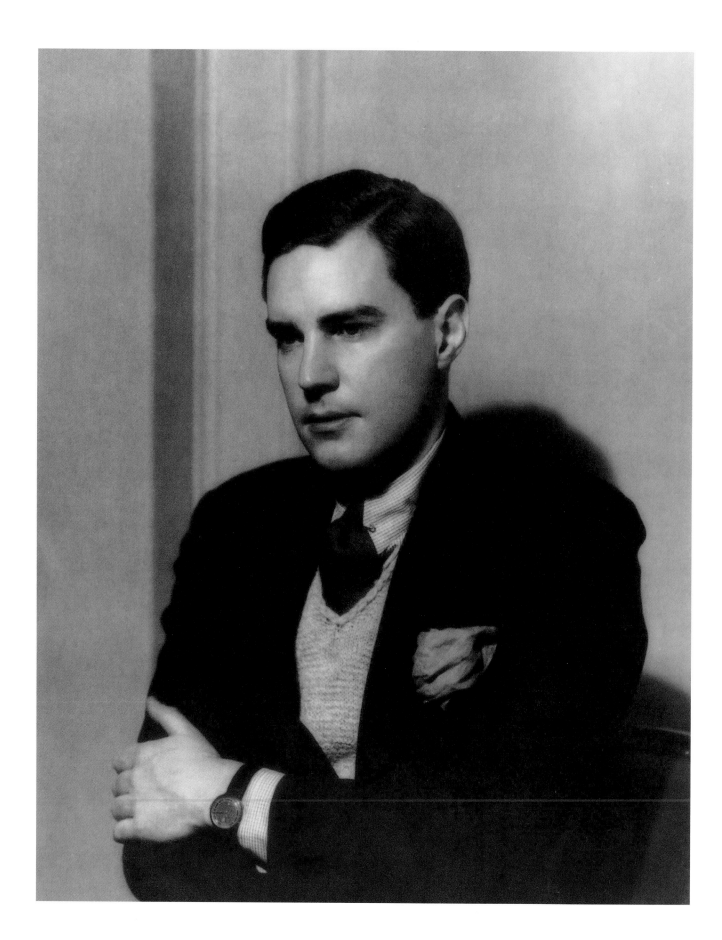

Springtime in the Museum:
Modern Art comes to Hartford

ERIC ZAFRAN

Following a visit in October 1935 to Hartford to present his challenging lecture "The Radiant City," the famed Swiss architect Le Corbusier wrote, it was "a small city which has acquired a reputation through the quality of the initiatives of its vibrant museum, the Wadsworth Atheneum." He continued: "The museum in Hartford, architecturally young, joyously lit, is only worthwhile because its director, Mr. Austin, and his two great friends, Messrs. Soby and Hitchcock, have lively and optimistic natures. Springtime may be born again to the museums of the world, when the living drives out the academic … Hartford has become a spiritual center of America, a place where the lamp of the mind burns."[1]

Le Corbusier had correctly identified the two key elements that transformed the once-dour Wadsworth Atheneum into a beacon of contemporary culture – A. Everett Austin, Jr., its brilliant young director since 1927; and the sense of joyous adventure he and his circle of friends including the curator-collector James Thrall Soby and the Wesleyan University professor, architectural historian and sometime guest curator, Henry-Russell Hitchcock Jr., brought to the institution. Le Corbusier, who was photographed with them at Soby's home the morning after his lecture (Fig. 46), recognized that "Messrs. Austin, Soby, and Hitchcock of Hartford do not by any means represent the general range of American aspirations. They appear, rather as meteors, and thus, they play a perilous and exhausting role."[2] He might have added that, as will be evident from their actions and correspondence, they had a great deal of fun as well.

A. Everett Austin, Jr., known as "Chick," (Fig. 45) was only twenty-six when he assumed the directorship of the Atheneum – October 27, 1927 – on the recommendation of his mentor Edward Forbes of Harvard where he had studied art and archaeology, but never attained a graduate degree. Austin was also creative in his own right; he loved to paint, act, design stage sets and perform magic. In essence, he was to transform the role of 'museum director' into that of an 'arts impresario'. Although, as his friends attested, he was not well read, he had a great eye and was cognizant of the latest artistic trends in Paris,

45
Lee Miller
Chick Austin, New York, 1933
Photograph

46
From left to right: Henry-Russell Hitchcock,
Jr., Robert Jacobson (translator), James Thrall
Soby and Le Corbusier at Soby's home,
Farmington, 1935

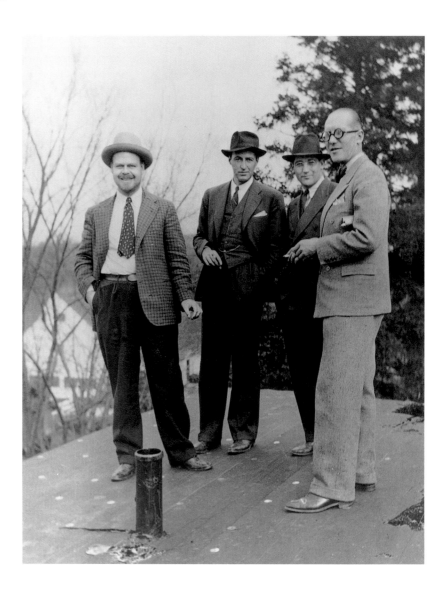

London, and New York. In addition, he was fluent in several languages
and a man of such ineffable charm that even the most seasoned of
crusty art dealers would extend him seemingly limitless credit. Finally,
as Le Corbusier perceived, there was an element of courage, which
allowed Austin and his friends to rally round the modern in the face of
all the opposition that the conservative capital of Connecticut and the
insurance business could muster.[3]

Austin's tenure as director was to be at its best a continual whirl-
wind of activity, and he jumped right in to his new position, oscillating
between the worlds of the old masters and moderns, more often than
not combining the two.

When in 1923 the Atheneum had shown in its Morgan Memorial
building a *Loan Exhibition of Modern Paintings*, it had featured noth-
ing more "modern" than several of the French Impressionists along
with the Americans George Bellows and Robert Henri.[4] Therefore,

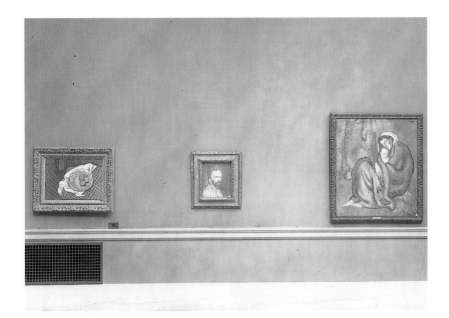

47
Modern French Painting, Wadsworth
Atheneum, 1928

when Austin presented from April 20 to May 5 of 1928 a *Loan
Exhibition of Modern French Paintings*, he could rightly claim that it
was "the first time that the museum has attempted to show the work of
the progressive school."[5] It was his conviction, as stated in that year's
Annual Report that, "A very important duty of the museum is the occa-
sional showing of paintings of this sort that the public may be given a
chance to become aware of what is going on around them. The purpose
of the Museum must be continually directed toward the education and
the improvement of the taste of the public."[6] The city's leading art
critic, T.H. Parker, bestowed his blessing on the venture, noting it was
"an innovation for Hartford, a collection of pictures entirely derived of
modernist art," and concluded by heaping praise on the young director:

> To Mr. A. Everett Austin, Jr., director of the Museum, goes
> unstinted thanks for bringing this modernist exhibition here.
> That Hartford should have gone so long without one is unthink-
> able, and that he should have so splendidly made up for this
> lacuna in the city's esthetic experience entitles him to hosannas.[7]

The exhibition consisted of nineteen paintings and seventeen works
on paper, and modern in this case actually began with Ingres and
Gauguin. With the exception of Van Gogh's *Self-Portrait* from Mrs. J.
J. Goodwin (later to enter the Atheneum's collection) and Henri
Rousseau's large *Jungle* from Mrs. John Carpenter, all the works were
lent by New York dealers. Among them were some very notable paint-
ings including Picasso's Blue Period *Maternity* and a Matisse *Still Life*
from Wildenstein and a Braque *Still Life* from Durand-Ruel.[8] The spa-
cious hanging in the grand Morgan galleries accorded these truly mod-
ern masters a powerful presence (Fig. 47). Simultaneously, in April and

48
Charles Demuth
Still Life with Eggplant and Squash, c. 1927

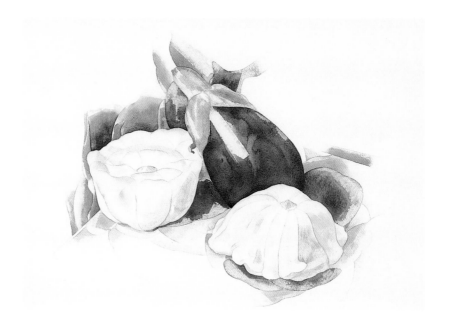

49
A room in Chick Austin's apartment, 1928,
Modern Decorative Arts

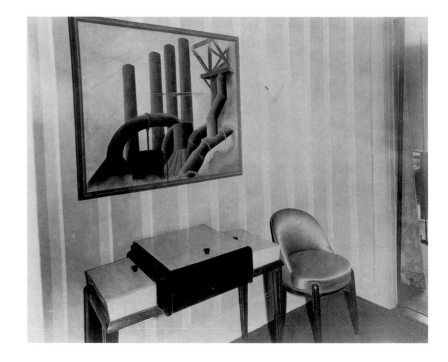

May of 1928, Austin also offered two additional exhibitions of draw-
ings and watercolors that further suggest the continuity of the modern
with the old masters. *The Paul J. Sachs Collection of Drawings* began
with Pollaiuolo and Mantegna and concluded with two Picassos.
Modern American Water Colors, which oddly included one Cézanne
landscape, featured examples by Charles Demuth and John Marin. In
this first year of his directorship, Austin also purchased for the
museum drawings and watercolors by Demuth (Fig. 48), Dickinson,

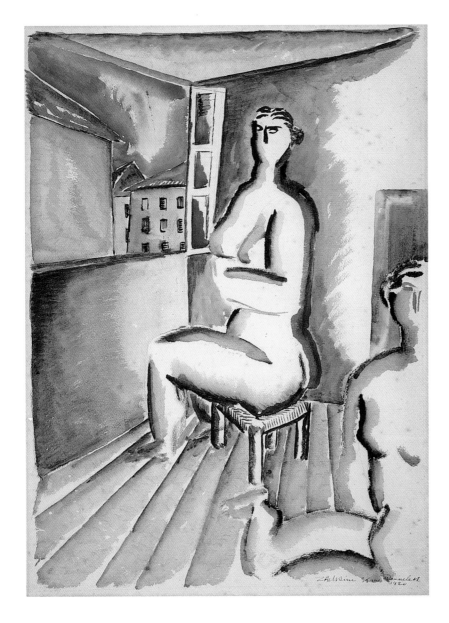

50
Ossip Zadkine
Interior with Two Nudes, 1920

and Hopper. The last was featured in the concluding exhibition of
1928, *The Watercolors of Edward Hopper*.[9]

Then, in an innovative step toward encouraging modern taste and
an advanced design sensibility, Austin turned his bachelor apartment
at 379 Farmington Avenue into an open house exhibition where
he mixed Art Deco and Modernism (Fig. 49). The thin yellow cata-
logue that accompanied this event was titled *Exhibition of Modern
Decorative Arts*. It reveals that the pieces of furniture, borrowed
from New York dealers, by Ruhlmann, Jourdain, and Chareau, were
accentuated by a *Still Life* by Juan Gris and a watercolor by Zadkine
(Fig. 50) owned by Austin plus a Charles Sheeler painting and a
Kuniyoshi drawing which were loaned. According to the director's
account in the *Annual Report* seven hundred people took advantage of

this opportunity to see "some of the best work of the modern designers."[10]

The following year Austin cemented his relationship to Hartford by marrying in Paris Helen Goodwin, scion of the city's most powerful family. This was to have positive consequences for the Atheneum's collection as several of the Goodwins were also collectors. One aunt, Mrs. F. Spencer Goodwin purchased Tanguy's 1940 oil *Imprevu* (Fig. 51) and gave it to the museum, but even more significant was Helen's cousin, Philip Goodwin. A life-long bachelor, he was an architect by profession and had a long association with the Museum of Modern Art as both a designer and trustee, before settling in Connecticut at the end of his life. He had donated some sculptures to the museum, but following his death at age seventy-two in 1958, an extensive group of works were willed by him or donated by his heirs to the Atheneum. Among these were the notable examples in the present exhibition by de Chirico, Miró, and Picasso (Fig. 9, 21, and 26).

In 1929 Austin presented as his major modern show *A Loan Exhibition of Selected Contemporary French Painting*, which was divided between the Atheneum and the New Britain Institute. There were loans by the director's circle of avant-garde friends, collectors, and dealers including a Chagall from Mrs. Edith Halpert, three Picassos from Paul Sachs, and a Eugene Berman from Russell Hitchcock. Once again the bulk of the works were from New York galleries and represented an eclectic range from Derain and Dufy to Modigliani and Matisse. The paintings of the last named artist drew press attention as one was said to be valued at what was at the time a staggering price of $22,000.[11] Austin also singled out the Matisses as among the most important works on view, but for their aesthetic rather than monetary value; assuming his role as educational impresario he declared, "It is the duty which everyone in Hartford owes himself to come at least once to the exhibition of selected paintings by contemporary French masters now on view at the Morgan Memorial."[12] Perhaps most notable about this selection of works was the presence of the Italian artist, Giorgio de Chirico. The little catalogue listed de Chirico's *The Endless Voyage* (Fig. 21) and another work as lent by the Valentine Galleries.[13] The former, which much later entered the Atheneum's collection, was the first recorded surreal subject to be displayed here. There were, however, additional de Chiricos not included in the catalogue. Through Alfred Barr, the Director of the newly created Museum of Modern Art, Austin had been alerted to those owned by Miss Lizzie Bliss on Park Avenue,[14] and according to a newspaper article on the exhibition written by Henry-Russell Hitchcock, there were four pictures by this "painter of dreams" – two early ones of 1914 and two of 1926.[15] After the exhibition closed, Austin wrote to Miss Bliss:

51
Yves Tanguy
Imprevu, 1940
Checklist no. 59

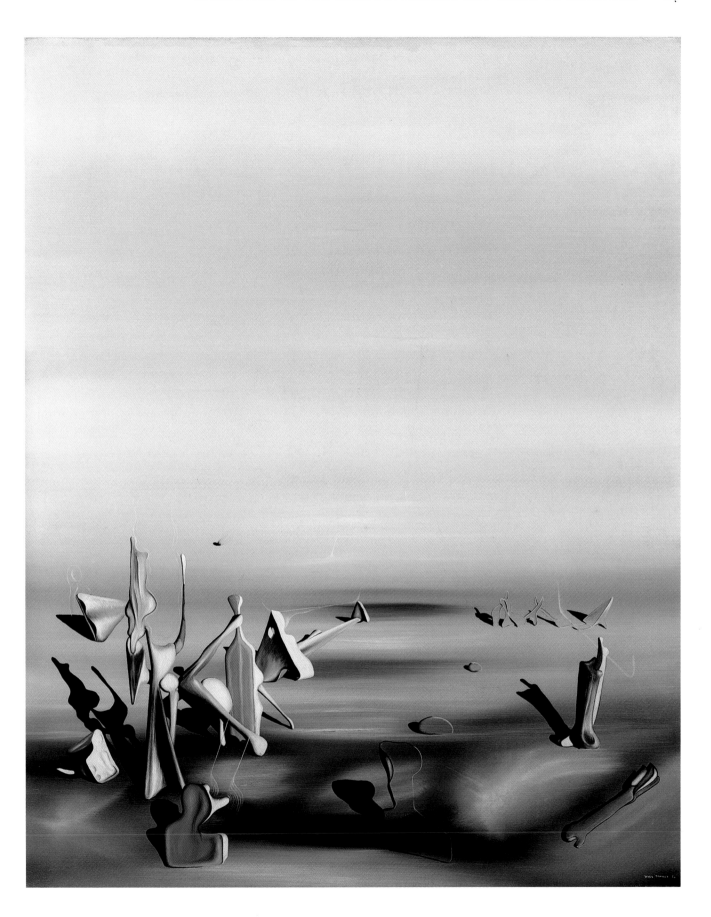

I cannot begin to tell you how very much I appreciated your generosity in lending your Chiricos to our museum. So few people have any interest in Hartford and so few Hartford people collect pictures that it is only with the greatest difficulty that we can arrange loan exhibitions. It seems to me that only in this way, however, and by continued stimulation, we can produce here an interest in modern art and in collecting.[16]

Austin's wish to generate a following for modern art was to be fulfilled in rather spectacular fashion by the sudden entry on to the Hartford art scene of James Thrall Soby (Fig. 52). Soby, whose family had made a fortune in pay telephones and who, after schooling at Williams College, dabbled in publishing at a local book store, later recounted in an unpublished autobiography, his conversion to modern art took place in 1930:

I had become fascinated by the contemporary School of Paris artists, particularly Matisse and Derain, in whose works the eloquent and now much-underestimated books of Clive Bell had made me interested ... I read Bell and Roger Fry and poured over the pages of *Cahiers d'Art* ... The names of Matisse and Derain were uppermost in my mind and one day in 1930 I went to New York and bought from the gallery of Valentine Dudensing a picture by each of the two artists. These pictures were not cheap even in those days and I was rather frightened by the money I'd spent all in one afternoon. I'd never spent more than $1,000 or at the most $1,500 for a picture before and now suddenly I'd blown a total of almost $15,000 in a few hours. I drove home to West Hartford with the Matisse [*The Red Sofa*, c. 1923] and the Derain [*Landscape* of the late 1920s] in the car, trembling and dreaming of lawyers, actuaries and other officials in bankruptcy proceedings awaiting me with guns drawn at my front door. I was delighted with my purchases when I got them home and up on the living room walls. I was also scared. A few days later, in dire need of comfort, I went from the bookshop over to the Wadsworth Atheneum and asked timorously to see the Director whose name – A. Everett Austin, Jr. – I knew but whom I'd never met. I knew enough about him from his exhibitions to be sure that he, if anyone in Hartford, would give me the moral support I badly needed ... His 1929 show *Selected Contemporary French Painting* had left me spell bound and been perhaps a decisive factor in my decision to buy works by members of the School of Paris ... I went to his office and there ensued what for me will always be a golden moment. When I told him the names of the artists whose pictures I'd bought in New York, he quite literally grabbed me by the coat, flung me into his car and we drove off with his customary contempt for speed limits to my West Hartford house. He couldn't

have been more excited if the purchases had been his own. From that day on we became close friends and worked together for almost ten years on various exhibitions and projects in the Wadsworth Atheneum. During those years I saw many examples of Chick's extraordinary generosity of spirit. I think I never saw it more clearly than on that first day of our friendship, when his enthusiasm for my Matisse and Derain scattered my fears of extravagance like dead ashes in a strong wind.[17]

In fact Soby was soon spending less and less time at his book business and becoming increasingly involved in the Atheneum, where he served as an honorary curator. He continued to purchase new art and among his significant buys was a large Derain, *The Bagpiper*, (formerly in the distinguished collection of modern art formed by John Quinn) for which Soby paid an impressive $14,000, and which was exhibited all by itself at the Atheneum for two weeks in June 1930.[18] Then in November Austin persuaded him to show a further ten works from his collection, in an *Exhibition of Contemporary Paintings Lent by Mr. and Mrs. James T. Soby*. As the local press observed:

Mr. and Mrs. James T. Soby of No. 18 Westwood road, West Hartford, have loaned ten pictures from their collection which is fast becoming one of the leading privately owned collections of modern work in the country ... In the group are many famous names. André Derain's "Bagpipe Player," which Mr. Soby bought last spring is one of the artist's early masterpieces ... Henri Matisse, the great colorist, is represented with two figure paintings [*The Red Sofa* of 1923 and *Reclining Nude* of 1926]. There are two Segonzac drawings. Other painters in the show include Marie Laurencin, André Lhote and Moise Kisling. Last year's modern show caused a great deal of comment favorable and otherwise ... This year's show will probably not offend so severely the sensibilities of those who do not approve of modernistic art.[19]

Austin himself was quoted as saying:

Mr. and Mrs. Soby are to be congratulated for their taste shown in the selection of these pictures ... Modern art naturally belongs to the young. They should understand it without difficulty ... These private collections even though they may be owned by one individual become in some strange way the property of the whole city, and often, as in this case now in Hartford, the public may on occasion share in this joy of possession.[20]

Combined with the presentation of the Soby works was an exhibition borrowed from the Demotte Gallery in New York of *Paintings by Giorgio de Chirico*. These recent works were primarily in the "Romantic" rather than Surrealist manner of the Italian master, but they received an enthusiastic welcome from another local art critic,

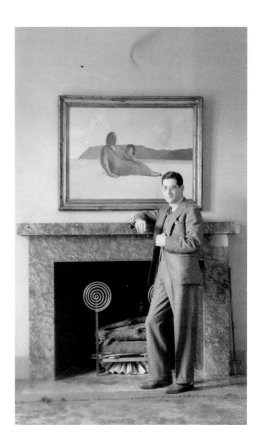

52
James Thrall Soby at his Farmington home with Bérard's *La Plage* and Calder's Andirons, 1939
(Digital Image © 2002, The Museum of Modern Art, New York)

Florence Berkman, who was to be a lifelong supporter of both modern art and Chick Austin. Her piece entitled "Chirico Collections Height of Modernism Incites Discussion and Argument" observed:

> Giorgio de Chirico is the most powerful personality in the new school of painting, which definitely became crystallized about 1920 ... The paintings of de Chirico express the interest of his decade in the Freudian pre-occupation with the subconscious. Intentionally they yield a strangely incongruous result ... There is a strange sensation of theatricality about the figures, of a fantastic momentary sensation of action.[21]

Earlier in 1930 Austin had exercised his Harvard connections to create a flurry of rapidly revolving modern presentations. His friends Lincoln Kirstein and Edward Warburg, along with John Walker III, had formed The Harvard Society for Contemporary Art in 1929[22] and the first of their inventive programs brought the architect Buckminster Fuller to Hartford in March 1930 for a lecture and viewing of the model of his futuristic Dymaxion house.[23] This was followed the next month by *Modern Mexican Art*. Included, as the *Bulletin* reported, were "those men in Mexico whose work in connection with the Renaissance of fresco painting in Mexico City has been so singularly stimulating and vital."[24] These were Diego Rivera, Rufino Tamayo, and David Alfaro Siqueiros, and the Parisian-born Jean Charlot. To fill out the original Harvard show, Alma Reed, the Director of Delphic Studios in New York, sent an additional group by José Orozco and Carlos Mérida.[25] Then for two weeks in May came *Modern German Art*, also from the Harvard group and the first presentation of the German Expressionists in Hartford. The *Hartford Times* prepared its readers for this experience by noting:

> The effects of the war are thought to be more palpably expressed in German art than in that of any other painting. The corruption, the intellectual and physical starvation, the insanity and degradation resulting from the terrible four years found profound and hideous expression in many of the contemporary paintings.[26]

Most of the paintings by Max Beckmann, Erich Heckel, Ludwig Kirchner, Oskar Kokoschka, and Karl Schmidt-Rottluff were lent by the respected Director of the Detroit Institute of Art, Dr. W. R. Valentiner. A group of Paul Klee oils came from J. B. Neumann of New York and one of the Heckel watercolors was lent by Mrs. John D. Rockefeller. After the exhibition, Austin thanked Dr. Valentiner:

> I cannot begin to tell you how much I appreciated your cooperation and how much I have enjoyed having your things here. The exhibition was a great success and I am very glad to say that seventeen prints were sold. This, perhaps, would not be surprising in

53
Pierre Roy
The Electrification of the Country, 1930
Checklist no. 52

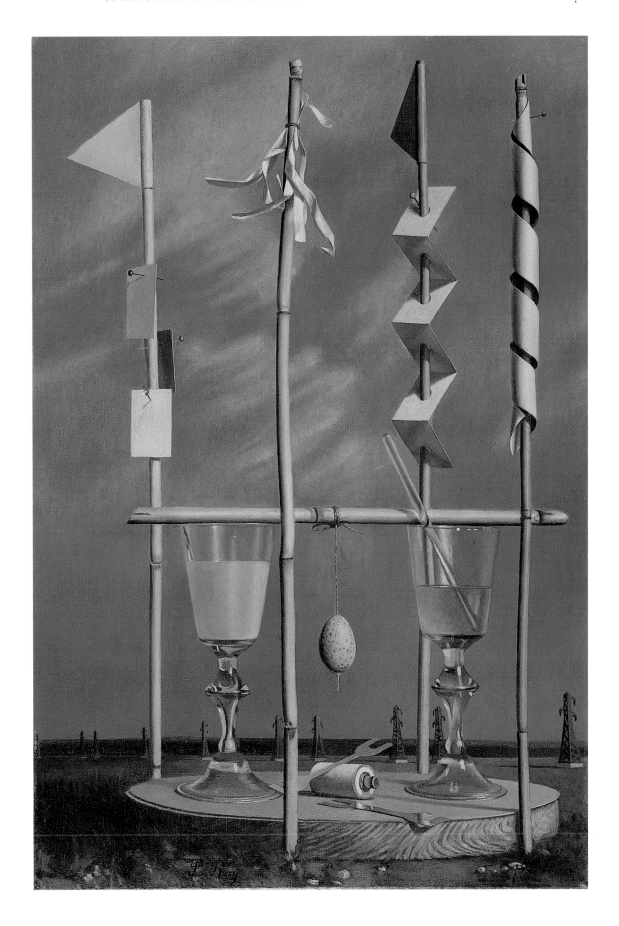

Detroit, but here it practically amounts to a miracle as there are few collectors of anything but early American furniture in this city.[27]

In defense of his challenging exhibition program, Austin wrote of his year's activity, "It seems very important that a museum should exhibit as much contemporary art as possible if it is to be of real educational value ... In Hartford the museum should be a Museum of Modern Art as well as a Metropolitan Museum, so to speak."[28]

Further evidence of this diversity was seen in December, when again relying on the Harvard connection there was a photography exhibition, which included works by such major but then generally little-known photographers as Walker Evans, Charles Sheeler, Edward Steichen, Paul Strand, Doris Ulmann, and Edward Weston.[29] The year ended with an exhibition entitled *Four Modern Artists*, all of whom had Connecticut connections, but of whom only Hartford-born Milton Avery was to achieve fame.[30]

In January of 1931, Austin presented the first of what would become a series of exhibitions, each surveying specific genres of painting. In these he always incorporated some surprising examples of modern art. This initial one was devoted to landscape,[31] and the modern, or at least the twentieth century, began chronologically with Henri Rousseau and Utrillo but spiritually with a Picasso and two works each by André Derain and Matisse. More surprisingly, there was also Paul Klee's *In the Grass* lent by Sidney Janowitz and a Mondrian *Abstraction* from Philip Johnson. However, the hit of the exhibition was *The Electrification of the Country* (Fig. 53) by the French painter Pierre Roy lent by the Brummer Gallery in New York, where it had been included in an exhibition of the painter's work during November 1930. The fame of this painting was established by a reproduction of it in the respected magazine, *The Arts*, to accompany a review of this show by the prominent writer Lloyd Goodrich.[32] Austin was so taken with *Electrification de la campagne*, as it was titled in French, that he purchased it for the museum at the rather substantial price of $2100.[33] It thus has the distinction of being the first modern painting acquisition. Much later Austin would write his own highly personal epigrammatic descriptions of his purchases for an unpublished catalogue of the Atheneum's collection; about this painting he related:

> Roy, following the example of de Chirico, applied the trompe l'oeil technique of former centuries to the Surrealist convention of the disparate object, achieving a crystallized poetry in the French eighteenth-century tradition of tasteful elegance. Here the child's box of electrical toys of a past generation is contrasted poetically with the high tension wires of the French countryside, the ensuing surprise as agreeable as the discovery of gaily colored birds' eggs on a walk through the woods.[34]

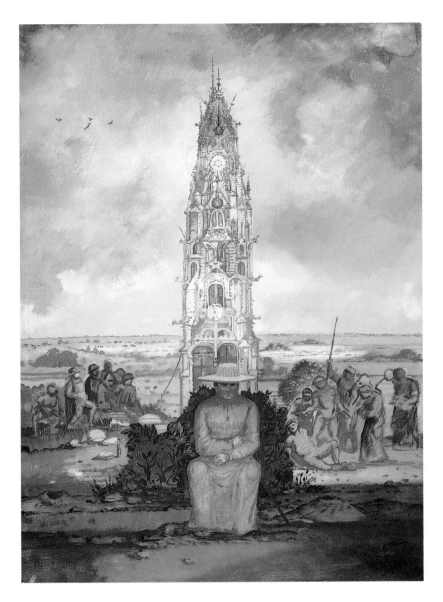

54
Kristians Tonny
Portrait of Gertrude Stein after Van Eyck,
c. 1936

Austin's desire to present the latest in international artistic develop-
ments mounted in intensity during the course of 1931. In April he
organized an exhibition sometimes referred to as *Five Young French
Painters.*[35] In fact only one of them, Christian Bérard, was French.
The others were Pavel Tchelitchew, (who was born in Russia), and the
two brothers (also Russian), Eugene Berman and Leonide, and
Kristians Tonny (born to Dutch parents in Paris). They had, however,
all been active in Paris and were identified as the Neo-Romantics. To
these Austin also added four drawings by Jean Cocteau that were not
listed in the catalogue.[36] As Soby was to make clear in his book *After
Picasso* published in 1935, these artists "who deliberately renounced
the value of all abstract art" and painted "the very elements of senti-
ment which abstract art had been careful to suppress" had "a haunting

elegance" that then seemed to be the path of the future,[37] and he lent his own large, somber Tchelitchew painting *Enterrement du Clown.* Loans also came from the circle of the Soby-Austin friends – the photographer George Platt Lynes, Henry-Russell Hitchcock, Jere Abbott, Carl van Vechten, Mr. and Mrs. Alfred H. Barr, Duncan Phillips, and Henry Francis and the bulk of the remaining works were from the Marie Harriman Gallery, the Balzac Galleries, and Demotte. Gertrude Stein was asked to write an introduction for the catalogue[38] and lend two paintings by Tonny, who had briefly been a favorite of hers,[39] but she did neither. However, in 1937 the museum purchased his drawing of Miss Stein in an Early Netherlandish guise (Fig. 54); that same year Austin gave the Dutch painter the plum commission of decorating the walls of the Atheneum's new theatre.[40]

After the Neo-Romantics came a showing of prints and drawings by Picasso lent by the John Becker Gallery of New York. As the newspapers pointed out:

> The exhibition is a small one and for this reason can give but little idea of the artist's versatile genius, but the abstractions are interesting and singularly delicate in color. The flowing and expressive line employed in the classical drawings is extraordinary.[41]

Austin was more than convinced of the artist's prime importance, and in April arranged for Wildenstein & Co. to send him two small Picasso paintings for consideration. One was an abstraction, and the other was identified by Felix Wildenstein as a "classical figure."[42] Now known as *The Bather* (Fig. 11), it previously belonged to Samuel Kootz and was available for $2500.[43] Austin was able to use the museum's acquisition fund to purchase this work, about which he later wrote:

> Picasso became in the early Twenties the author of a revived neoclassical style, born of his admiration for Roman sculpture during a visit to Italy with Diaghilev in 1917. This small but monumental picture belongs to this period, when even the encaustic surfaces of ancient frescoes were approximated by his brush-work.[44]

In June, he wrote to the dealer, "I feel that it was a very good purchase for us as it represents an opening wedge. I am sailing for Europe Friday of this week and hope to have the pleasure of seeing you in Paris."[45]

The wedge for Modernism was to be considerably widened as a result of this trip, for it was in Paris that summer that Austin discovered a new, and truly remarkable painter. The Pierre Colle Gallery was presenting a one-man exhibition of the young Spaniard Salvador Dalí. Austin may have been tipped off to the amazingly original and somewhat shocking works on view, all painted with a miniaturist's mastery of detail, by his friend, the New York art dealer Julien Levy,

who purchased what would be for most Americans the very touchstone of Surrealism, Dalí's *Persistence of Memory*.[46] Other American collectors of modern art, A. Conger Goodyear and Mrs. W. Murray Crane, also purchased Dalís, and sensing a trend, Levy and Austin decided to organize a survey exhibition to introduce Surrealism and Dalí to America. While Levy could justifiably take credit for culling a group of Ernsts and de Chiricos, it was Austin who located the Dalís in America and imported five others plus three Massons from Pierre Colle in Paris.[47] This daring exhibition was given the name *Newer Super-Realism*. The term "Super-Realists" had been employed earlier by the writer James Johnson Sweeney to refer to the Surrealists "with their predilection for the fantastic and mysterious."[48] Then, according to Soby's memoirs, because the director felt "Salvador Dalí's advent on the Paris art scene had given surrealism a new and important impetus," the "Newer" was added to the title.[49] The name "Super-Realism" stuck for only a short time, but for this historic exhibition, Austin assembled forty-nine works by eight modern artists, including Picasso, Masson, Roy, and the lesser known Leopold Survage. Dalí was represented by two drawings and eight paintings, but inevitably it was Levy's *Persistence of Memory*, which aroused the most attention and made its first appearance in the American press.[50]

Fortuitously the dealer Pierre Matisse had also recently established his independent gallery in New York and written to the Atheneum in October of 1931,[51] so that in the first of a long exchange of correspondence and dealings, Austin wrote to him noting: "I am arranging an exhibition of Picasso, Miró, Max Ernst, Masson, Dalí, and Survage … Could you lend to us on this occasion a Miró and a good Super-Realist Chirico?"[52] In response the obliging dealer sent Miró's *Nature Morte* and de Chirico's large *La Famille de l'artiste*. Three other de Chirico paintings were added to this. There were fourteen paintings by Max Ernst, eight came from Julien Levy and three each were lent by the photographer Berenice Abbott and Katherine Dreier's Société Anonyme, which likewise was the source for two Mirós. Another Miró was the *Portrait of Mrs. Mills in Costume of 1750* from the Valentine Gallery, later purchased by Soby. Of the seven Picassos the five that came from Wildenstein were not very surrealist, but there was also a sixteenth-century anamorphic painting lent by Mr. and Mrs. Barr to provide a historical prototype for the modern day Surrealists.[53]

All the works were listed in a tiny folded catalogue (Fig. 55), which had on its cover a photograph in the surrealist manner by George Platt Lynes titled *As a Wife Has a Cow*. In addition there was a chronology of Surrealism, an excerpt from a prose text by André Breton on *Soluble Fish*, a poem by Cary Ross entitled *Nothing*, and a portion of an essay by Samuel Putnam on *The After-War Spirit in Literature*. This was an incredibly heady mix for the citizens of Hartford to digest, so in the *Hartford Times* Austin published his defense of the radical undertaking:

55
Newer Super-Realism, catalogue cover, 1931

Fashion in art is very much like fashion in dress. Most of our clothes are bought with the idea of ultimately discarding them and a few indeed with the idea that they will ultimately be acquired by museums, yet we do not hesitate to dress in fashion because we fear that next year the mode will alter. We know it will, but we can take pleasure in what we have on today ... These pictures which you are going to see are chic. They are entertaining. They are of the moment. We do not have to take them too seriously to enjoy them. We need not demand necessarily that they be important. Many of them are humorous and we can laugh at them. Some of them are sinister and terrifying but so are the tabloids. It is much more satisfying aesthetically to be amused, to be frightened even, then to be bored by a pompous and empty art which has become enfeebled through the constant reiteration of outmoded formulae.

I am being continually asked to explain super-realism. That is very difficult. It is essentially an attempt to exploit, in terms of paint, the more exquisite reality of the imagination, of the dream, even of the nightmare – the desire to push reality beyond the visual actualities of most painting. In it there is much of Freud, of our contemporary interest in the subconscious mind ... The artist seeks to create an effect of surprise and astonishment, made breathtaking by the juxtaposition of strange and disparate objects. Sensational, yes, but after all, the painting of our day must compete with the movie thriller and the scandal sheet. As a matter of fact, super-realism is not unknown in this country. We have all met it and some have recognized its spirit, more diluted and more popularized in 'Mickey Mouse' and the 'Silly Symphonies' ...[54]

The *Hartford Courant* titled its review "There's Method in the Madness of French Surrealists whose Odd Works are Now on View Here" and attempted to explain the art of Dalí to puzzled viewers with reference to theories of the subconscious:

Let us look at the paintings by Salvador Dalí. Truly now, isn't there something familiar about those landscapes? Think way back into your childhood if necessary ... Now do you remember?

All this is the stuff that dreams are made of. But dreams, you know, are but a door to the subconscious – to the greater mind. Now we see that the world of the superrealists is the world of the mind. Care and precision go into the painting of all objects in Dalí's pictures, because he is painting a definite world. He seems to know what he is about when he puts in his clocks, watches, screws, keys and eggs, or even his purely imaginary objects, which sometimes serve as cabinets for his household hardware. But why all this stuff? And why the limp watches?[55]

56
Salvador Dalí
La Solitude, 1931
Checklist no. 13

57
A wall with works by Gérôme, Dalí, and
Kandinsky in the exhibition *Literature and
Poetry in Painting Since 1850*, 1933
Photographed by James Thrall Soby
(Photograph © 2002, The Museum of
Modern Art, New York)

The limp watches of *La Persistence de la Memoire* had surely made
a hit, and Levy who had acquired it for $250 was willing to sell it to the
Atheneum for $350, but this was more than Austin could then muster
and instead he purchased from the group sent by Colle the small *La
Solitude* (Fig. 56) for $120.[56] It was the first Dalí to enter any
museum's collection.

In April of 1931, Austin organized for the nearby Slater Memorial
Museum in Norwich, Connecticut, a wide-ranging exhibition of
Trends in Twentieth Century Painting. In this too he included Dalí's
Persistence de la Memoire.[57] This painting was to return yet again to
Hartford in 1933 for a three week showing as one of eighty canvases in
An Exhibition of Literature and Poetry in Painting Since 1850.[58] This
was a wide-ranging loan show in which the works were chosen for
their literary content. An effort was made to parallel the subjects of
the modern compositions with those of the nineteenth century, and
Dalí's painting was rather uncomfortably squeezed between Jean Léon
Gérôme's famous *L'Éminence grise* from the Museum of Fine Arts,
Boston, and Kandinsky's large *Improvisation No. 30* from the Art
Institute of Chicago (Fig. 57). Austin once again exhorted the public:

> In visiting such an exhibition, it is essential to begin with an
> unbiased mind and allow the paintings themselves to make one's
> point of view. In an age when the world moves so rapidly, and
> ideas are in a state of flux, it is unreasonable to single out paint-
> ing as an art which should remain static.[59]

For Henry-Russell Hitchcock, Jr., who wrote the catalogue
"Explanation:"

It was the Surrealist movement which pointed the revival of subject matter, although as the Surrealists themselves recognized, the early works of Chirico already achieved brilliantly the ends they sought.[60]

This may explain why in the loan request letter Austin sent to Mrs. Chester Dale, he referred to her painting *Morning Haze* as "late 'Surrealiste' Monet."[61] The true "moderns" on view ran the gamut from the Italian proto-Surrealist de Chirico to the Expressionists, Kandinsky, Klee, and Dix. There were five Picassos and a selection of the Neo-Romantics as well as a good representation of the Surrealists – three works by Max Ernst, *Loplop with Butterflies* (Fig. 25), *Dancers*, and *Sun on the Desert*, all from Julien Levy. He likewise supplied *Faces*, by his mother-in-law, the English artist Mina Loy, who was described as painting "poetic and mystic subject matter."[62] Also there were two Massons – *Le Poisson* from Soby and *Composition ("Les Captives")* from Pierre Matisse, who also lent a Severini. And returning once again to Hartford was de Chirico's *The Endless Voyage* (Fig. 21). There were two Roys: the Atheneum's picture and one purchased by Soby titled *Music*. For good measure also included were the American artists Louis Elshemius, Arthur B. Davies, and Morris Kantor. In addition Austin wrote to Alfred Stieglitz requesting the loan of a painting by Georgia O'Keeffe, preferably "one of the poetic variety, like the skull and rose ones." The dealer replied he had been delayed in answering due to O'Keeffe's illness but was indeed willing to lend her *Horse's Skull with White Rose* valued at $2000, if the museum assumed "full risk."[63]

Once again, it was the Dalí, which garnered the most attention. One review noted:

Side by side on one wall, hang 'L'Eminence Grise' of Gérôme, and the 'Persistence de la Memoire' of Dalí – at first glance totally unrelated. But, the former shows a group of seventeenth century figures from an epoch really familiar to the painter; the latter goes to dreamland for subject matter which is unknown and unreal. The colors of the two are extraordinarily similar. Each is painted with the most painstaking accuracy of detail.[64]

Austin explained the Kandinsky:

The picture by the Russian artist Wassily Kandinsky called "Improvisation" has caused a good deal of comment in Hartford. Judging from the attendance records at the museum during this exhibit, at least 5,000 people have looked at this picture and no doubt the majority of them have wondered what it is about … Kandinsky feels that for every note in the musical scale there is a color to correspond. In other words he is painting music. That is to say he has broken down the barrier between music and

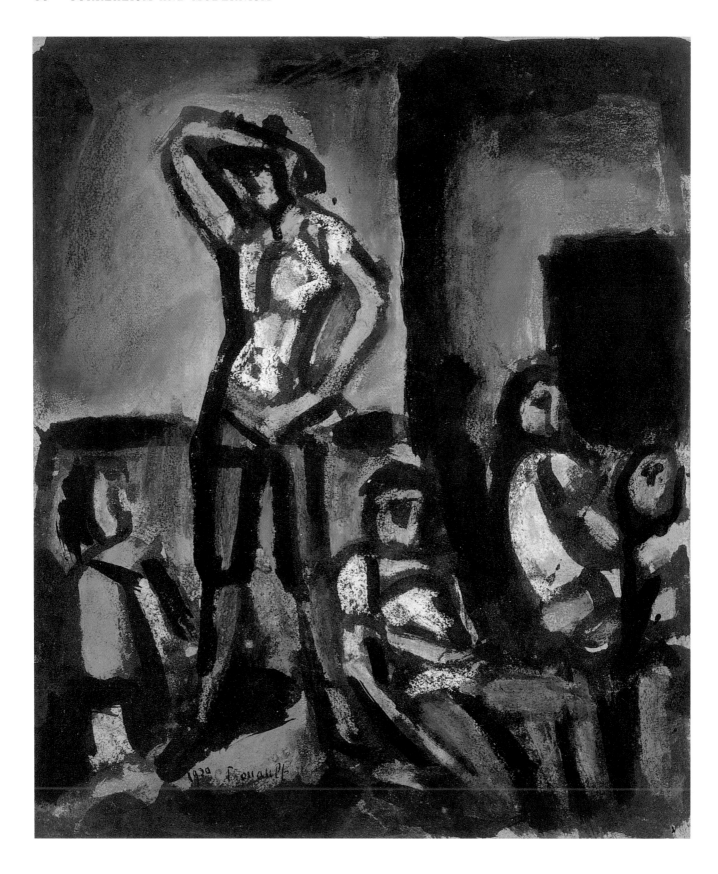

59
Paul Klee
Marionettes in a Storm, 1929

painting, and has isolated pure emotion ... Standing before
Kandinsky's drawings and pictures one gets a keener and more
spiritual pleasure than from any other kind of painting.[65]

Having come to Hartford to see this remarkable mélange of works
for himself, Pierre Matisse wrote enthusiastically to Austin, "I enjoyed
tremendously your exhibition ... I have rarely seen a livelier show
than this and some of the 'rapprochement' were amazingly 'revela-
teurs.'"[66] Pierre Matisse and Austin were to grow closer as they contin-
ued to do much business together, but a unique opportunity was missed
a few months later when Henri Matisse was in America and traveling
with his son in May of 1933 unexpectedly stopped in Hartford.
Unfortunately Austin was not at the museum when they called there.[67]

58
Georges Rouault
The Workers, 1930

60
Henri Matisse
Le Chant du Rossignol, 1920

The director apologized for this and, despite the lack of a work by the elder Matisse in the collection, actually returned a drawing by him to the gallery. He decided instead to keep one by the artist whose name he spelled "Roueau".[68] For this Austin paid $300 and got Rouault's brilliant pastel and watercolor *The Workers* of 1930 (Fig. 58).[69]

Later that year Austin on his annual trip to Europe, went to Germany, where he visited the leading Berlin dealer Alfred Flechtheim and took home five watercolors by Paul Klee. From these he selected two – *Mr. Pep and his Horse* and *Marionettes in a Storm* (Fig. 59). Klee refused to give any reduction on their price, so the dealer had to forego his commission and sold them for a mere $200 each.[70]

Since the Atheneum had demonstrated its interest in Pierre Roy, the New York dealer Joseph Brummer wrote Austin in early March of 1933 the day before opening an exhibition of the artist's new work, alerting him to the fact and inviting him in for a viewing.[71] Austin promised to come[72] and when he did found the thirty-five works so appealing that he arranged for twenty-two of them to be sent to Hartford.[73] To these he again added the Atheneum's painting plus Soby's *Musique*. Roy's easily palatable form of Surrealism made him extremely popular, and the exhibition received remarkable press coverage.[74]

The fame and importance of Roy would eventually fade, but the major acquisition made by Austin in 1933 would turn out to be of long-lasting significance. This great achievement was not a single work but an entire collection formed by the dancer Serge Lifar and his mentor Serge Diaghilev of costumes, drawings, and paintings, relating to the latter's company the *Ballets Russes*.[75] The dealer Julien Levy, who was exhibiting the collection, acted as the intermediary, arranging the sale for $10,000 to help salvage Lifar's touring ballet company during its floundering American tour.[76] Austin had been an enthusiastic follower of the *Ballets Russes*, since having seen them in Paris in 1923 and was now able in one fell swoop to add to the Atheneum's holdings a remarkable mass of material, which was displayed for the first time in Hartford in November of 1934. He described the collection as "an unique pictorial record of the greatest artistic movement of the first three decades of the twentieth century," and clearly drawing on his own memory went on to add:

> It represents the work of the many artists who created the ever novel visual aspects of the ballet from its earlier years when first, in 1909, fresh from Russia, it fell like some great flaming comet at the feet of the enchanted audiences in Paris, to the last period, when internationalized, the ballet chose for its decorators the, at the time, often unknown younger painters of the School of Paris ... Forever fortunate are those who were privileged to see the creations of Diaghilev. To them the joyful pangs of memory will be a constant proof that the twentieth century has known splendor devoid of vulgarity and taste kept inviolate from commercial degradation.[77]

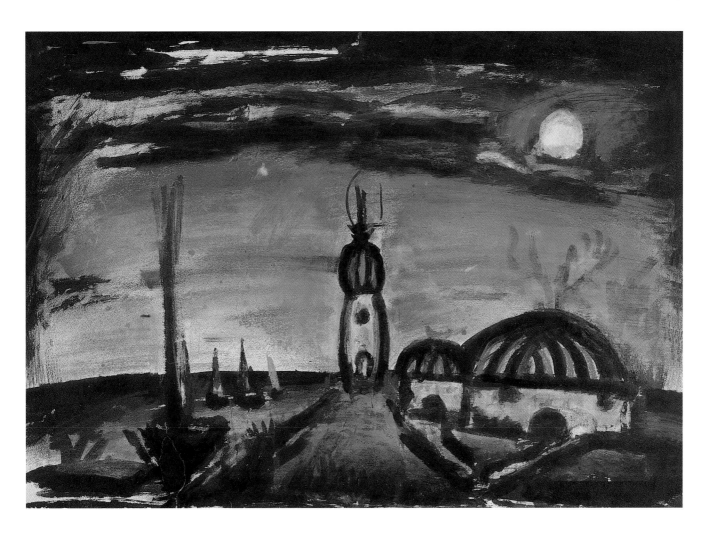

61
Georges Rouault
Scene I, Night, from *Le fil prodigue,* 1929

The great impresario Diaghilev had indeed brought together the leading innovators in music, such as Stravinsky, Prokofiev, and Satie, with the best of modern artists from whom he commissioned sets, costumes, theater curtains, and programs. Notable among the many works he assembled were Bakst's drawing for Nijinsky's costume in *Le Spectre de la rose*; Benois' set and costume designs for *Petrouschka* and *Giselle*; Braque's *Les Fâcheux*; Derain's *La Boutique Fantasque* and *Jack in the Box*; Nathalie Gontcharova's *Les Noces* and *Firebird*; Juan Gris *Les Tentations de la bergère*; Marie Laurencin's *Les Biches*; Léger's *La Création du Monde*; Matisse's *Le Chant du Rossignol* (Fig. 60); Picasso's *Le Tricorne*; and Rouault's *Le fil prodigue* (Fig. 61).

It was Serge Lifar, who took the credit for introducing Diaghilev to the work of the Surrealists Ernst and Miró in 1926,[78] and the examples acquired at that time provided inspiration for the production of *Romeo and Juliet*, which in two acts was not the full Shakespeare play but a rehearsal class and scenes from the story.[79] Three powerful oil and graphite *frottages* by Ernst served as the basis for set drops with only marginal connection to the action – *The Sea, The Night (Balcony*

62
Joan Miró
Dream Painting, 1925

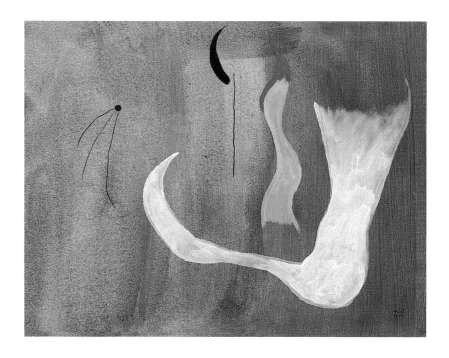

63
Leon Bakst
*Costume Design for the King's Guards in the
Ballet Sleeping Beauty*, 1922

64
Leon Bakst
Nijinsky as the Faun, 1912

Scene), and *The Death of Juliet*. In addition Ernst gave to Lifar another design not used in the ballet but entitled *The Sun* which he inscribed: "To Serge Lifar, let him dance on the lines of his hand, affectionately, Max Ernst."[80] There was also a Miró oil on linen known as *Dream Painting* dated 1925, and it was probably acquired in Paris by Diaghilev, who then had it enlarged for the front cloth of *Romeo and Juliet*.[81] A horizontal *Dream Painting* (Fig. 62) of the same date was also acquired at the same time but not employed for the ballet.[82] Perhaps best represented in the Lifar collection is Giorgio de Chirico. There are a number of his set designs and many costume studies for *Le Bal*, a 1929 ballet with choreography by Balanchine to music of Rieti.[83] In de Chirico's more classical mythological vein are three set designs created for Lifar's own 1931 production of *Bacchus et Ariane* at the Paris Opera.[84] There were also in the Lifar collection many works by the Neo-Romantics, Bérard and Tchelitchew, including by the last, a pen and ink study of Lifar in full flight as Albrecht in *Giselle*.[85]

Realizing the significance of this unique dance collection Austin continued to add to it, most notably with the famed Bakst drawing of Nijinsky as the Faun in *L'après midi d'un faun* (Fig. 64),[86] and subsequent directors and curators have followed his lead with more *Ballets Russes* drawings and costumes right up to the present with the purchase of a Bakst study for *Sleeping Beauty* in 2001 (Fig. 63).[87]

Another major ballet-related event for Hartford of 1933, which was to have even more major repercussions for the dance world at large, was the effort made by Austin and his friend Lincoln Kirstein to bring the *Ballets Russes'* young choreographer George Balanchine to America where he was eager to form a new school of ballet. With great

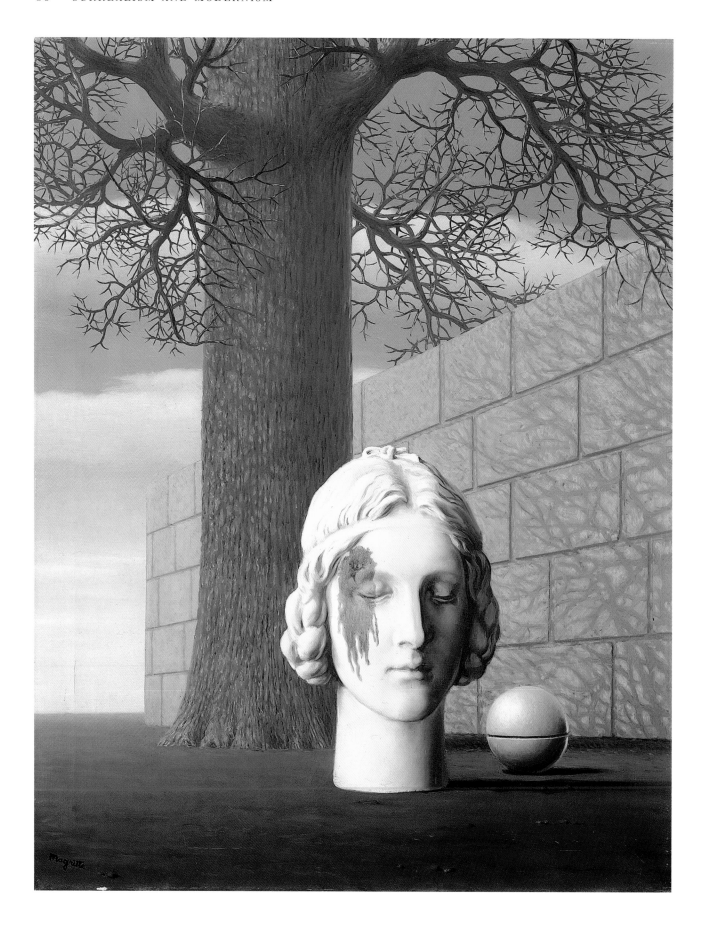

66
Avery Court, Wadsworth Atheneum,
photographed by Meyers Studio, Hartford,
1934

effort they succeeded in achieving their goal, but after only nine days in Hartford, Balanchine realized that, despite Austin's enthusiasm, this was not the city to support his grand ambitions. He went to New York City and there founded the School of American Ballet, which, however, as a token of gratitude toward Austin did give its first public performances at the Atheneum in December of 1934.[88] There were to be longer range benefits from this historic incident as well. In 2000 Balanchine's widow and muse of the 1950s, the great American dancer, Tanaquil Le Clercq, decided that the appropriate place to give the Magritte painting *The Fickleness of the Heart* (Fig. 65), which the couple had purchased in the 1950s, was the Atheneum.[89]

The performance of Balanchine's ballet company was but one of the many events that made 1934 into perhaps the liveliest and most memorable year of Austin's tenure. The grandest occasion was the opening of the new $600,000 Avery Memorial building with a Bauhaus-inspired interior primarily designed by the director with the whimsical placement of a fountain with a white marble mannerist *Venus* by Francavilla at the center (Fig. 66). It was dubbed the "finest modern museum in the country."[90] To complement this, Austin both organized a major Picasso retrospective in the new galleries (Fig. 67)

65
René Magritte
The Fickleness of the Heart, 1950
Checklist no. 26

67
Picasso Exhibition in Avery Memorial,
Wadsworth Atheneum, 1934

68
Florine Stettheimer
Beauty Contest: To the Memory of P. T.
Barnum, 1924
Checklist no. 56

and arranged for the premiere in the building's new theater of the Virgil Thomson and Gertrude Stein opera *Four Saints in Three Acts*.[91] The sets for this were designed by the inventive New York society painter Florine Stettheimer, whose sister would later give the Atheneum one of the artist's major works (Fig. 68).

The Picasso exhibition, the largest such survey of the artist in America to that point, had seventy-eight paintings incorporating all the Spanish master's various phases and including such famous works as the 1903 *Old Guitarist* from the Art Institute of Chicago, the 1905 *Woman with a Fan*, then in the Averell Harriman collection, the 1906 *Self Portrait* from the Gallatin collection, a cubist *Seated Woman* of 1909 and the *Three Musicians* of 1921 both from Paul Rosenberg of Paris, who had come to the Atheneum in December 1933 and let it be known that these works "will never be seen in this country again."[92] A number of classical works of the early 1920s were there to provide a context for the Atheneum's own *Nude*, and the Sobys lent their two major paintings, *Le Soupir* of 1923 and the 1927 *Seated Woman*. The exhibition concluded with three works of 1932 that were among the seven lent by Picasso himself. In addition there were another sixty drawings and prints from public and private collections and a selection of books illustrated by Picasso.[93]

All of this activity received wide notice and the art reviewer of the Boston-based *Christian Science Monitor* felt it necessary to visit the "small city near the Connecticut River" to see the retrospective exhibition of Picasso, "the most ingenious and baffling of modern painters," and her considered judgment was:

> To us it appears Picasso often runs up blind paths. It is a mistake to exhibit every one of his pictures for many are experimental and fail to integrate. The onlooker must be on his tiptoes. The process is long and tiring, but soon a selection of canvases can be made which are as delectable as any great masterpiece. There is no doubt that the blatant designs and raw colors of a number of canvases at Hartford simply obliterate the finer works of the Spaniard. Small wonder the layman was so obviously bewildered.[94]

Fortunately for Austin the professionals did not feel this way and Philip Johnson for one wrote him, "The Picasso Show was of course splendid and comes out beautifully against the white background. The whole thing made the Museum here [MoMA] look very drab and dull."[95] Years later Soby would recall that the Picasso show "surprisingly complete for that date" was a sheer delight to work on, but there were days and days when only a handful of people came to see it after the excitement of the opening subsided."[96]

If this extravaganza was not enough, Austin also installed and presented the enlarged permanent collection and added special loans in honor of the occasion including not just nineteenth-century highlights by Van Gogh, Gauguin, and Renoir, but also a selection of the

69
Chick Austin's office at the Wadsworth
Atheneum, c. 1934

Neo-Romantics and in the court some distinguished modern sculpture – a bronze by Ernst Barlach, two works by Wilhelm Lehmbruck (Fig. 73) lent by Soby, and Brancusi's *Blond Negress* then owned by Philip Goodwin. In the director's office (Fig. 69), "a striking example of modern design," with walls and furniture of dark South American canaletta wood, chromium, and glass and chairs designed by Le Corbusier were displayed, a large abstract painting by Miró and a Maillol marble *Seated Nude* from the Pierre Matisse Gallery.[97]

Matisse and Austin had at last begun addressing each other by their first names, and it was this gallery that supplied the museum with the great new work by Miró, which is known simply as *Painting* (Fig. 70). The New York dealer had it on consignment from Paul Guillaume (1891–1934) in Paris who refused to be flexible on his price and so Matisse wrote to Austin in January 1934:

> In regards to the Miró painting Composition 4–4–33 in view of the recent financial developments I am sorry to say that I shall not be able to maintain the price I have quoted you unless I hear from the museum that the purchase will be made in the near future at a definite date … I have given you an extremely low price which any fluctuation of the exchange would make it impossible for me to make a profit at all. I hope that you will be kind enough to let me know your decision this week.[98]

Austin consented to the price of $580 to be paid by that April, for the still unlined (and therefore fragile) painting. It is one of the Atheneum's and America's most important Surrealist works. Austin later wrote of it: "Here Miró's art is akin to that of the microscope, the strangely beautiful and humorously sinister patterns of bacteria dancing before our eyes."[99]

In May of 1934 the Soby collection, which had grown considerably, reappeared at the Atheneum, presented as *Modern French Paintings Drawings and Sculptures*. Now in addition to the Derains, Matisses and Picassos previously shown, there were works by the Neo-Romantics, most notably the odd double self-portrait by Bérard entitled *La Plage*, bid for by Pierre Matisse in Paris.[100] Also on view were a 1932 Bonnard, Paul Klee's *Gift for I*, plus works by Léger, Rouault, Juan Gris, and the Lehmbruck sculptures.

Soby was also responsible for the next exhibition in October, which comprised his own collection of one hundred photographs by his friend, the American surrealist, Man Ray. Soby's holdings had served him as the illustrations for his recent book on the artist,[101] and as the *Hartford Courant* noted:

> Man Ray's experiments in creative chiaruscuro and the camera's nerveless eye have been increasingly esteemed in this country over the last decade, and increasingly exhibited since the coming of the Surrealist Seance.[102]

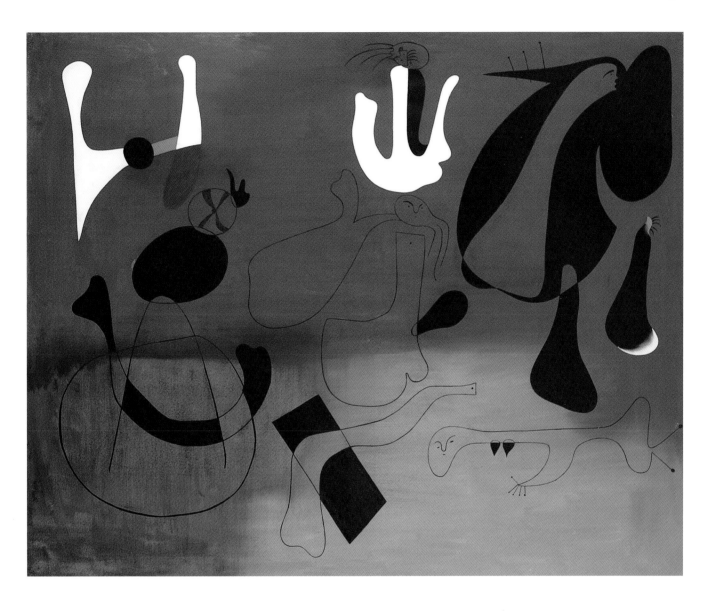

The "Surrealist Séance" was to get a further push in both America and Hartford with the arrival of Salvador Dalí. The Spanish painter was presenting his most recent work at Julien Levy's gallery in New York in November of 1934 and under the dealer's supervision Dalí and his wife Gala were doing everything possible to promote his reputation including entry into the social whirl of the New York art world. Hartford, under Austin, had become a key outpost of this activity, so the Dalís joined the entourage that assembled there on December 6 for the premiere public performance of the new School of American Ballet.[103] The Dalís were photographed at the opening, and the caption in the newspaper the next day was, "Dalí is that famous modern painter best known in this country for the little picture Persistence of Memory sometime known as 'The Wet Watches' which was shown at the Morgan Memorial."[104] After the performance Dalí joined the

70
Joan Miró
Painting, 1933

other celebrities at a festive party at the home of Mr. and Mrs. Soby, and it seems likely that it was then that Austin invited him to return to Hartford to present a formal lecture.

There had been other public talks at the Atheneum, but this was the first slide lecture to be presented by a famous modern artist, and it was in French. It was scheduled for Chick Austin's birthday, December 18, and to make the event even more significant the director arranged to have nine of the small Dalí paintings and two drawings sent from Levy's gallery for a two-week showing in his own office.[105] The evening lecture was attended by one hundred and nine people,[106] among them reporters not only from the local papers but also Joseph W. Alsop, Jr., from the *New York Herald Tribune*, who wrote a detailed account of the event. In Alsop's telling this began with an introduction by Austin, "evidently more apprehensive than at any of his previous efforts to make Hartford the new American Athens." This was in part because the lecture was to be preceded by a screening of the Dalí-Buñuel short film *Un Chien Andalou*, and Austin "politely requested the audience not to be upset by the forthcoming motion picture." Alsop continued, "when this bit of shock had finished, Mr. Dali, a slight, swarthy man with delicate features and a toothbrush mustache, walked onto the stage," and then providing a summary translation, the reporter continued recording Dalí's remarks: "It is perfectly natural for the public not to understand my pictures. I do not understand them at first myself. Then I begin to grasp the symbols which I can never explain. This is true of most surrealist paintings." Alsop then summarized Dalí's address, which included the memorable phrase, "The only difference between me and a madman, is that I am not a madman. I am able to distinguish between the dream and the real world." Alsop concluded his account by noting that "The audience, chiefly art students, took the lecture with an admirable calm and then departed for Mr. Austin's near-by offices, where there was an exhibition of Dalí's miniatures of horror."[107]

This mini-exhibition actually contained a remarkable number of some of Dalí's finest paintings of the early 1930s, such as *The Specter of Sex Appeal* (now in the Fundacio Gala Salvador Dalí at Figueras) and the 1933 *Myself at the Age of Ten When I was the Grasshoper Child* (acquired by Joseph Cornell and now in the collection of the Salvador Dalí Museum, St. Petersburg).[108] The one, however, that most appealed to Austin was the tiny enigmatic panel titled *Paranoic-astral Image* (Fig. 29). He acquired it for the Atheneum at a cost of $620,[109] and later wrote of it, "Dalí often tends, as in this example, to extend his landscapes into vast dreamy realms, haunted by the ghosts of his childhood (in this instance those of his father and nurse), and recalling for us the dream beauty of seashore post card views of the 1900s."[110] In addition Austin purchased for $100 one of the two Ingres-like Dalí drawings also on view.[111]

Likewise Soby, evincing a growing taste for the surreal, acquired from those works on show in the director's office Dalí's *Specter of Vermeer*. It was, however, de Chirico who would become his greatest obsession beginning with a showing in 1935 at Pierre Matisse's gallery of what the dealer described as "all the best de Chiricos I could get hold of."[112] These were the great metaphysical paintings of 1911 to 1917 and after he had purchased four of them, Soby wryly wrote to Matisse, "I consider you very wicked for putting on such an exhibition ... one more show like that and I will take my soup and hard bread with the rest of the town charity cases."[113] With the exception of a few pieces, such as his large Marino Marini *Rider* (Fig. 71), the Lehmbruck *Head of a Woman* (Fig. 73), and paintings by Matta and Tchelitchew,[114] James Thrall Soby's collection would ultimately be left to the Museum of Modern Art, where he first became involved in 1937, so it was fortunate that the Atheneum also began to add works by the Italian master to its holdings.

71
Marino Marini
Rider, 1947
Checklist no. 30

72
Marino Marini in his studio, Milan, May 1948
Photo by James Thrall Soby

73
Wilhelm Lehmbruck
Head of a Woman, 1910

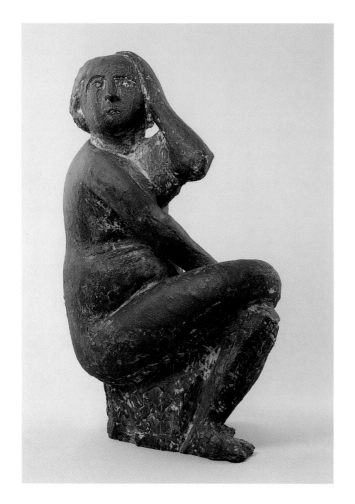

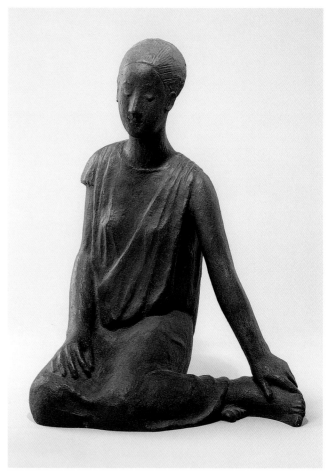

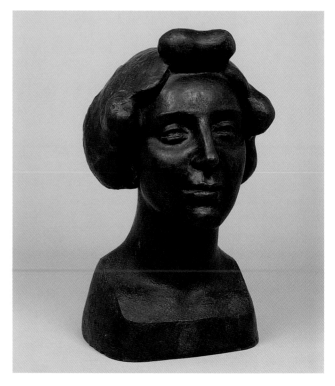

74
Marino Marini
Seated Figure, 1944
Checklist no. 32

75
Gerhard Marcks
Cinderella, 1941
Checklist no. 29

76
Aristide Maillol
Girl with Top Knot, n.d.
Checklist no. 28

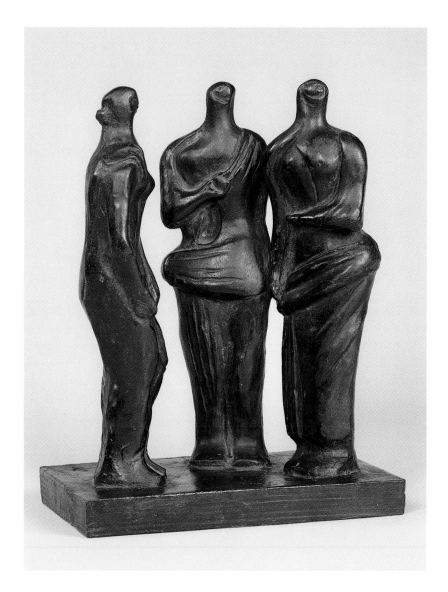

77
Henry Moore
Study for Battersea Park Figures, c. 1947
Checklist no. 38

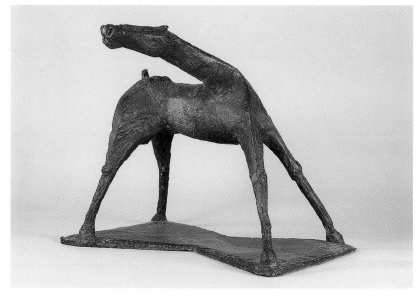

78
Marino Marini
Small Horse, 1950
Checklist no. 31

79
Arthur B. Davies
Protest Against Violence, c. 1911–12
Checklist no. 16

The first painting by de Chirico was acquired in 1937, when in February of that year Pierre Matisse sent for consideration two canvases identified as *The General's Illness* (Fig. 20) and *The Evil Genius of a King.*[115] Austin chose the former, and it is one of the painter's significant works of 1914–15, reflecting his unease over the outbreak of World War I.[116] In 1937 Austin was also able to buy, for only $35, a fine drawing on wood by Miró from Theodore Schempp in Paris. This *Composition* (Fig. 24) with the image of a smoker and biomorphic forms had been produced by the automatic method the artist employed

80
Alexander Calder
Little Blue Panel, c. 1935

in 1924.[117] For Austin, while it did not possess the "power and the grandeur" of Miró's *Painting*, which he had previously acquired, it nevertheless "shows the characteristic gaiety of his formal patterns."[118]

That same year, the Atheneum, used the James Junius Goodwin Fund to purchase from the Museum of Modern Art, a major Surrealist sculpture, Jean Arp's 1928 relief *Objects Placed on Three Planes like Writing* (Fig. 27), which sold for only $67.50.[119]

The fast pace of changing exhibitions and special events at the Atheneum continued throughout the 1930s. The year 1934 concluded with the rather odd presentation of *Impressionism to Abstraction: 13 Woman Painters*, which was significant as the first time that the formidable Connecticut collector Katherine Dreier lent a large group of works from her remarkable Société Anonyme collection. She had been assisted in forming this by Marcel Duchamp, and of the ladies presented it was perhaps only his sister, Suzanne Duchamp, and Miss Dreier herself who were to be remembered in later years.[120]

Of much greater consequence was the exhibition which was presented from January 29 to February 19 of 1935, *American Painting and Sculpture of Three Centuries*. The twentieth-century painters it

81
Alexander Calder
The Dragon, 1957
Checklist no. 5

encompassed were tremendously varied, with examples by Peter Blume, Ben Shahn (one of his Sacco and Vanzetti series lent rather incongruously by Mrs. John D. Rockefeller, Jr.), Arthur B. Davies (see Fig. 79), Stuart Davis, Arthur Dove, John Kane, Edward Hopper, Max Weber, and John Marin. From the Atheneum's collection there were watercolors by Charles Demuth and Preston Dickinson, and Edith Halpert of the Downtown Gallery lent oils by Alexander Brook and Yasuo Kuniyoshi, since, as she wrote, "neither artist is represented in Hartford. I do hope that the paintings will prove tempting."[121] The two women painters represented in the exhibition were polar opposites: Georgia O'Keeffe and Florine Stettheimer. Even more notable perhaps was the section of sculpture. In addition to such traditional practition-eers as Gaston Lachaise, Paul Manship, and Jacop Epstein (who was born in New York), there were such highly innovative sculptors as Noguchi and Zorach. Also receiving his first museum showing was Joseph Cornell, whose *Crystallized Dream* was subtitled "Surrealist Object."[122] Its reclusive creator did not come to Hartford, but did write to request copies of the catalogue.[123] This catalogue also lists one *Mobile* by Alexander Calder, but in fact Austin, entranced by the new

form of moving sculpture, added two others and included in the cata-
logue an inserted sheet with a statement by James Johnson Sweeney
explaining the works.[124] One, which was mechanized and has become
known as *Little Blue Panel* (Fig. 80) was purchased from Calder's then
dealer, Julien Levy for $75.[125] Also on view was a larger one suspended
from the ceiling, and the local newspaper reported following the open-
ing night:

> The 'mobile' by Alexander Calder designed especially for the
> occasion attracted much attention and curiosity. This is a combi-
> nation of wires and small and large spheres, which might be run
> by clockwork, but which last evening were kept in more or less
> constant motion by occasional proddings from a stick in the hand
> of Mr. Austin.[126]

The year of 1935 was to be renowned in Atheneum history as the
one in which Austin became convinced of the merits of pure abstrac-
tion. The year's activities began with a January lecture at the
Atheneum by Gertrude Stein on her first return trip to America since
1904. Her announced topic was "Pictures and What They Are," and
her companion Alice B. Toklas sent a terse note detailing the arrange-
ments:

> It is understood that Miss Gertrude Stein is to lecture on the
> eighteenth of January for a fee of $150. Miss Stein does not wish
> to be introduced, nor to have anyone sit on the platform or stage.
> As she reads the lecture, she wishes a light on the table and a
> glass of water upon the table. Miss Stein is looking forward with
> pleasure to her lecture at Hartford.[127]

Miss Stein's reputation in Hartford was already well established due
to the earlier presentation of *Four Saints in Three Acts*, so the local
press devoted a great deal of attention to her – publishing a photo and
commenting on her appearance (Fig. 82):

> She wore a dress of dark blue silk with a rather full pleated skirt
> and yellow scarf across her shoulder. Her most distinctive feature
> was a truly beautiful head with aquiline nose and very close-
> cropped hair, which makes her look like a young Jewish boy.[128]

Although it was reported that this lecture would "use sentence
structure which is understandable by those uninitiated into the mys-
teries of ultra modern English," and it was "delivered in a slow con-
versational tone," she concluded by stating, "When it came first to
Matisse and then to Picasso nothing was a bother to me," and then
launched into a reading of her set prose poems of these two artists. So
in the end it could be reported that, "Miss Stein's repetitious manner-
isms were extremely tiresome in spots."[129] Her abstract use of lan-
guage must, however, have delighted Austin.

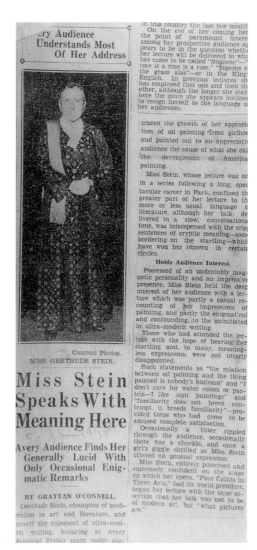

82
Press cuttings for Gertrude Stein's visit to
Hartford, 1935, from the Wadsworth
Atheneum Archives

83
Antoine Pevsner
Bas Relief, 1923

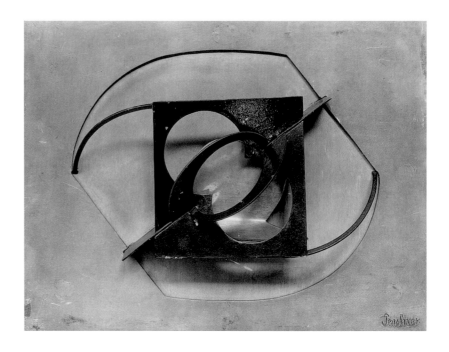

Shortly after this, he went off to Paris where his conversion to abstract art, begun by Kandinsky and the Calder pieces, was completed with a visit to the studio of Piet Mondrian. Recognizing the quality of the Dutch painter's compositions, Austin immediately planned, in conjunction with the Arts Club of Chicago, an exhibition simply titled *Abstract Art*.[130] He had Mondrian send a selection of four works for purchase consideration and inclusion in this. To these four *Compositions* was added Philip Johnson's previously borrowed Mondrian on deposit at the Museum of Modern Art. While in Paris, Austin had also discovered the non-figurative sculpture created by members of the group called *Abstract Creation*, consisting of the émigré brothers Gabo and Antoine Pevsner (both Russians) and César Domela (from Amsterdam). Austin agreed to purchase, for $200 each, Pevsner's lead and metal *Bas Relief* (Fig. 83) and the electrified *Abstract Construction* (Fig. 84) by Domela made of bakelite, glass, and steel.[131] He later recalled that he brought these back to America without paying any customs duty by declaring the strange constructions to be lamps![132] The remaining other fragile sculptures were to be shipped to New York, but the Chicago organizer, Austin's good friend, the irrepressible collector Bobsie Goodspeed, wrote him that Gabo's works had been seized by his landlord because the sculptor was behind in his rent.[133] However, in the end she was able to arrange for them to be sent. Austin supplemented the loans from France with a Pevsner *Torso* owned by Connecticut resident Katherine Dreier and a Domela from Smith College. The exhibition of these four artists (Fig. 86) was hailed as, "the perfection of abstraction, the ultimate in modernism."[134] However, in a departure from the printed listing of the

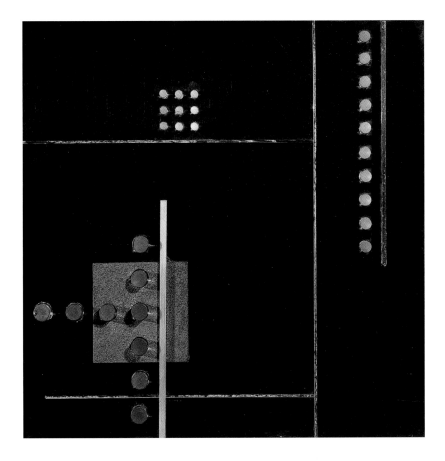

84
César Domela
Abstract Construction, 1935

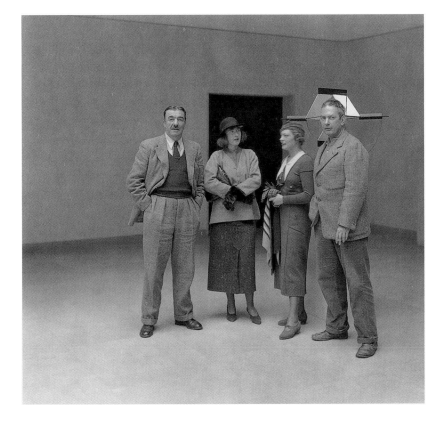

85
From left to right: Fernand Léger, Louisa
Calder, Mme. Simone Herman and Alexander
Calder in Avery Court, December 1935

86
Abstract Art Exhibition, Avery Court, 1935

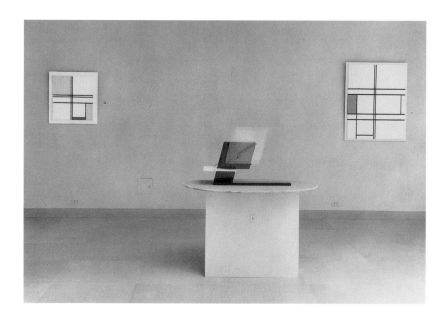

exhibition, Austin also included two works by Alexander Calder. The wall label text certainly written by the director made the connection:

> The American sculptor, Alexander Calder, clearly derives from the conceptions of Mondrian. His work is a plastic restatement of these ideas, using extremely simplified geometric forms of different primary colors, into which he has injected the element of time by the movements which animate his sculptures known as 'Mobiles.'[135]

When Calder, joined by his friend the French artist Fernand Léger, visited the Atheneum later that year, they were photographed in Avery Court with pieces from the exhibition (Fig. 85).[136]

From the four paintings which Mondrian had sent to Hartford, Austin selected *Composition in Blue and White* (Fig. 19) which was purchased for 6000 francs ($399.65) for the Atheneum. But even after the exhibition was sent on to the Arts Club of Chicago, poor Mondrian had not yet been paid and had to write several times to the director, who finally replied:

> Dear Mr. Mondrian,
> I am sorry that as yet I have not been able to send you the money for your beautiful picture which the Museum has acquired. There has been some difficulty caused this year by the loss of money in the funds but, within a month or so, you may expect to be paid in full. I regret very much the delay, but it has been unavoidable.[137]

Finally in July 1936 the payment was made, and Austin was able to write later of his purchase:

Mondrian was one of the most sensitive and impressive among those artists who, in the twentieth century, painted pure abstractions. Into his carefully balanced compositions, he translates the ordered cleanliness of the interiors painted in the seventeenth century by de Hooch and others. His influence on contemporary typography, architecture and industrial design has been very considerable.[138]

Of course Austin, by acquiring and exhibiting Mondrian and the several sculptures, was only proving the profundity of his catholic taste in search of the new. This was evident both in his museum purchases, and in the ongoing exhibitions.

For example, in 1936 Austin was approached by Katherine Dreier about showing an exhibition entitled *4 Painters*.[139] She was one of them and the other of note was Joseph Albers, the German-born master from the Bauhaus who was then teaching at Black Mountain College in North Carolina. His statement for the exhibition catalogue was a succinct summary of his approach:

Why I favor Abstract Art:
Abstracting is the essential function of the Human Spirt.
Abstract Art is the purest art: it strives most intensely toward the
 spiritual.
Abstract Art is Art in its beginning and is the Art of the
 Future.[140]

Learning through Miss Dreier that Austin was interested in his painting *Janus*, Albers wrote him from North Carolina in March of 1937: "I like your museum particularly well and consider it one of the best I have seen in this country. So I would like very much to be represented there. Therefore if you are still interested in having this picture let me know what you are able to pay for it."[141] Sadly, due to limited funds, no additional purchases or exhibitions of Albers' art was arranged.

Austin did, however, manage to present over the course of the next few years a number of one-man shows by a diverse assortment of artists. In 1935 he featured Tchelitchew with seventeen paintings and fifty-one drawings lent by the artist through Julien Levy.[142] This included the Russian's famed portrait of his poet companion Charles Henri Ford and several of his recent bull fighting scenes (Fig. 88). Then from January 21 to February 11, 1936, there was *Paul Klee*, consisting of fifty works both oils and watercolors lent by J. B. Neuman's Art Circle of New York. In March 1938 Austin unveiled the exhibition *Constructions in Space*, a selection of twelve sculptures and one drawing by Nahum Gabo, which Julien Levy had organized in Paris for the Atheneum. From this the museum purchased *Construction on a Line in Space* (Fig. 87) for $500,[143] a sculpture that was to have a sad history.

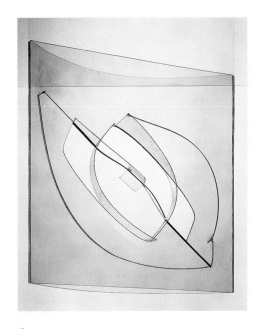

87
Naum Gabo
Construction on a Line in Space, 1937

88
The Tchelitchew Exhibition at the Wadsworth
Atheneum, 1935

Following damage to it in 1953, Gabo made a plexi-glass replacement, but this was unfortunately placed in an airtight case, resulting in its irreparable collapse.

Even more remarkable for Hartford were the presentations of Austin's continuing musical and theatrical events and his thematic exhibitions. In February of 1936 he organized the extensive Hartford Festival with performances of Stravinsky's *Les Noces* with Austin himself recreating Gontcharova's sets after the designs in the Lifar collection. Balanchine presented his company in *Serenata* and then the audience saw a historic staging of Eric Satie's *Socrate* with a mobile set designed by Calder. To top it all off there was a costume gala dubbed "The Paper Ball," and for this Tchelitchew was employed to create a décor and design many of the costumes including Austin's appropriately brazen *Ringmaster* (Fig. 80).[144]

The first big theme exhibition the following year (1937) was *43 Portraits*,[145] in which following an impressive array of Old Master and nineteenth-century ladies and gentlemen came as number forty-three Salvador Dalí's *Geodesical Portrait of Gala*, (now in the Yokohama Museum of Art),[146] a haunting 1936 back view of the painter's wife. Austin noted that, "For the more or less abstract painters of the early twentieth century the portrait could be but a paradox. Only within the last five years, with the various forms of reaction against abstract art, has the portrait, as something other than commercialized flattery, entered upon a revival."[147] One of the local newspapers observed:

> [Dalí's] portrait called 'Geogesical' (sic) which will be shown proclaims him as a technically irreproachable painter, a craftsman of the first order, a draughtsman of great virtuosity, who has a very real feeling for form. Though Dalí is stylistically a miniaturist, this picture, despite its careful painting and minute attention to detail, has a breadth of manner which gives the feeling of life-sized portraiture.[148]

Organized along the same lines, but with many more modern works was the major exhibition of 1938, *The Painters of Still Life*. This time the catalogue foreword was by both Austin and Hitchcock and therefore signed "jrs." They wrote:

> First Cubism and then Surrealism, while neglecting perhaps the object as such, served to recall in the many characteristic works, which are certainly still-lifes, the possible significance of the object in painting. The Cubist manipulates his objects for the purpose of his composition, with almost total disregard of their recognizability, but with a method that he could hardly use as successfully with landscape or figures. To the Surrealists, objects are symbols, and in order that they should function effectively, their recognizability becomes important. Indeed, and this is the

89
Pavel Tchelitchew
Chick as Ringmaster, 1936

90
Alexander Calder
Mantis, 1936

significant point, it is clear again that there is pleasure, not easily to be dismissed as non-aesthetic, in recognizability as such.[149]

To illustrate their points two Picassos were on view – *The Green Still Life* of 1914 from the Museum of Modern Art and *Two Eggs*, lent by Wildenstein; Braque's *The Mantelpiece* of 1924 from the Marie Harriman Gallery, that the newspaper described as "a Cubistic confusion;"[150] Derain's *Vase with Landscape* from Soby; and two paintings by Matisse – *The Rose* of 1910 from Soby and *The Gourds* of 1916 lent by MoMA. For the Surrealist contingent Austin once again relied on Julien Levy, who supplied Magritte's *The Key of Dreams* and Dalí's *The Accommodations of Desire*, an important work once in the collection of André Breton, which likewise aroused some confusion as having "objects which are recognizable but apparently meaningless."[151] In addition, there were two examples by de Chirico from Soby, and from the Atheneum's own collection Louis Fernandez's elongated *Still Life* of pots, which had been shown in MoMA's 1936 exhibition *Fantastic Art Dada Surrealism* and purchased from the sister institution for $125.[152] Also on view were two great Mirós, *The Horse* and *The Vase of Flowers*, from Pierre Matisse, and the two now well known Roys, belonging to the Atheneum and Soby. The modern element included two German examples – Max Beckmann's *Mexican Vase* and Paul Klee's *Still-Life with Little Box*, both lent by J. B. Neumann of New York.

There was also a case of works by Joseph Cornell, which may have included the remarkable box construction *Soap Bubble Set* (Fig. 91), which had previously been displayed in the Museum of Modern Art's *Fantastic Art* exhibition.[153] The evidence for this is an undated letter from Cornell's dealer Julien Levy, to Chick Austin giving the following information:

> Cornell is very cut up about selling the 'Soap Bubble Set' which he says took him a summer to make, etc. After it all boils down he concludes that he would love the Museum to have it and would sell it for $75. No less (he originally asked about $300. As he is a madman, but I told you I was sure I could get it down to 75. But probably not 50.) He begs of you to give him a photograph of his case in the Still Life show in case you have one made.[154]

It was appropriately on April 1, 1938, that the Atheneum purchased Cornell's *Soap Bubble Set* for a modest $60.[155] Well aware of the distinguished company he was joining, Cornell from his home on Utopia Parkway in Flushing, Long Island, typed the following letter to the Atheneum:

> Dear Sirs,
> Just recently I learned that my "Soap Bubble Set" was to be a permanent guest of your museum, and I should like to express

91
Joseph Cornell
Soap Bubble Set, 1936

92
Joseph Cornell
Untitled (for Juan Gris), c. 1960
Checklist no. 9

93
Joseph Cornell
Homage to the Romantic Ballet, 1966
Checklist no. 10

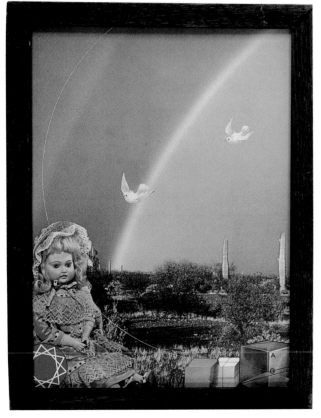

94
Joseph Cornell
Untitled, 1965
Checklist no. 12

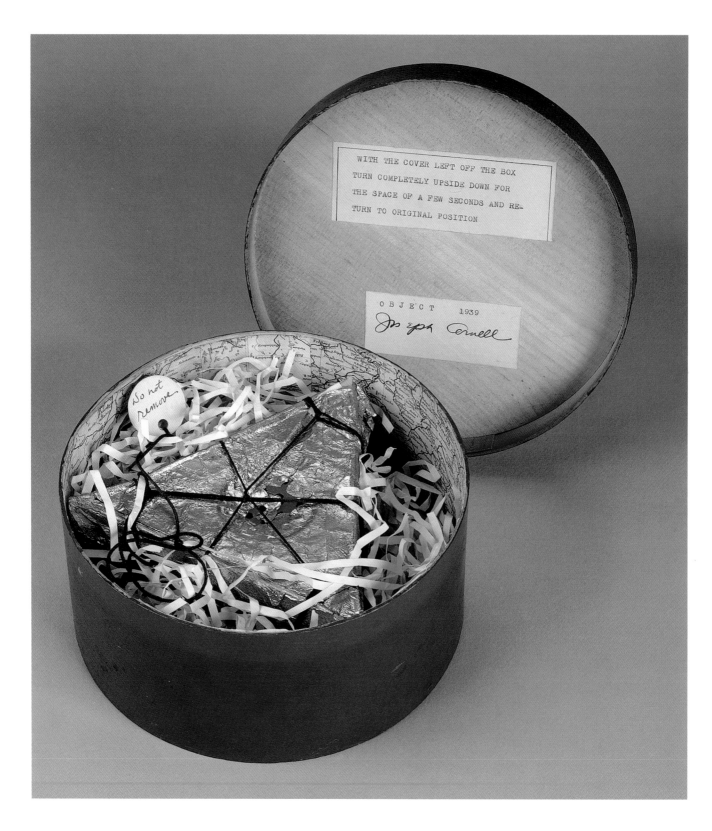

95
Joseph Cornell
Bel Echo Gruyere, 1939
Checklist no. 11

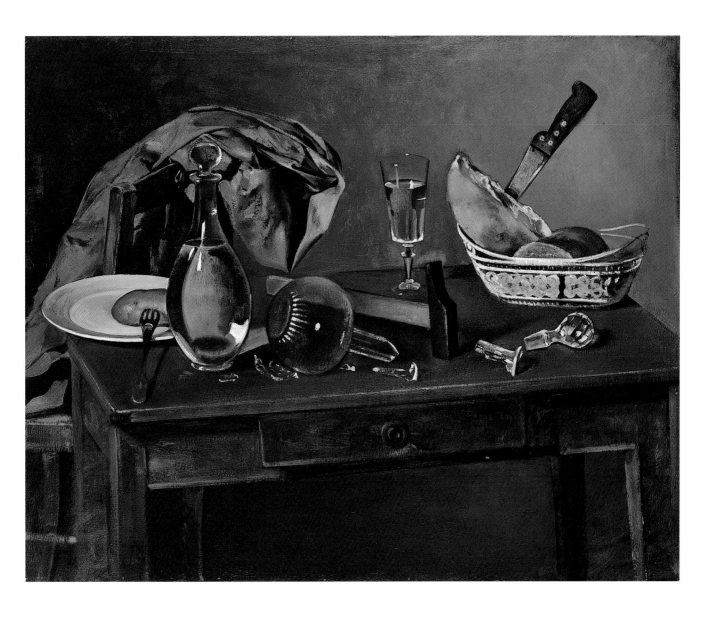

96
Balthus (Balthasar Klossowski de Rola)
Still Life, 1937

my gratitude for your very kind hospitality. This being my first acceptance by a museum it becomes quite an occasion for me. Will you kindly mail me three or four of your bulletins when, and if, there is a formal mention of it?[156]

Another significant construction, acquired that same year, after a certain amount of wrangling with the artist and which had also been in MoMA's exhibition of *Fantastic Art* was Alexander Calder's *Mantis* of 1936 (Fig. 90). Austin was able to get the price down from $500 to $350, and in 1943 Calder restrung this delicate piece of painted wood, wire, and string for $15 providing as well a diagram of how to maintain it.[157]

A great twentieth-century still life, which was not in the 1938 exhibition was, however, acquired by the museum that very year. This was

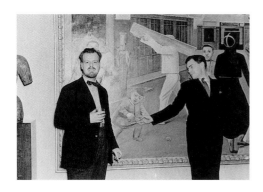

97
Henry-Russell Hitchcock, Jr. and Chick Austin
in front of Balthus' *The Street*, Farmington,
1939
Photographed by James Thrall Soby

the *Still Life* (*Nature morte*) (Fig. 96) by the Paris-born painter of Polish ancestry, Balthazar Klossowski, known as Balthus. In later years it was sometimes titled "Still Life in Violence,"[158] and it is certainly a most disturbing variation of the traditional genre with its smashed glass and the knife thrust into the bread. It was brought from Paris to New York by Julien Levy from whom it was purchased for $600 in 1938, and Austin later wrote about it and the painter:

> Balthus, of Polish extraction, worked in Paris before the war. He revives for contemporary eyes a feeling for romantic violence and sinister sentiment akin to that of Emily Brontë, for whose *Wuthering Heights* he has made illustrations. Here even the inanimate object has been shattered by these romantic passions.[159]

The work of Balthus was in fact already well known among the small circle of Hartford cognoscenti, for in 1937 Soby had purchased one of the painter's masterpieces – *The Street* of 1933. The collector had fallen in love with this work "an imaginative transcription of a scene on the short rue Bourbon-le-Chateau in Paris" when it had first been exhibited at Pierre Loeb's Paris gallery. But, as he wrote:

> It was nearly 6½ × 8 feet and as Loeb frankly said essentially unsalable because the painting's left section included a passage which even the French, usually calm about such matters, found hard to take. The passage shows a young girl being seized by the crotch by a strangely Mongolian-looking young man who has come up behind her, his face taut with easily decipherable excitement.[160]

Soby, despite his fears, was able to bring the work successfully through customs to Hartford and hung it proudly in his home where it served as an appropriate backdrop to the carryings on of Austin and the Hartford set (Fig. 97) until Soby came to feel his young son's friends were making too much of a fuss over it and it was banished to his vault. Fearing that it would be unexhibitable at MoMA after his death, Soby in 1956 sent it back to Balthus to have the offending passage repainted, and he could happily report, "The boy's hand had been moved very slightly to a less committed position on the young girl's body, though his eyes were tense with the same fever. I think *The Street* is safe now anywhere from Puritanical rage."[161] Of course what Soby chooses to omit in his autobiographical reminiscence of Balthus, but is evident from his correspondence, is that he had actually also purchased the painter's much more obviously shocking *Guitar Lesson*, a painting he ultimately traded.[162]

While Balthus himself never came to America, a sign of the increasingly turbulent situation in Europe was the appearance in this country in 1939 of several of the leading Surrealists. First Dalí returned to New York to attend the opening of a Surrealism show at

98
Detail from Fig. 30, Salvador Dalí
Apparition of a Face and Fruit Dish on a Beach, 1938

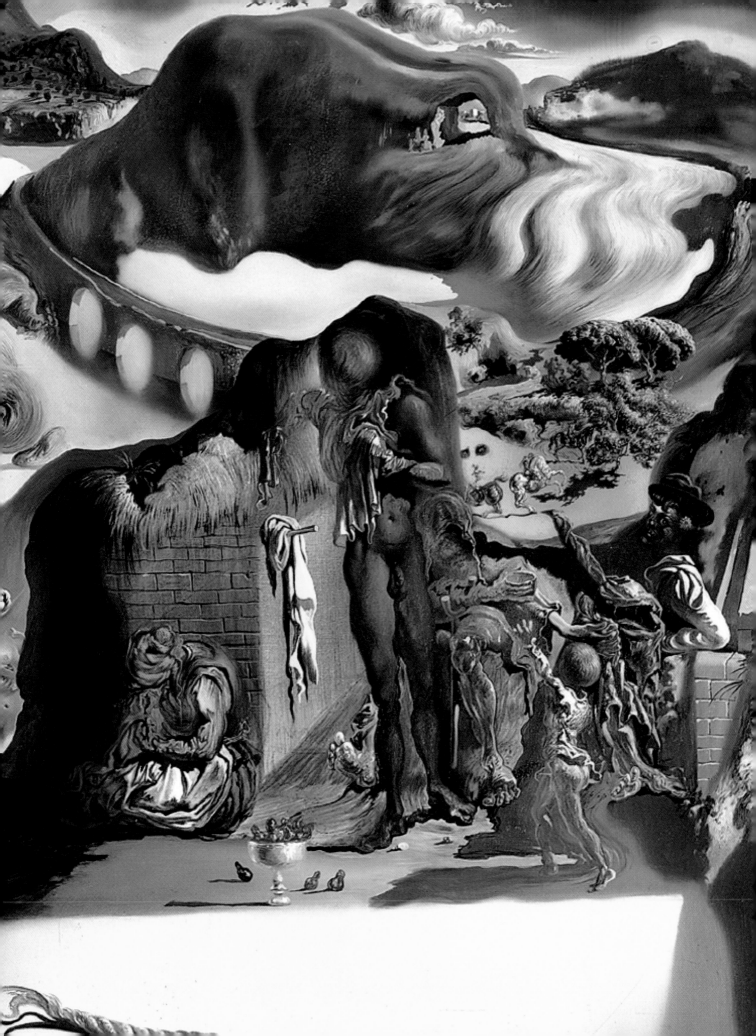

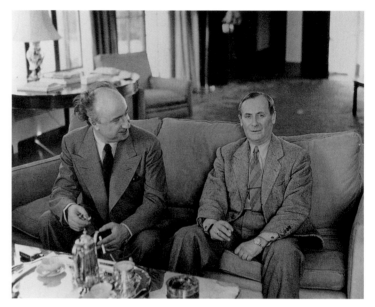

99
From left to right: Salvador and Gala Dalí,
Mrs. Soby, Julien Levy and Edward James,
searching for four-leaf clovers on the lawn at
Soby's house 1939

100
Salvador and Gala Dalí at Soby's home, 1939

101
From left to right: Joan Miró, Teeny Matisse,
Yves Tanguy, Mrs. Soby, Mrs. Miró, Pierre
Matisse and Kay Sage at Soby's home, 1947

102
Yves Tanguy and Joan Miró at Soby's home,
1947

Photographs by James Thrall Soby

MoMA and to drum up publicity for his one-man exhibition at Julien
Levy's gallery.[163] Included in this were some of the most complex
paintings Dalí had yet created, incorporating his recently developed
concept of "paranoiac-critical" pictures of double images with his per-
sonal iconography relating to his murdered former companion, the
poet García Lorca. While the most elaborate, *The Endless Enigma*,
(now in the Museo Nacional Centro de Arte Reina Sofia, Madrid) con-
sisting of six superimposed images went unsold at $3000,[164] Chick
Austin paid $1750 for the great *Apparition of a Face and Fruit Dish on
a Beach* (Fig. 30),[165] which he described as a "frozen dream."[166] Its
arrival in Hartford was heralded in the local press:

A large and impressive painting by Salvador Dalí has just been
purchased by the Wadsworth Atheneum ... The canvas is

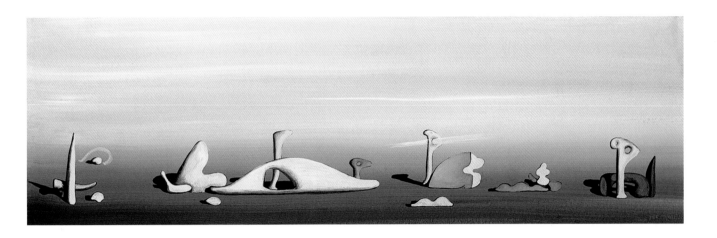

approximately five feet long by four deep ... The picture is as the title implies an example of the 'double image' genre which is Dalí's latest mode and combines images of the face and the fruit-dish, whole or part, worked into a composition which includes small landscapes, many figures, human or fantastic, and numerous small objects. Looking at the painting, the observer sees at one time, for instance, a fruit-dish with its pedestal, at another the human face that emerges from the contours of the dish, and still again the features of the face as unrelated objects. For instance, the left eye is really a small jar lying on the beach; the right eye is the head of a small human figure placed upside down.[167]

Dalí must have been fond of Austin and Hartford where more works of his were now on view than in any other museum, and during 1939 he and his wife Gala came to visit and stayed with the Sobys in Farmington. Soby, an amateur photographer, fortunately recorded such occasions, in particular one weekend when the Dalís in the company of Julien Levy and the devoted English Dalí collector Edward James were all together and Gala insisted they search for four leaf clovers (Fig. 99).[168] These pictures of the Dalís (Fig. 100) are among the most intimate ever taken of the couple.

While Dalí now had three paintings and a drawing in the Atheneum's collection, another leading figure of Surrealism, Yves Tanguy, was represented by only one work, a 1933 gouache on paper, *Dream Landscape* (Fig. 103), which had been purchased for $35 from Julien Levy in 1936.[169] It later inspired Chick Austin to write, "The landscapes of Tanguy may well be compared with those of Patinir. Both artists make use of strange formations and evoke a sense of eerie and illimitable distance."[170]

Tanguy, however, was destined to have a major role in Atheneum and Connecticut history. One of the first artists forced into exile, he came to the United States in 1939. In December of that year his future

103
Yves Tanguy
Dream Landscape, 1933
Checklist no. 58

104
Kay Sage
Quote–Unquote, 1958
Checklist no. 53

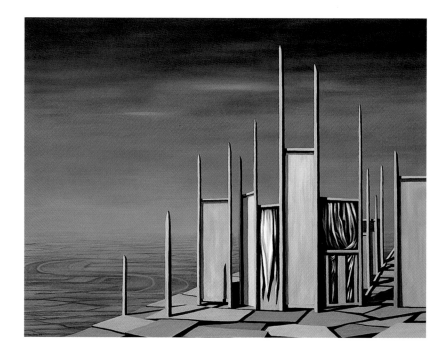

105
Yves Tanguy
La Rose des Quatres Vents, 1950
Checklist no. 61

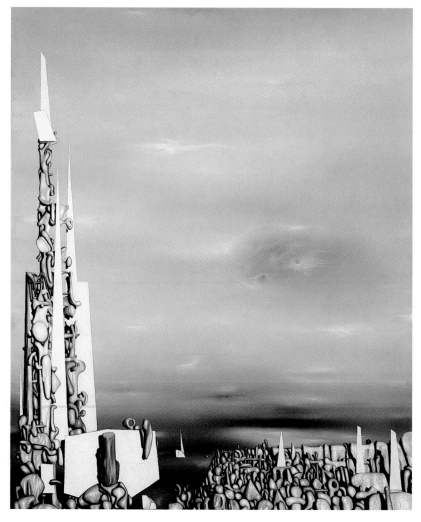

wife, Kay San Faustino, (better known as the painter Kay Sage) helped organize a show of his work at the Pierre Matisse Gallery. She was also a relative by marriage of Chick Austin, who had lent a work to the show, and through her aunt, Betty (the former Mrs. Walter Goodwin) made contact with him to bring this to Hartford.[171] On November 28 Austin wrote to her saying, "We would like very much to have the exhibition of Tanguys for the Wadsworth Atheneum after its conclusion in New York."[172] Mrs. San Faustino informed him that of those works in the New York showing, "Mr. Barr is lending the museum canvas but Mrs. Barr did not care to let their own personal one leave New York. I have written to Mr. Soby asking him if he will lend his to you which I take it for granted he will do as he lives so near you. The same applies to Mr. Cooley."[173] As the *Hartford Times* reported, the Tanguy exhibition attended by the artist, Kay San Faustino, and Mr. and Mrs. Pierre Matisse, was opened with an afternoon tea at which Mrs. Austin and Mrs. Soby poured.[174]

Soby wrote in his autobiography that, "unlike Surrealism's overlord, André Breton, Tanguy had no prejudice against the American people or the language they spoke,"[175] and thus he and his wife, Kay Sage, soon settled in Woodbury, Connecticut, where the painter "made an effort to converse with his neighbors," and in 1948 became an American citizen.[176] Tanguy and Sage would become part of the Connecticut artistic circle that included such American "surrealists" as Peter Blume (Fig. 35) and Alexander Calder.[177] The Sobys were also good friends and often hosted the festivities when these artists got together or when European celebrities in exile like Miró came to town – occasions, which once again Soby fortunately recorded for posterity (Figs. 101 and 102). Yves Tanguy and Kay Sage were given a joint exhibition at the Atheneum in 1955. Sadly he died the following year and in 1963 she committed suicide, following which Pierre Matisse, as the executor, distributed works by and owned by them. Thus the Atheneum received a fine Kay Sage (Fig. 104), several Tanguys (Fig. 34, 105 and 106), and its first Magritte (Fig. 28).

A sign of the times was that in 1939, Austin instead of making his annual summer trip to Europe, went to Mexico (where he had been as a college student to help preserve the pre-Columbian frescoes), and in his typically enthusiastic fashion, he acquired for the Atheneum works of both colonial and contemporary art he discovered there. Of the two modern artists he favored, one was the now largely forgotten Jesús Guerrero Galván, who was even later in 1943 to be given a one-man exhibition at the Atheneum by Austin.[178] His painting, *The Little Nurse (La Vigornia)* (Fig. 107) purchased for $175 was, at the time, much appreciated as a token of Mexican imagery and had even been reproduced in *Life Magazine*.[179] Austin described the painter as "one of the most distinguished among the younger Mexican painters, he has achieved a monumental style without the customary political and

106
Yves Tanguy
Untitled Drawing, 1949
Checklist no. 60

107
Jesús Guerrero Galván
The Little Nurse, 1937

108
Diego Rivera
Young Girl with a Mask, 1939
Checklist no. 49

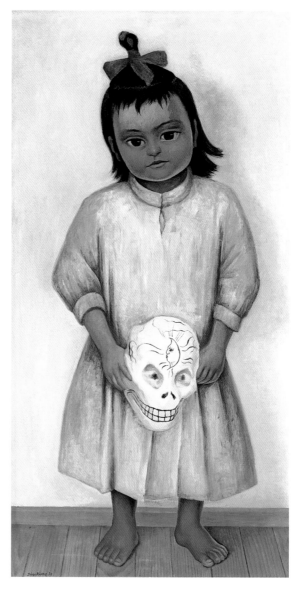

mural trappings."¹⁸⁰ Much more famous as a painter of both murals and political themes was Diego Rivera, but the painting Austin bought from him for $620 was the disturbing genre image of a *Young Girl with a Mask* (Fig. 108). Austin commented the painter had "returned to a less abstract and more sentimental manner," and that "the *papier-mâché* skull mask held by the little girl, is everywhere to be found in Mexico during the celebration of the Day of the Dead."¹⁸¹

Another significant addition to the museum's collection came also in 1939 as a gift from Austin's friend, the architect and collector Philip Johnson. In 1933 Alfred Barr, while in Germany was appalled by the Nazi government's abrupt closure after only one day of an exhibition in Stuttgart by the Bauhaus master Oscar Schlemmer, and he

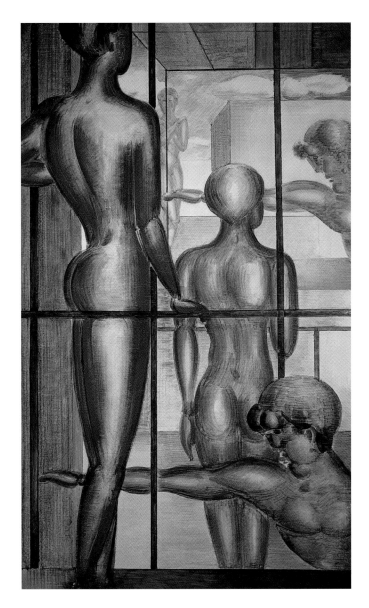

109
Oskar Schlemmer
The Race, 1930

cabled Johnson for the funds to purchase works by the painter "just to spite the sons of bitches."[182] Purchased by Johnson were both the *Staircase* given by him to MoMA and the equally great masterpiece, *The Race (Wettlauf)* of 1930, (Fig. 109), which he gave, still in its original frame, to the Atheneum where it was exhibited in Avery Court beginning in January of 1940 as "Course of the World."[183]

Despite the troubled situation in Europe, Pierre Matisse and his family did return there in 1939, and his wife, Teeny, sent a letter to Austin from New York on October 17, 1939: "Pierre writes Balthus is at the front. The whole situation is very frightening – no one here even guesses how 'real' war can become almost overnight. I got back with the children on the Manhattan about ten days ago. Pierre is at Fort

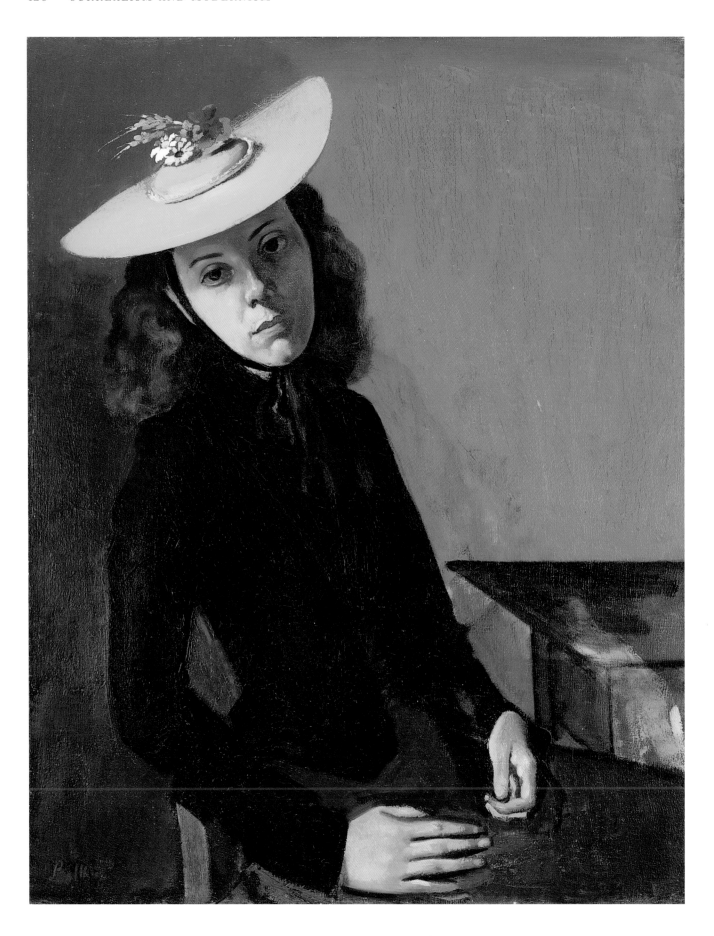

Charenton near Paris for the present." But ever attentive to business, she also enclosed three photographs of paintings for possible purchase, noting:

> The Balthus is very exceptional. It has the bigness and dramatic quality which until now Balthus has only been able to express when the subject matter itself excited and affected him emotionally. I feel although it is a simple figure subject, it is equally as dramatic and felt as his greatest and most frightening paintings. It is painted with great assurance and somehow one feels he has greatly matured.[184]

Austin responded immediately: "I have been very upset at hearing the rumors about Pierre. I shall be down to see you and look at the various things you mentioned in your letter. What are you asking for the Balthus portrait, which I thought very beautiful?"[185] The work in question was *The Bernese Hat* (Fig. 110) and the price was $1200, which was approved by the Atheneum's trustees in February of 1940. Soby, who identified the sitter as the artist's wife, observed:

> The Museum's recent portrait seems more closely related to the sheltered elegance of Degas' portraits than to the Anglo-Germanic turbulence of an earlier Romanticism. By contrast with the Museum's astonishing Balthus *Still life*, full of psychological malaise and violence, *Le chapeau bernoise* displays a new objectivity. Egocentric and literary preoccupations have vanished, and in their place have come visual insight and mastery of pigment, the simple things which make great painting so difficult for all but a few.[186]

And Austin himself later summed it up – "Here the painter clearly illuminates his own intention *to do Surrealism after Courbet*. He uses a realistic, even academic technique to create an image of super-real intensity."[187]

For some time Austin, as has been observed, had been in touch with the great but cantankerous collector of modern art, Katherine Dreier, who lived in West Redding, and had been an occasional lender to his shows; she also lectured at the museum. In 1939 they finally arranged for an extensive exhibition of nearly seventy works from the Société Anonyme's collection to honor its twentieth anniversary, the following year.[188] This was entitled *Some New Forms of Beauty, 1909–1936*. In addition to such familiar artists as Miró, de Chirico, Klee, and Léger, there was a whole range of masters never or rarely seen before in Hartford, including Arshile Gorky, John Graham, Joseph Stella and the eastern Europeans Moholy-Nagy, Lissitsky, and Malevich, as well as the famous *Revolving Glass* by Duchamp. Miss Dreier had written to Austin who had been ill, "You must take good care – for the American Art world has tremendous need of you. You are one of the

110
Balthus
The Bernese Hat, 1938–9
Checklist no. 3

very very few directors who care for Art and not names – and we must swing back to that attitude if we are ever to develop an Art consciousness in this country." She concluded by asking, "Are you at all in a position to put a little back into the coffers of the Société Anonyme to enable us to go on with our work? It isn't a deciding question – but it would help us tremendously."[189] The show was hung in Avery Court and the always supportive local art reviewer Marian Murray found:

> From a purely decorative point of view, the exhibition looks very handsome on the Avery walls. Some of the paintings are very large, others are small, but they have been hung with great care and regard for the pattern they make as a whole. In addition, they have been grouped in such a way as to give an idea of how, for instance, certain Abstract conceptions begin to appear in German Expressionism, or what Futurism has become in the hands of the later Italians ... This exhibition should not be missed. It offers an informative and comprehensive survey.[190]

Miss Dreier wrote Austin that she was coming to see the show on January 26,[191] but when she arrived, he was not there and she was quite amazed to see that he had hung five of her horizontal paintings (including the Kandinsky and the Moholy-Nagy) vertically. As she quickly wrote him:

> I admired you too much to mention this to anyone and I made my friends promise me that they would not for I felt how frightfully embarrassing it must be to you not to recognize the construction of a painting ... You can imagine my surprise when it was told in Springfield by someone from your Museum as a good joke!!! Frankly I do not understand such an attitude either towards you or towards art.[192]

Caught out in his antics, Austin had to confess, "I intentionally hung the five paintings vertically rather than horizontally, since I felt that the installation was much better, and I knew that only one or two persons would know the difference. Also, I often feel that if an abstract picture is fine enough, its balance is satisfactory no matter how the picture is hung." He went on to say, "the pictures were much appreciated in Hartford, and for the first time the public looked at them with interest and with some comprehension," but he concluded, "Since the Wadsworth Atheneum seems to be incurring your disfavor, I think it would be wiser in the future for you to avoid tempting me with exhibitions. I am, however, eternally grateful to you for what you have done in the past."[193] The collector could only answer the next day: "I am sorry you feel about this incident as you do – but feeling about it as you do there is nothing further for me to say – except that I am sorry!! Funny under what illusions we live!"[194]

That may have been the end of that relationship, but Austin continued to remain on good terms with James Thrall Soby, whose collection was once again shown that March with its new Dalís and de Chiricos.[195] As Soby recalled, although he sent his great Balthus *The Street* to the museum, probably at this time, it was not placed on view in the galleries, but rather in the director's office and as a result "both of us were faced with irate trustees who never openly said how mad they were but let us know indirectly."[196]

As the year progressed Austin still had other creative ideas to pursue. One of these was another of his thematic exhibitions – *Night Scenes*, which probably grew out of his desire to highlight the great Caravaggio *Ecstasy of St. Francis* he was trying (ultimately successfully) to acquire. He noted in his introduction that while the Cubists and Surrealists did few night scenes, they were more prevalent among the Neo-Romantics:

> With the turn of the century and the Fauve reaction against Impressionism, a preference for violent and somber color is obvious. ... That the Surrealists are not attracted except occasionally by nocturnal subjects, can be explained by the fact that they normally seek to make vivid and concrete in terms of the day the dreamed irrationalities of the night.[197]

To represent "The Modern School" he included from the Atheneum's collection two watercolors – Klee's *Mr. Pep and his Horse* and Rouault's *The Workers* (Fig. 58). Soby lent his finest Dalí – *Debris of an Automobile Giving Birth to a Blind Horse Biting a Telephone*, which the collector had purchased from Julien Levy in 1939. From Pierre Matisse came de Chirico's *La Lumiére fatale* and Miró's *Auto-Portrait Number 2* and the Museum of Modern Art lent a powerful Orozco – *The Cemetery*. There were the requisite works by Tchelitchew and Berman and they were joined by a little known American, Franklin Watkins (1894–1972), who was described as "now one of the most powerful of the painters of the American Romantic Revival."[198]

The Neo-Romantic taste also reappeared in a retrospective exhibition of Eugene Berman in November of 1941. This traveling show had been organized by The Institute of Modern Art in Boston.[199] Austin installed it not in Avery Court but in the grand spaces of the Morgan Great Hall (Fig. 111) and he wrote to the artist, "Your exhibition opened last Saturday with great success ... quite a large crowd for us participated. I think it looks very well."[200]

Although Austin's time as director was soon to end, his few years still in control during the 1940s were to witness some more outstanding modern acquisitions. In fact since the Atheneum's trustees often found it difficult to support his purchases of new art, they decided, according to Soby's account, that each of the five members of the Art

111
The Eugene Berman Retrospective installed in the Morgan Great Hall, Wadsworth Atheneum, 1941

112
Matta
Composition, 1936

Committee, himself included, would be annually allocated $2000. As Soby relates, "Only Mr. Robert W. Huntington [the chairman of the committee] of the three older members used part of his fund. Chick and I at once went off to New York; he to buy pictures by Campigli, Jimmy Ernst, Clyde Singer, Tchelitchew, John Atherton, Corrado Cagli, Max Ernst and Leon Kelly among others; I to buy paintings by Max Ernst, Yves Tanguy, Tchelitchew and Matta."[201] One of Soby's first finds at Julien Levy's gallery was the remarkable painting *Prescience* (Fig. 33) by the precocious young Chilean Surrealist Matta. This was sent on approval to the Atheneum for the special price of $400, and by the fall of 1940, Matta in desperate need of funds had contacted Levy to try and get his money. The dealer wrote to Austin on behalf of the painter:

> Will you try to let me know about the Matta painting you took on approval last Spring? I do hope you can buy it. We all feel he is enormously promising, — and he is in an absolute and immediate financial mess. He must go to Cuba for his re-entry permit before October 20 and for this will need some $300. Otherwise he will be deported forever etc.[202]

Austin finally agreed to the payment of the $400 in June of 1941.[203] As Soby later wrote, he was convinced of the young painter's importance and acquired several of his works for his own collection.[204] In Chick Austin's unpublished catalogue of the Atheneum's collection, he wrote apropos of *Prescience*:

Matta came to New York in 1939. The thin liquidity of his surfaces seem always restless as in the changing patterns of a kaleidoscope. A creator of abstract yet emotionally affective patterns, his style is extremely personal, and has in a short time influenced many contemporary painters. [205]

The special allotment also served in 1942 to bring Matta's oil and pencil drawing, *Composition* (or *Personage Transperance)* of 1939 (Fig. 112) into the collection for $125 from Levy.[206] Purchased directly from the artist for $100 was Jimmy Ernst's 1941 painting *Vagrant Fugue.*[207] Of much more significance were works by his father, Max Ernst. Julien Levy supplied the 1930 drawing collage *Loplop with Butterflies* (Fig. 25), which had previously been shown in Hartford in the *Literature and Poetry in Painting* exhibition of 1933.[208] But one of the Atheneum's key Surrealist works came in 1942 when Austin used his allotment for modern art to acquire the even greater Max Ernst painting *Europe after the Rain* (Fig. 32). This had been shown in Pierre Matisse's notable exhibition of March 1942 *Artists in Exile*, which brought together works by fourteen artists whom Soby described as "a disparate group" from "captive lands" to whom Americans should say "Welcome."[209] Ernst's painting acquired for $1400 was reproduced in the magazine *View* and quickly became one of the major icons of the war-torn 1940s.[210] Ernst himself called it "one of the most important and representative [works by him] of the period 1939–49,"[211] and in a letter to the Atheneum also described the difficult circumstances under which he produced the painting:

> *Europe After the Rain* started in my country home in southern France (Saint Martin d'Ardeche) two months before the collapse of France, interrupted by an involuntary stay in French concentration camps (May–July 1940) and its after effects, continued late in 1940 and finished in New York, December 1941 and January 1942.[212]

Another émigré artist included in Pierre Matisse's exhibition *Artists in Exile* was Yves Tanguy. Soby, although already working at the Museum of Modern Art, was still a trustee of the Atheneum and on its behalf selected a work by Tanguy, which he thought worthy of its collection. On May 24, 1943 he wrote to Chick Austin:

> I hope to God the remainder of my part of the purchase fund is still available because I've bought the W.A. a Tanguy ... I hope you'll like the picture. I've looked at it fifteen or twenty times over the past six months, and each time I've been more and more convinced that it's one of the best, if not the best, of the recent Tanguys ... this one was painted with special care and enthusiasm for Pierre Matisse's exhibition 'Artists in Exile' last year.[213]

The still unnamed picture was duly sent to Hartford, and Soby wrote again to Austin on May 27: "I am delighted that you like the Tanguy and that there is enough left in my part of the purchase fund to pay for it. I have been more and more crazy about the picture every time I have seen it and I am very glad it is going up there."[214] But there was obviously some misunderstanding as to which picture was indeed going to the Atheneum, for on October 29, 1943, Soby wrote the following aggrieved letter to Matisse:

> I am absolutely positive that some mistake was made in sending the Tanguy *Five Strangers* to the Wadsworth Atheneum instead of *Time and Again*. I remember writing Chick that I was most anxious to buy the picture which was in the "Artists in Exile" show at your gallery, and I think I described it to him as a dark green one ... I just barely recognized *Five Strangers* from the photo you sent me. The whole thing seems to have been a misunderstanding of some kind ... However, Chick seems to like *Five Strangers*. If he isn't just being polite, the matter can stand as it is.[215]

And it did. The *Five Strangers* (Fig. 114) was approved for a cost of $680.[216] Austin would later write of it, "Tanguy is a Surrealist who invents fantastic landscapes, the infinite space of which is occupied by shapes poetically evocative of the sea, yet undetermined by actuality."[217]

By 1942 Austin, constrained by war-time economics and his own waning interest in the Atheneum's political battles, was doing less grand and less original programming, but he still managed to beat the drum for Modernism. An exhibition running from February 24 to March 22, borrowed entirely from New York dealers, was called *In Memoriam: An Exhibition of Paintings Under $1000*. Among the bargains were Tanguy's *Poetic Landscape* of 1941 for $600, Matta's *No. 1204* for $500, an untitled Miró of 1939 for $300, Chagall's *The Circus* for $900, Balthus's *Girl with Cat* for $850, and a Siqueiros *Shell* for $500.[218]

The example of the Pierre Matisse exhibition *Artists in Exile* and the acquisition of the Ernst painting may have given Austin the inspiration for assembling in Hartford for one week a group of works by the exiled artists as part of the gala premiere of his performance in *The Elements of Magic* presented in May of 1942. This exhibition he called *Painters in Attendance*, and as he explained to Peggy Guggenheim, who was then Mrs. Max Ernst:

> I should like to open a small show which would be called 'Painters in Attendance' which would include let us say the works of Ernst, Tanguy, Masson, Matta, and possibly Tchleitchew

113
Chick Austin as "The Sea-God of Magic,"
Avery Theater, Wadsworth Atheneum,
December 1944

which would help to publicize their cause further in the
provinces where in Hartford in many instances their pictures
were shown for the fist time by an American Museum ... I am
taking the liberty of imposing on your kindness in whipping up
some excitement about the doings ... I am so anxious to have the
various painters who have not seen the museum get a look at it
before I collapse totally and it seems a good opportunity to have a
Hartford outing at that time ... Give me any ideas that you
might have about the show. I should be most grateful. Hartford
has begun to depress me so this winter that I shall go mad I am
afraid if there is not at least a temporary influx of human beings
to cheer me up![219]

Austin also wrote directly to Breton asking if he would be willing to
lend a few objects and to Masson who informed his dealer Curt
Valentin about "the exhibition in connection with Black Magic"[220]
and his willingness to participate. The director indicated to some close
friends like Pierre Matisse, Philip Johnson, and May Sarton that this
would be his "final Hartford spree," and last show, "because I am sure
to be out of a job after it is over but I am still determined to do it. The
Trustees have become increasingly maddened at my antics yet they
give me no money for exhibitions or other museum activities so I am
forced to keep on going in some way."[221] Johnson wrote back "What
nonsense about your swan song," and promised to come.[222] Kay Sage
Tanguy wrote from Woodbury thanking him for the invitation and "to
say that Yves and I hope to be there," but in the end most of the artists
themselves, as well as old friends like Virgil Thomson,[223] were not.

114
Yves Tanguy
Five Strangers, 1941

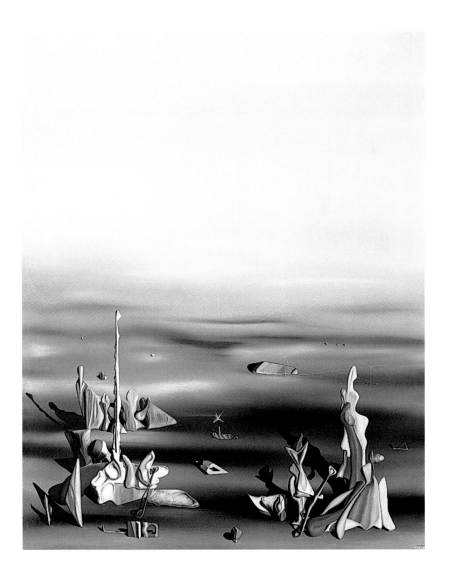

The exhibition consisted of twenty-one works by artists, who with the exception of Cornell, were foreigners. Among them were Chagall, Breton, Ernst, Masson and Matta, but it was probably the elaborate magic show he staged that was the director's greatest triumph.[224]

Later in 1942, due to wartime fears about the safety of works of art, Julien Levy sent to the Atheneum for safe keeping a large group of 111 paintings and one sculpture. Among the better known artists were nearly twenty de Chiricos, a Delvaux *Woman with Lamps*, seven Ernsts, a Magritte titled *Abstraction*, and by Dalí two drawings, the *Double Portrait* and *The Image Disappears*.[225] From this material Austin was able to create that fall his last truly remarkable exhibition *Painters of Fantasy*. No catalogue was published,[226] but the ever loyal Mrs. Murray provided a detailed description:

> The exhibition has been hung with a great deal of skill, to emphasize the similarities and differences in the approaches of

various paintings, and to show the color of each item to best advantage ... Some of the items touch only the border-line of fantasy, but the emphasis throughout is on the strange — sometimes the poetic, often the bizarre, always the dreamlike quality that touches the emotions and leads the imagination into far places.[227]

Unable to let his own imagination have free reign, Austin took a leave of absence from the Atheneum beginning in July 1943.[228] He did not return to his directorial duties and officially resigned as of January 1, 1945. However, he did write the wonderfully evocative texts for a proposed museum catalogue, which have been quoted extensively, and appropriately he did have an encore in the museum's Avery Theater in December 1944 as his magician alter-ego, The Great Osram, appearing among various guises of his own design as "The Sea-God of Magic" (Fig. 113).

While his departure signaled the end of an era for Hartford, the pioneering efforts of Austin and his circle of friends had set the stage for all following directors and curators to pursue distinctive aspects of the new art of their own periods and to continue that tradition of being in the forefront of modern taste. After Austin's untimely death in 1957, a memorial exhibition featuring many of his contemporary purchases was organized, and his friend and former colleague James Thrall Soby recalled in the accompanying catalogue, "Our struggle was not always easy ... I am proud to say that we fought together whenever necessary against the prejudices of the reactionaries, the rancors of unsuccessful artists, and at times, the apathy and suspicion of the public."[229] The present exhibition serves as a fitting tribute to what they and their successors accomplished in this process of illumination.

Notes

1. Le Corbusier, *Quand Les Cathédrals étaient blanches*, Paris, 1937, pp. 192 and 194, translated by the author.

2. Ibid., p. 197. On Le Corbusier's visit to Hartford, see Mardges Bacon, *Le Corbusier in America*, Cambridge, MA, 2001, pp. 88–90.

3. For a detailed study of Austin, see Eugene R. Gaddis, *Magician of the Modern*, New York, 2000.

4. *Loan Exhibition of Modern Paintings*, Wadsworth Atheneum, Hartford, 1923.

5. Austin in the *Hartford Courant*, March 31, 1928. This and all subsequent quotes from Hartford newspapers are taken from the newspaper scrapbooks of the Atheneum's Archives.

6. Austin in the Wadsworth Atheneum *Annual Report for 1928*, Hartford, 1929, p. 4.

7. T. H. Parker in the *Hartford Courant*, April 1928.

8. *Loan Exhibition of Modern French Paintings*, Morgan Memorial, Hartford, April 20– May 5, 1928.

9. On the Sachs collection and the Hopper and Watercolor exhibitions, see Wadsworth Atheneum *Bulletin*, April 1928, pp. 13–14, and July 1928, pp. 21–23.

10. Austin in the Wadsworth Atheneum *Annual Report for 1928*, Hartford, 1929, p. 7.

11. *Hartford Courant*, November 22, 1929.

12. Austin quoted in *Hartford Courant*, March 31, 1928.

13. *Loan Exhibition*, 1928, no. 7 *Le Voyage sans fin* and no. 8 *Horses*.

14. Cable from Alfred Barr to Austin, November 22, 1929 in Atheneum Archives.

15. Henry-Russell Hitchcock, Jr., in the *Hartford Times*, December 7, 1929. A lender's card in the Atheneum registrar's office actually indicates that three de Chiricos were lent by Miss Bliss: *La Joie Londaine*; *L'Annonciation*; and *Le Plaisir du Poet*.

16. Austin to Miss Bliss, December 14, 1929. Except where indicated, all correspondence is in the Archives of the Wadsworth Atheneum.

17. Soby ms., ch. 5, p. 1. A copy of Soby's unpublished autobiography, which he tentatively titled "Once Over Lightly: A Life in the Art World," is on deposit int the Wadsworth Atheneum Archives. On Soby see Rona Robb, "James Thrall Soby," in *Studies in Modern Art 5*, The Museum of Modern Art, New York, 1995, pp. 175–251.

18. See the *Hartford Times*, June 5, 1930.

19. *Hartford Times*, November 15, 1930.

20. In the *Hartford Times*, November 19, 1930.

21. Florence T. Berkman, "Chirico Collections Height of Modernism," *Hartford Courant*, November 22, 1930.

22. On the history of the Harvard Society for Contemporary Art, see Nicholas Fox Weber, *Patron Saints*, New York, 1992.

23. Buckminster Fuller appeared on March 17, 1930 and the Atheneum reprinted the pamphlet from Harvard on the Dymaxion House with its name on it.

24. Wadsworth Atheneum *Bulletin*, July 1930, p. 31.

25. Delphic Studios to Austin, cable April 17, 1930.

26. *Hartford Times*, May 17, 1930.

27. Austin to Valentiner, June 7, 1930.

28. Austin in the Wadsworth Atheneum *Annual Report for 1930*, Hartford, 1931, p. 5.

29. At Harvard the exhibition was called *International Photography* but at Hartford it was trimmed to just *Photography 1930* and the date given only as December 1930.

30. *Four Modern Artists*, December 22, 1930 – January 11, 1931. The artists were Milton Avery, Aaron Berckman, Clinton O'Callahan, and Russell Cheney.

31. *Retrospective Exhibition of Landscape Painting*, Wadsworth Atheneum, Hartford, January 20 – February 9, 1931.

32. Lloyd Goodrich, "Exhibitions," *The Arts*, vol. 17, December 1930, p. 187, rep. p. 182.

33. Receipt of February 12,1931 in Atheneum files.

34. Text by Austin in Registrar's files at the Atheneum. This and the other texts by Austin subsequently quoted were written in the mid-1940s for a proposed catalogue of the Atheneum's Sumner collection. Although typeset the publication was never printed and the texts were cut up and placed in the appropriate object folder.

35. In fact the catalogue is entitled *Tonny, Tchelitchew, Bérard, Berman, Leonide*.

36. The Cocteau drawings were lent by the Demotte Gallery according to an annotated copy of the catalogue in the Atheneum Archives.

37. James Thrall Soby, *After Picasso*, Hartford and New York, 1935, pp. 5 and 12.

38. Draft of a letter to Gertrude Stein from Henry-Russell Hitchcock, Jr., with a note "Sent 3/18/31" in Atheneum Archives.

39. See Gertrude Stein, *The Autobiography of Alice B. Toklas*, New York, 1960, p. 95.

40. See the Atheneum *News Bulletin*, December 1937, p. 1; and Gaddis, 2000, pp. 323–61; and Soby, *After Picasso*, 1935, p. 49.

41. *Hartford Courant*, May 16, 1931.

42. Letter from Felix Wildenstein to Austin, April 8, 1931.

43. Ibid.

44. Text by Austin in Atheneum files.

45. Letter from Austin to Felix Wildenstein, June 3, 1931.

46. See Julien Levy, *Memoir of an Art Gallery*, New York, 1977, pp. 70–71.

47. See Deborah Zlotsky, "'Pleasant Madness' in Hartford: The First Surrealist Exhibition in America," *Arts Magazine*, February 1986, vol. 60, no. 6, pp. 55–6; and Eric Zafran, "I am not a Madman : Dalí in Hartford," in *Dalí's Optical Illusions*, Hartford, 2000, pp. 38–42.

48. James Johnson Sweeney, "A Note on Super-Realism," *The Arts*, May 1930, p. 612.

49. Soby, ms., chap. 9, p. 19.

50. *Hartford Times*, November 7, 1931, p. 5.

51. On the founding of the Pierre Matisse Gallery, see John Russell, *Matisse Father & Son*, New York, 1999, p. 78; and *Pierre Matisse and His Artists*, The Pierpont Morgan Library, New York, 2002, p. 155.

52. Austin to Pierre Matisse, October 30, 1931. Letter in the Pierre Matisse Archive at the Pierpont Morgan Library.

53. *Newer Super-Realism*, Wadsworth Atheneum, Hartford, November 15 – December 6, 1931.

54. Austin quoted in "Museum Plans Major Exhibits," *Hartford Times*, November 7, 1931, p. 5.

55. *Hartford Courant*, November 30, 1931.

56. Receipt in Atheneum files of March 10, 1932.

57. *Trends in Twentieth Century Painting*, Slater Memorial Museum, Norwich, April 11 – 26, 1932; "Super-Realism in Art," *Norwich Bulletin*, April 20, 1932.

58. *An Exhibition of Literature and Poetry in Painting Since 1850*, Wadsworth Atheneum, Hartford, January 29 – February 14, 1933, p. 12, no. 17.

59. Austin in the *Hartford Times*, February 4, 1933.

60. *Literature and Poetry*, Hartford, 1933, p. 5.

61. Letter from Austin to Mrs. Dale, December 7, 1932.

62. *Literature and Poetry*, Hartford, 1933, p. 15.

63. Correspondence between Austin and Steiglitz of January 4 and 14, 1933.

64. "Modern Paintings Shown at Exhibit," *Hartford Courant*, January 25, 1933.

65. *Hartford Times*, February 10, 1933.

66. Pierre Matisse to Austin, February 20, 1933.

67. Pierre Matisse to Austin, May 20, 1933.

68. Austin to Pierre Matisse, May 24, 1933.

69. Pierre Matisse to Austin in a letter of May 25, 1933 and a cable of May 26, 1933. The watercolor is acq. no. 33.95.

70. Correspondence between Austin and Flechtheim of December 1, 1932, April 27, May 10 and 31, and June 12, 1933.

71. Letter from Joseph Brummer to Chick Austin, March 3, 1933.

72. Letter from Austin to Brummer, March 6, 1933.

73. *Paintings by Piere Roy*, Wadsworth Atheneum, Hartford, April 22 – May 2, 1933.

74. "Roy Exhibition to be Shown Here," *Hartford Times*, April 1, 1933.

75. See Alexander Schouvaloff, *The Art of Ballets Russes, The Serge Lifar Collection*, New Haven, 1977, pp. 13–15.

76. Gaddis, 2000, pp. 222–23.

77. Austin in the Atheneum *Bulletin*, October – December, 1934, pp. 30–32; and a fuller text in typescript in Atheneum Archives.

78. Schouvaloff, p. 20.

79. Ibid., p. 194.

80. Ibid., pp. 194–99, nos. 114–17.

81. Ibid., pp. 262–64, no. 161.

82. Ibid., pp. 264–65, no. 162.

83. Ibid., pp. 155–69.

84. Ibid., pp. 172–75.

85. Ibid., pp. 142–46; 323–31.

86. Ibid., pp. 74–78, no. 10.

87. Leon Bakst, *Costume Design for the King's Guard, Sleeping Beauty*, acq. no. 2000.23.1. Acquired at Sotheby's New York, November 2, 2001, no. 185.

88. Gaddis, 2000, pp. 198–200.

89. Acq. no. 1998.48.1.

90. On the new Avery building see the Atheneum's *Bulletin*, October 1932, pp. 26–27, and January – March 1934, pp. 1–13; the newspaper articles in the *Hartford Times*, February 8, 1934 and the *Hartford Courant*, November 18, 1933; *Museum News*, February 1, 1934, p. 1; and also Eugene R. Gaddis, ed., *Avery Memorial*, Wadsworth Atheneum, Hartford, 1984.

91. On *Four Saints*, see Steven Watson, *Prepare for Saints*, New York, 1998.

92. Quoted in the *Hartford Times*, December 22, 1933.

93. *Pablo Picasso*, Wadsworth Atheneum, Hartford, February 6 – March 1, 1934; the drawings, watercolors, and prints, numbered 78–137 were listed in a special insert.

94. Dorothy Adlow, "Picasso in Hartford," *Christian Science Monitor*, February 17, 1934.

94. Johnson to Austin, February 8, 1934.

96. Soby ms., ch. 4, p. 12.

97. *Wadsworth Atheneum, The Collections in the Avery Memorial*, Hartford, 1934, pp. 38–39, 46, and 67; M. Murray in the *Hartford Times*, February 3, 1934.

98. Letter from Pierre Matisse to Austin, January 17, 1934.

99. Austin text in Registrar's file.

100. Letters between Pierre Matisse and Soby of June 2 and July 3, 1935 in the Pierre Matisse Archives of the Morgan Library.

101. J. T. Soby, *Photographs by Man Ray*, Hartford, 1934.

102. "Avery Shows Photographs by Man Ray," *Hartford Courant*, October 15, 1934.

103. See Lincoln Kirstein, "The Ballet in Hartford," in *A. Everett Austin, Jr., A Director's Achievement*, Hartford and Sarasota, 1958, p. 69; and Fox Weber, 1992, pp. 250–57.

104. *Hartford Times*, December 7, 1934.

105. According to the shipping receipts of December 15, 1934 and January 4, 1935 in the Wadsworth Atheneum Registrars' department.

106. According to the notation in the Avery theater log book in Atheneum Archives.

107. Joseph W. Alsop, Jr., "Dalí is Seeking a Place in the Sun…," *The New York Herald Tribune*, December 20, 1934.

108. See Zafran in *Dalí*, Hartford, 2000, pp. 48–49.

109. Receipt in Atheneum files of January 18, 1935.

110. Austin text in Registrar's file.

111. The Dalí drawing is acq. no. 1935.11.

112. Pierre Matisse to Soby, November 1, 1935. Letter in Pierre Matisse Archives at the Morgan Library.

113. Soby to Matisse, November 5, 1925. Letter in the Pierre Matisse Archives at the Morgan Library.

114. Both a copy of Soby's will of November 21, 1957 and a list of the items transferred from the Museum of Modern Art to the Wadsworth Atheneum are in the Soby papers at the MoMA Archives.

115. Correspondence from P. Matisse to Atheneum, February 30, 1937 in Pierre Matisse Archives at the Morgan Library.

116. See J. T. Soby, *Giorgio de Chirico*, Museum of Modern Art, New York, 1955, p. 101.

117. The invoice of December 11, 1937 from Schempp describes the work as "1 painting."

118. Austin text in Registrar's file.

119. The Arp was acq. no. 1937. 91; purchased for 1000 francs according to letter from MoMA to Atheneum, February 11, 1937.

120. Letter from Atheneum to Miss Dreier, October 26, 1934. The exhibition was entitled *Impressionism to Abstraction: 13 Women Painters* and opened on December 20, the same evening on which Miss Dreier spoke.

121. Edith Halpert to Austin, January 11, 1935.

122. *American Painting, American Sculpture Three Centuries*, Wadsworth Atheneum, Hartford, January 29 – February 19, 1935, p. 10, no. 14.

123. Letter from Cornell to Atheneum, May 14, 1935.

124. James Johnson Sweeney, *Alexander Calder's Mobiles*, 1935, insert for Atheneum's catalogue.

125. Acq. no. 1935.63. Receipt in Atheneum files of January 25, 1935.

126. *Hartford Times*, January 30, 1935.

127. Note from Alice B. Toklas to Austin's assistant, Ms. Howland, December 23, 1934.

128. *Hartford Times*, January 19, 1935.

129. Ibid., and January 17, 1935; and *Hartford Courant*, January 19, 1935.

130. On Austin's revelatory visit to Mondrian, see Soby in *A Director's Taste*, 1958, p. 27.

131. The Pevsner is acq. no. 1936.15 and the Domela is 1936.16.

132. Austin to Charles C. Cunningham, November 1947.

133. Bobsie Goodspeed to Austin, August 25, 1935.

134. *Hartford Times*, October 19, 1935.

135. *Abstract Art*, Wadsworth Atheneum, Hartford, October 22 – November 17, 1935. The text panels are in the files of the museum's Registrar.

136. *Hartford Times*, December 7, 1935.

137. Receipt of March 11, 1936 for Mondrian in Atheneum files.

138. Austin text in Registrar's file.

139. *4 Painters: Albers, Dreier, Drewes, Kelpe*, Wadsworth Atheneum, Hartford, December 11 – 31, 1936.

140. Ibid.

141. Albers to Austin, March 5 and May 5, 1937.

142. *Paintings by Pavel Tchelitchew*, Wadsworth Atheneum, Hartford, March 12 – April 14, 1935.

143. The original acq. no. was 1938.269.

144. See Gaddis, 2000, pp. 300–10.

145. *43 Portraits: An Exhibition of the Wadsworth Atheneum*, Hartford, January 26 – February 10, 1937.

146. Robert Descharnes, *Salvador Dalí: The Paintings*, Cologne, 1997, no. 608.

147. Austin, "Foreword," *43 Portraits*, 1937, p. 4.

148. M. Murray, "'43 Portraits' Includes Work of Surrealist," *Hartford Times*, January 16, 1937.

149. *The Painters of Still Life*, Wadsworth Atheneum, Hartford, January 25 – February 15, 1938, p. 2.

150. M. Murray in *Hartford Times*, January 26, 1938.

151. Ibid.

152. Purchased in May 1937.

153. Alfred Barr, ed., *Fantastic Art, Dada, Surrealism*, The Museum of Modern Art, New York, 1936, p. 220, no. 309 is Cornell's *Soap Bubble Set* but described as "Photograph with additional effects by George Platt Lynes."

154. Undated letter from Levy to Austin.

155. Invoice of April 1, 1938 in Atheneum files.

156. Letter from Cornell to Atheneum, July 5, 1938.

157. See Eric Zafran, *Calder in Connecticut*, Wadsworth Atheneum, Hartford, 2000, pp. 42–45.

158. Austin for example used this title in his unpublished entry on the painting. In Atheneum files.

159. Ibid.

160. Soby ms., ch. 6, pp. 2 and 5.

161. Soby ms, ch. 6, p. 6.

162. On *The Guitar Lesson* see Nicholas Fox Weber, *Balthus, A Biography*, New York, 1999, pp. 205–48, pl. 5.

163. See Ian Gibson, *The Scandalous Life of Salvador Dalí*, 1997, pp. 446–47.

164. See "Art – Salvador Dali," *Life*, April 17, 1939, p. 45.

165. Receipt dated May 9, 1939 in Atheneum files.

166. A. Everett Austin, "Hartford Reports the Year's Purchases," *Art News*, 38, October 14, 1939, p. 9.

167. M. Murray, "Avery Acquires Salvador Dali Double Image," *Hartford Times*, May 18, 1939.

168. Soby ms., chap. 12, pp. 3–4.

169. Acquisition no. 36.59. Receipt of April 4, 1936 paid December 4, 1936 in Registrar's files.

170. Austin text in Registrar's files.

171. *Yves Tanguy, Paintings, Gouaches, Drawings*, Pierre Matisse Gallery, New York, December 12 – 30, 1939. Undated letter from Kay San Faustino to Austin.

172. Letter from Austin to Kay San Faustino, November 28, 1939.

173. Kay San Faustino to Austin January 1, 1940.

174. "Tea Will Open Avery Exhibit by Yves Tanguy," *Hartford Times*, January 16, 1940.

175. Soby ms., ch. 18, p. 1.

176. Ibid.

177. See Zafran, *Calder*, 2000, pp. 64–69, pp. 109–13; idem., "A Survey of Surrealism in Hartford," in *Masterpieces of Surrealism*, Salvador Dalí Museum, St. Petersburg, FL, 2000, pp. 72–73.

178. The *Exhibition of Recent Paintings by Jesús Guerrero Galván* opened on March 16, 1943 in the Morgan Tapestry hall according to the Atheneum *Bulletin*, March 1943, p. 2.

179. *Life*, vol. 4, no. 11, March 14, 1938, p. 30.

180. Austin text in Registrar's file.

181. Austin text in Registrar's file.

182. The information gleaned from Barr's papers at MoMA is given in several sources: Alice G. Marquis, *Alfred H. Barr, Jr.*, Chicago, 1989, p. 118; Lynn H. Nichols, *The Rape of Europa*, New York, 1994, pp. 6–7; Kirk Varnedoe, "Philip Johnson as Donor to the Museum Collections," *Studies in Modern Art 6*, Museum of Modern Art, New York, 1998, p. 13; Sybil G. Kantor, *Alfred H. Barr, Jr.*, Cambridge, MA, 2002, p. 371.

183. See the *Hartford Times*, January 6, 1940.

184. Teeny Matisse to Austin, October 7, 1939.

185. Austin to Teeny Matisse, October 19, 1939. Letter in the Pierre Matisse Archives of the Morgan Library.

186. Text in Atheneum file, but according to Virginie Monnier, *Balthus Catalogue raisonné*, Paris, 1999, p. 135, P. 116, the model is Antoinette de Watteville.

187. Austin text in Registrar's file.

188. *Some New Forms of Beauty, 1909 – 1936*, January 6 – February 1, 1940. No catalogue was published, but a typed list of the works lent is in the Atheneum Archives.

189. K. Dreier to Austin, December 1, 1939.

190. M. Murray in *Hartford Times*, January 6, 1940.

191. K. Dreier to Austin, January 23, 1940.

192. K. Dreier to Austin, February 26, 1940.

193. Austin to K. Dreier, March 6, 1940.

194. K. Dreier to Austin, March 7, 1940.

195. See the Atheneum *News Bulletin*, October 1940, p. 1; and *Hartford Times*, March 30, 1940.

196. Soby in a letter to Margaret Miller of February 28, 1947 in the Soby Papers at MoMA.

197. Austin, "Introduction," *Night Scenes*, Wadsworth Atheneum, Hartford, p. 4.

198. Ibid, nos. 65, 66, and 70.

199. The arrangements were made in correspondence between Austin and James Plaut, Director of the Institute of Modern Art, Boston in a letter from Plaut to Austin of March 3, 1941.

200. Austin to Berman, November 28, 1941.

201. James T. Soby, "A. Everett Austin, Jr. And Modern Art," in *A Director's Taste and Achievement*, exhib. cat., Wadsworth Atheneum, Hartford and John and Mable Ringling Museum of Art, Sarasota, 1958, p. 32.

202. Letter from Levy to Austin, October 7, 1940 and another undated.

203. Receipt in Registrar's file dated June 20, 1941.

204. Soby ms., chap. 10, pp. 9–10.

205. Austin text in Registrar's file.

206. Invoice letter from Pierre Matisse of April 16, 1942 for $125.

207. Acq. no. 1942.338 and the receipt from the artist is in the Registrar's file.

208. The receipt from Julien Levy of June 30, 1942 also gives the title as *Personnage with Butterfly*.

209. James Thrall Soby, "Europe," in *Artists in Exile*, Pierre Matisse Gallery, New York, April 21 – May 9, 1942.

210. Receipt dated March 31, 1942. See *View*, 2nd series, no. l, April 1948, p. 25; see also "Painters Interpret the War," *Portfolio*, March 1943, p. 107.

211. Letter from Ernst to the Atheneum requesting it for loan, December 9, 1949.

212. Letter from Ernst to Charles Cunningham, October 10, 1946.

213. Letter from Soby to Austin, May 24, 1943.

214. Letter from Soby to Austin, May 27, 1943.

215. Letter from Soby to Pierre Matisse, October 29, 1943 in Morgan Library Matisse Archives.

216. Receipt of May 22, 1943, paid on July 21, 1943 in Registrar's file.

217. Austin text in Registrar's file.

218. *"In Memoriam:" An Exhibition of Paintings Under $1000*, Wadsworth Atheneum, Hartford, February 24 – March 22, 1942.

219. Undated letter from Austin to Peggy Guggenheim.

220. Undated letter from Austin to André Breton and from Curt Valentin (Masson's dealer) to Austin, May 16, 1942.

221. Undated letters from Austin to Johnson and May Sarton; letter to Pierre Matisse of May 8, 1942 in the Pierre Matisse Archive of the Morgan Library.

222. Johnson to Austin, undated letter.

223. Letter from Kay Tanguy to Austin; undated cable from Thomson to Austin; letter expressing regret from Masson to Austin, May 23, 1942.

224. *Painters in Attendance*, Wadsworth Atheneum, Hartford, May 22–29, 1942. For details of the magic show see Gaddis, 2000, pp. 354–55.

225. List of works sent from Julien Levy to the Wadsworth Atheneum in Registrar's file as loan no. 31.42.

226. The exhibition is listed in the *Wadsworth Atheneum News/Bulletin*, October 1942, pp. 1–2 and November, 1942, p. 1.

227. M. Murray in *Hartford Times* September 29, 1942.

228. The announcement of Austin's six month leave of absence was made with little fanfare in the Atheneum *Bulletin*, October 1943, p. 5.

229. Soby in *A Director's Taste*, 1958, p. 32.

* denotes works exhibited in Washington and Newport Beach
† indicates those shown in Fort Worth and Sarasota

1. Arp, Jean (French, 1888–1966)
Objects Placed on Three Planes Like Writing, 1928
Painted wood, 37 × 44 ¾ in.
Purchased through the gift of James Junius Goodwin,
1937.91
Fig. 27, p. 42

2. Avery, Milton (American, 1893–1965)
The Green Settee, 1943
Oil on canvas, 27 ⅞ × 36 in.
Gift of Mr. and Mrs. Alexis Zalstem-Zalessky,
1964.280
Fig. 115, p. 135

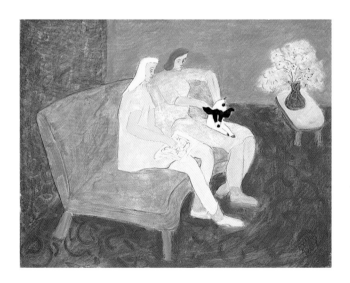

115. Milton Avery, *The Green Settee*, 1943.
Checklist no. 2

3. Balthus (Balthasar Klossowski de Rola), (French,
1908–2001)
The Bernese Hat, 1938–39
Oil on canvas, 36 ¼ × 28 ⅝ in.
The Ella Gallup Sumner and Mary Catlin Sumner
Collection Fund, 1940.26
Fig. 110, p. 120

4. Blume, Peter (American, born Russia, 1906–1992)
The Italian Straw Hat, 1952
Oil on paper on board, 22 ¼ × 30 ⅜ in.
The Henry Schnakenberg Fund, 1955.32
Fig. 43, p. 55

5. Calder, Alexander (American, 1898–1976)
The Dragon, 1957
Metal, wire, paint; 16 ⅓ × 16 ¾ × 9 ⅞ in.
Anonymous gift, 2000.34.5A, B
Fig. 81, p. 98

6. Chagall, Marc (French, born Russia, 1887–1985)
Autumn in the Village, 1939–45
Oil on canvas, 32 × 25 ¾ in.
Gift of Mr. and Mrs. Alfred Jaretski, Endowed by Mr.
and Mrs. Charles Gill, 1952.438
Fig. 116, p. 136

7. de Chirico, Giorgio (Italian, 1888–1978)
The General's Illness, 1914–15
Oil on canvas, 23 ¼ × 17 ¼ in.
The Ella Gallup Sumner and Mary Catlin Sumner
Collection Fund, 1937.89
Fig. 20, p. 34

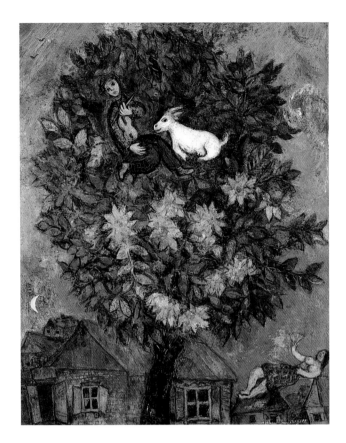

116. Marc Chagall, *Autumn in the Village*, 1939–45
Checklist no. 6

8. de Chirico, Giorgio
The Endless Voyage, 1914
Oil on canvas, 34 15/16 × 15 11/16 in.
The Collection of Philip L. Goodwin through James
L. Goodwin and Henry Sage Goodwin, 1958.221
Fig. 21, p. 36

*9. Cornell, Joseph (American, 1903–1972)
Untitled (for Juan Gris), c. 1960
Mixed media; 17 ½ × 9 ¾ × 4 ⅞ in.
Gift of the Joseph and Robert Cornell Memorial
Foundation, 1996.34.2
Fig. 92, p. 108

†10. Cornell, Joseph
Homage to the Romantic Ballet, 1966
Collage; 16 ⅞ × 11 ⅝ in., 13 ⅞ × 8 ½ in.
Gift of the Joseph and Robert Cornell Memorial
Foundation, 1996.34.16
Fig. 93, p. 109

*11. Cornell, Joseph
Bel Echo Gruyere, 1939
Mixed media; 3 ⅝ × 7 ¾ in.
Gift of the Joseph and Robert Cornell Memorial
Foundation, 1996.34.1A,B
Fig. 95, p. 110

†12. Cornell, Joseph
Untitled, 1965
Collage: 13 ⅛ × 11 ⅝, 10 ⅛ × 8 ½ in.
Gift of the Joseph and Robert Cornell Memorial
Foundation, 1996.34.7
Fig. 94, p. 109

13. Dalí, Salvador (Spanish, 1904–1989)
La Solitude, 1931
Oil on canvas, 13 ⅞ × 10 ¾ in.
Purchased through the gift of Henry and Walter
Keney Fund, 1932.218
Fig. 56, p. 77

14. Dalí, Salvador
Paranoiac-astral Image, 1934
Oil on panel, 6 ¼ × 8 ¾ in.
The Ella Gallup Sumner and Mary Catlin Sumner
Collection Fund, 1935.10
Fig. 29, p. 44

15. Dalí, Salvador
Apparition of Face and Fruit Dish on a Beach, 1938–9
Oil on canvas, 45 in × 56 ⅝ in.
The Ella Gallup Sumner and Mary Catlin Sumner
Collection Fund, 1939.269
Fig. 30, p. 45

16. Davies, Arthur B. (American, 1862–1928)
Protest Against Violence, c. 1911–1912
Oil on canvas, 40 × 26 ¼ in.
The Ella Gallup Sumner and Mary Catlin Sumner
Collection Fund, 1992.81
Fig. 79, p. 96

17. Davis, Stuart (American, 1892–1964)
Midi, 1943
Oil on canvas, 28 × 36 ¼ in.
The Henry Schnakenberg Fund, 1954.56
Fig. 6, p. 19

18. Dove, Arthur (American, 1880–1946)
Approaching Snow Storm, 1934
Oil on canvas, 25 × 31 ½ in.
In memory of Henry T. Kneeland, by exchange, and
The Ella Gallup Sumner and Mary Catlin Sumner
Collection Fund, 1992.29
Fig. 38, p. 51

19. Ernst, Max (German, 1891–1976)
Europe after the Rain, 1940–1942
Oil on canvas, 21 ⅝ × 58 ⅓ in.
The Ella Gallup Sumner and Mary Catlin Sumner
Collection Fund, 1942.281
Fig. 32, p. 48

20. Ernst, Max
The Kiss in the Night, 1927
Oil on canvas, 51 ¼ × 63 ⅞ in.
Gift of Mr. and Mrs. Alfred Jaretzki, Jr., 1953.235
Fig. 13, p. 26

21. Gleizes, Albert (French, 1881–1953)
Imaginary Still Life, Green (Nature Morte
Imaginaire, Verdatre), 1924
Oil on composition board, 40 × 30 in.
The Ella Gallup Sumner and Mary Catlin Sumner
Collection Fund, 1950.211
Fig. 10, p. 23

22. Kirchner, Ernst Ludwig (German, 1880–1938)
Suburb of Berlin, 1912
Oil on canvas, 28 ½ × 39 ½ in.
The Ella Gallup Sumner and Mary Catlin Sumner
Collection Fund, 1975.58
Fig. 2, p. 15

23. Klee, Paul (Swiss, 1879–1940)
Architecture, 1924
Oil on canvas, 12 ¾ × 12 ½ in.
Gift of Mr. and Mrs. Alfred Jaretzki, Jr., 1953.226
Fig. 22, p. 37

24. de Kooning, Willem (American, born The
Netherlands, 1904–1997)
Standing Man, c. 1942
Oil on canvas, 41 ⅛ × 34 ⅛ in.
The Ella Gallup Sumner and Mary Catlin Sumner
Collection Fund, 1967.67
Fig. 40, p. 52

25. Magritte, René (Belgian, 1898–1967)
The Tempest, 1931
Oil on canvas, 19 ½ × 25 ¾ in.
Bequest of Kay Sage Tanguy, 1963.195
Fig. 28, p. 43

26. Magritte, René
The Fickleness of the Heart (Les Intermittences du
Coeur), 1950
Oil on canvas, 38 ¾ × 31 ⅝ in.
Gift of Tanaquil Le Clerc and George Balanchine,
1988.48.1
Fig. 65, p. 86

27. Maillol, Aristide (French, 1861–1944)
Pomona, 1925
Bronze, 35 ¼ × 11 × 8 in.
Anonymous gift, 1956.476
Fig. 14, p. 27

28. Maillol, Aristide
Girl with Top Knot, n.d.
Bronze, 14 ¼ × 10 × 8 ½ in.
Gift of E. Weyhe, 1955.396
Fig. 76, p. 94

29. Marcks, Gerhard (German, 1889–1981)
Cinderella, 1941
Bronze, 15 ¾ × 11 ¼ × 7 ¼ in.
Gift of James Junius Goodwin, 1953.12
Fig. 75, p. 94

30. Marini, Marino (Italian, 1901–1980)
Rider, 1947
Bronze, 34 ¾ × 31 ½ × 16 ¾ in.
Bequest of James Thrall Soby, 1980.71
Fig. 71, p. 93

31. Marini, Marino
Small Horse, 1950
Bronze, 19 × 17 ½ × 22 in.
Gift of Mr. and Mrs. Alfred Jaretzki, Jr., 1953.234
Fig. 78, p. 95

32. Marini, Marino
Seated Figure, 1944
Bronze, 24 × 13 ½ × 11 ½ in.
Wadsworth Atheneum Purchase Fund, 1951.55
Fig. 74, p. 94

33. Matisse, Henri (French, 1869–1954)
The Ostrich-Feather Hat, 1918
Oil on canvas, 18 ¼ × 15 in.
The Ella Gallup Sumner and Mary Catlin Sumner
Collection Fund, 1969.1
Fig. 17, p. 30

34. Matta (Roberto Antonio Sebastian Echauren
Matta, Chilean, 1911–2002)
Prescience, 1939
Oil on canvas, 36 × 52 ½ in.
The Ella Gallup Sumner and Mary Catlin Sumner
Collection Fund, 1941.389
Fig. 33, p. 48

*35. Miró, Joan (Spanish, 1893–1983)
Composition, 1924
Graphite chalk tempera on panel, 10 ¾ × 7 ½ in.
The Ella Gallup Sumner and Mary Catlin Sumner
Collection Fund, 1937.506
Fig. 24, p. 40

†36. Miró, Joan
Acrobatic Dancers, 1940
Watercolor on paper, 18 ⅛ × 15 in.
The Collection of Philip L. Goodwin through James
L. Goodwin and Henry Sage Goodwin, 1958.263
Fig. 26, p. 41

37. Mondrian, Piet (Dutch, 1872–1944)
Composition in Blue and White, 1935
Oil on canvas, 38 × 41 in.
The Ella Gallup Sumner and Mary Catlin Sumner
Collection Fund, 1936.338
Fig. 19, p. 33

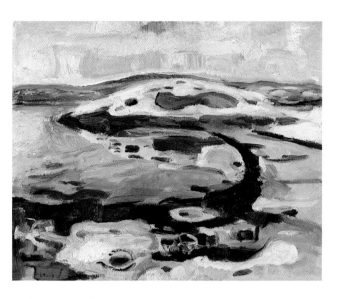

117. Edvard Munch, *Aagaardstrand*, c. 1904.
Checklist no. 40

38. Moore, Henry (English, 1898–1986)
Study for Battersea Park Figures, c. 1947
Bronze, 9 × 6 ¼ × 4 in.
Wadsworth Atheneum Purchase Fund, 1951.54
Fig. 77, p. 95

39. Munch, Edvard (Norwegian, 1863–1944)
Winter Landscape at Hvitsten, c. 1918
Oil on canvas, 23 ½ × 29 in.
The Ella Gallup Sumner and Mary Catlin Sumner
Collection Fund, 1970.121
p. 8

40. Munch, Edvard
Aagaardstrand, c. 1904
Oil on canvas, 28 ½ × 39 ½ in.
The Ella Gallup Sumner and Mary Catlin Sumner
Collection Fund, 1974.57
Fig. 117, p. 138

41. O'Keeffe, Georgia (American, 1887–1986)
The Lawrence Tree, 1929
Oil on canvas, 31 × 39 ¼ in.
The Ella Gallup Sumner and Mary Catlin Sumner
Collection Fund, 1981.23
Fig. 18, p. 32

42. Picasso, Pablo (Spanish, 1881–1973)
The Bather, 1922
Oil on panel, 7 ³/₈ × 5 in.
The Ella Gallup Sumner and Mary Catlin Sumner
Collection Fund, 1931.198
Fig. 11, p. 24

43. Picasso, Pablo
Still Life with Fish, 1923
Oil on canvas, 18 ¼ × 21 ½ in.
The Philip L. Goodwin Collection, 1958.220
Fig. 9, p. 22

44. Picasso, Pablo
The Painter, 1934
Oil on canvas, 38 ³/₄ × 31 ½ in.
The Ella Gallup Sumner and Mary Catlin Sumner
Collection Fund, 1953.215
Fig. 15, p. 28

45. Picasso, Pablo
The Women of Algiers, 1954
Oil on canvas, 25 ⁵/₈ × 28 ⁵/₈ in.
Gift of the Carey Walker Foundation, 1994.2.2
Frontispiece, p. 2

46. Picasso, Pablo
The Artist, 1963
Oil on canvas, 39 ³/₈ × 28 ³/₄ in.
Gift of the Carey Walker Foundation, 1994.2.1
Fig. 16, p. 29

47. Pollock, Jackson (American, 1912–1956)
Number 9, 1949, 1949
Oil on canvas, 44 ⅛ × 34 ⅛ in.
Gift of Tony Smith, 1967.15
Fig. 41, p. 53

48. Prendergast, Maurice B. (American, 1859–1924)
Red-Headed Nude, c. 1902
Oil on canvas, 24 ⅛ × 19 ⅛ in.
The Ella Gallup Sumner and Mary Catlin Sumner
Collection Fund, 1960.193
Fig. 12, p. 25

118. Charles Seliger, *Cerebral Landscape*, 1944
Checklist no. 54

49. Rivera, Diego (Mexican, 1886–1957)
Girl with a Mask, 1939
Oil on canvas, 42 ¼ × 21 ½ in.
The Ella Gallup and Mary Catlin Sumner Collection
Fund, 1939.579
Fig. 108, p. 118

50. Rothko, Mark (American, 1903–1970)
Untitled, 1949
Oil on canvas; 35 ½ × 54 ½ in.
Gift of Tony Smith, 1967.16
Fig. 42, p. 54

51. Rousseau, Henri (French, 1844–1910)
Landscape at Pontoise, 1906
Oil on canvas, 16 × 13 in.
Gift of Mr. and Mrs. Robert Montgomery, 1975.90
Fig. 4, p. 17

119. Graham Sutherland, *Palm Palisade*, 1948
Checklist no. 57

52. Roy, Pierre (French, 1880–1950)
The Electrification of the Country, 1930
Oil on canvas, 28 ¼ × 19 ½ in.
The Ella Gallup Sumner and Mary Catlin Sumner
Collection Fund, 1931.86
Fig. 53, p. 71

53. Sage, Kay (American, 1898–1963)
Quote-Unquote, 1958
Oil on canvas, 28 × 36 in.
Bequest of Kay Sage Tanguy, 1963.198
Fig. 104, p. 116

54. Seliger, Charles (American, b. 1926)
Cerebral Landscape, 1944
Oil on canvas, 24 ¼ × 18 ¼ in.
Gift of Mr. and Mrs. Alexis Zalstem-Zalessky,
1956.76
Fig. 118, p. 139

55. Spencer, Stanley (English, 1891–1959)
Silent Prayer, 1951
Oil on canvas, 40 × 55 in.
The Ella Gallup Sumner and Mary Catlin Sumner
Collection Fund, 1951.221
Fig. 44, p. 56

56. Stettheimer, Florine (American, 1871–1944)
Beauty Contest: To the Memory of P.T. Barnum, 1924
Oil on canvas; 50 × 60 ¼ in.
Gift of Ettie Stettheimer, 1947.242
Fig. 68, p. 88

57. Sutherland, Graham (English, 1903–1980)
Palm Palisade, 1948
Oil on canvas, 36 ⅛ × 43 ¼ in.
The Douglas Tracy Smith and Dorothy Potter Smith
Fund and The Ella Gallup Sumner and Mary Catlin
Sumner Collection Fund, 1993.90
Fig. 119, p. 140

*58. Tanguy, Yves (American, 1900–1955)
Dream Landscape, 1933
Gouache on paper, 3 ⅜ × 11 ⅛ in.
The Ella Gallup Sumner and Mary Catlin Sumner
Collection Fund, 1936.59
Fig. 103, p. 115

59. Tanguy, Yves
Imprevu, 1940
Oil on canvas, 31 ¾ × 25 ⅝ in.
Gift of Mrs. F. Spencer Goodwin, 1959.417
Fig. 51, p. 67

†60. Tanguy, Yves
Untitled Drawing, 1949
Ink on paper, 22 ⅛ × 28 ¼ in.
Bequest of Kay Sage Tanguy, 1963.51
Fig. 106, p. 117

61. Tanguy, Yves
La Rose des Quatres Vents, 1950
Oil on canvas, 28 × 23 in.
Bequest of Kay Sage Tanguy, 1963.196
Fig. 105, p. 116

62. Tanguy, Yves
Sans Titre, 1929
Oil on canvas, 25 × 21 in.
Bequest of Kay Sage Tanguy, 1963.197
Fig. 34, p. 49

63. de Vlaminck, Maurice (French, 1876–1958)
River Scene with Bridge, c. 1905
Oil on canvas, 19 ¾ × 25 in.
Gift of Mr. and Mrs. Robert Montgomery, 1972.13
Fig. 5, p. 18

Bakst, Leon (Russian, 1866–1924)
Nijinsky as the Faun, 1912
Graphite, tempera, gold paint on board,
15 ¾ × 10 ½ in.
The Ella Gallup Sumner and Mary Catlin Sumner
Collection Fund, 1935.37
Fig. 64, p. 85

Bakst, Leon
*Costume Design for the King's Guards in the Ballet
Sleeping Beauty*, 1922
Gouache and watercolor on paper, 25 ¾ × 18 ½ in.
European Painting and Sculpture Purchase Fund,
2001.23.1
Fig. 63, p. 84

Balthus (Balthasar Klossowski de Rola) (French,
1908–2001)
Still Life, 1937
Oil on panel, 31 ⅞ × 39 ⅜ in.
The Ella Gallup Sumner and Mary Catlin Sumner
Collection Fund, 1938.272
Fig. 96, p. 111

Calder, Alexander (American, 1898–1976)
Little Blue Panel, c. 1935
Wood, wire, paint, 19 × 14 ½ × 5 ½ in.
Purchased through the gift of Henry and Walter
Keney, 1935.63
Fig. 80, p. 97

Calder, Alexander
Mantis, 1936
Wood, wire, string, and paint, 78 × 51 × 40 in.
Purchased through the gift of Henry and Walter
Keney Fund, 1938.275
Fig. 90, p. 106

Cornell, Joseph (American, 1903–1972)
Soap Bubble Set, 1936
Box construction, mixed media, 15 ¾ × 14 ¼ in.
Purchased through the gift of Henry and Walter
Keney, 1938.270
Fig. 91, p. 107

Domela, César (Dutch, 1900–1992)
Abstract Construction, 1935
Steel, brass, and glass, 19 ¾ × 19 ¾ × 3 ¼ in.
Gift of the James Junius Goodwin Fund, 1936.16
Fig. 84, p. 101

Demuth, Charles (American, 1883–1935)
Still Life with Eggplant and Squash, c. 1927
Watercolor, 13 ½ × 19 ¾ in.
The Ella Gallup Sumner and Mary Catlin Sumner
Collection Fund, 1928.40
Fig. 48, p. 64

Ernst, Max (German, 1891–1976)
Loplop with Butterflies, 1932
Pencil, marbleized and embossed paper mounted on
cork with dissecting pins, 25 ½ × 31 in.
The Ella Gallup Sumner and Mary Catlin Sumner
Collection Fund, 1942.387
Fig. 25, p. 40

Gabo, Naum (American, born Russia, 1890–1977)
Construction on a Line in Space, 1937
Destroyed; plexiglass sculpture, 17 ⅛ × 17 ¼ in.
Purchased through the gift of Henry and Walter
Keney, 1938.269
Fig. 87, p. 103

Galván, Jesús Guerrero (Mexican, 1910–1973)
The Little Nurse, 1937
Oil on masonite, 46 ½ × 35 ½ in.
The Ella Gallup Sumner and Mary Catlin Sumner
Collection Fund, 1939.578
Fig. 107, p. 118

Hartley, Marsden (American, 1877–1943)
Military, 1913
Oil on canvas, 39 ¼ × 39 ¼ in.
The Ella Gallup Sumner and Mary Catlin Sumner
Collection Fund, 1973.2
Fig. 36, p. 50

Klee, Paul (Swiss, 1879–1940)
Marionettes in a Storm, 1929
Pastel and pen and black ink, 15 ⅝ × 20 ⅞ in.
Purchased through the Gift of James Junius
Goodwin, 1933.118
Fig. 59, p. 81

Lehmbruck, Wilhelm (German, 1881–1919)
Head of a Woman, 1910
Cast stone, 16 ¾ × 16 ¼ × 9 ¾ in.
Bequest of James Thrall Soby, 1980.69
Fig. 73, p. 93

Lewis, Wyndham (British, 1882–1957)
Portrait of an English Woman, 1913–4
Graphite and gouache on paper, 22 × 14 in.
The Ella Gallup Sumner and Mary Catlin Sumner
Collection Fund, 1949.457
Fig. 7, p. 20

Marin, John (American, 1870–1953)
Movement No. 3, Downtown, New York, 1926
Watercolor on paper, 17 ¼ × 22 ¼ in.
Gift of James L. Goodwin and Henry Sage Goodwin
from the Estate of Philip L. Goodwin, 1958.229
Fig. 37, p. 50

Matisse, Henri (French, 1869–1954)
Le Chant du Rossignol, 1920
Graphite and ink on board, 17 × 12 ⅞ in.
The Ella Gallup Sumner and Mary Catlin Sumner
Collection Fund, 1933.505
Fig. 60, p. 82

Matta (Roberto Antonio Sebastian Echauren Matta)
(Chilean, 1911–2002)
Composition, 1936
Oil and pencil, 19 ¼ × 25 ⅛ in.
The Ella Gallup Sumner and Mary Catlin Sumner
Collection Fund, 1942.280
Fig. 112, p. 124

Miró, Joan (Spanish, 1893–1983)
Dream Painting, 1925
Oil on unsized canvas, 19 ⅝ × 25 ¾ in.
The Ella Gallup Sumner and Mary Catlin Sumner
Collection Fund, 1933.508
Fig. 62, p. 84

Miró, Joan
Painting, 1933
Oil on canvas; 51 ⅔ × 64 ⅛ in.
The Ella Gallup Sumner and Mary Catlin Sumner
Collection Fund, 1934.40
Fig. 70, p. 91

Pevsner, Antoine (French, born Russia, 1886–1962)
Bas Relief, 1923
Lead, metal, glass, and tin, 11 ⅛ × 15 in.
Gift of the James Junius Goodwin Fund, 1936.15
Fig. 83, p. 100

Rouault, Georges (French, 1871–1958)
The Workers, 1930
Pastel and watercolor on paper,
13 ⅞ × 11 ⅞ in.
Purchased through the gift of Henry and Walter
Keney, 1933.95
Fig. 58, p. 81

Rouault, Georges
Scene I, Night, from *Le fil prodigue*, 1929
Pastel, ink, tempera and watercolor on paper, 20 ¼ ×
28 ¼ in.
The Ella Gallup Sumner and Mary Catlin Sumner
Collection Fund, 1933.536
Fig. 61, p. 83

Schlemmer, Oskar (German, 1888–1943)
The Race, 1930
Oil on canvas, 63 ⅝ × 38 in.
Gift of Philip Johnson, 1939.365
Fig. 109, p. 119

Yves Tanguy (American, 1900–1955)
Five Strangers, 1941
Oil on canvas, 35 ⅝ × 32 in.
The Ella Gallup Sumner and Mary Catlin Sumner
Collection Fund, 1943.220
Fig. 114, p. 128

Tchelitchew, Pavel (French, born Russia, 1898–1957)
Chick as Ringmaster, 1936
Watercolor on paper, 7 ⅞ × 16 ¾ in.
The Ella Gallup Sumner and Mary Catlin Sumner
Collection Fund, 1936.22
Fig. 89, p. 105

Tonny, Kristians (Dutch, 1907–1977)
Portrait of Gertrude Stein after Van Eyck, c. 1936
Watercolor on paper, 24 × 18 in.
The Ella Gallup Sumner and Mary Catlin Sumner
Collection Fund, 1937.78
Fig. 54, p. 73

Weber, Max (American, born Russia, 1881–1961)
Three Figures, 1910
Watercolor on paper, 18 ¾ × 24 ¾ in.
The Ella Gallup Sumner and Mary Catlin Sumner
Collection Fund, 1963.457
Fig. 38, p. 51

Zadkine, Ossip (French, born Russia, 1890–1967)
Interior with Two Nudes, 1920
Watercolor on paper, 22 ½ × 17 in.
Gift of Mrs. Helen Goodwin Austin, 1986.414
Fig. 50, p. 65

Page references in italics indicate photographs or illustrations.
Page references in bold italics indicate works exhibited.
Exhibitions organized by Chick Austin are listed under Wadsworth Atheneum
while works by individual artists appear under the artist's name.

Abbott, Berenice, 75

Abbott, Jere, 73

Abstract Création (Parisian sculptors), 99

Abstract Expressionism, 50–55, 57

Abstraction, 31–35, 74, 99–100, 103, 104

"Action Painting," 52

Albers, Joseph, 103

Alsop, Joseph W., Jr., 92

American Painting and Sculpture
 (exhibition at Atheneum), 97–99

American Romantic Revival, 123

Aragon, Louis, 39

Arp, Jean
 Objects Placed on Three Planes Like
 Writing, 42, *42*, 96, **135**

Art Deco, 65

Atheneum exhibits. *See* Wadsworth
 Atheneum

Atherton, John, 123

Austin, A. Everett, Jr. ("Chick"), 61–128
 photograph of, *61, 112, 127*
 apartment exhibit of (*Exhibition of
 Modern Decorative Arts*), 64, 65
 office at Wadsworth Atheneum, 89,
 90, 122
 Tchelitchew's costume design for
 (*Chick as Ringmaster*), 103–104, *105,*
 145

Avery, Milton, 72
 The Green Settee, 135, **135**

Bakst, Leon, costume designs by, 82, *84,*
 143

Balanchine, George, 84–87, 103

Ballets Russes, 82, 84

Balthus (Balthasar Klossowski de Rola),
 111–112, 118–121
 The Bernese Hat, 119–121, *121,* **135**
 Girl with Cat, 126
 Still Life (Nature morte), 111, *111,* 143
 The Street (La Rue), 112, 122

Barlach, Ernst, 89

Barr, Alfred, 66, 73, 75, 117

Beckmann, Max, 70
 Mexican Vase, 106

Bellows, George, 62

Benois' set and costume designs, 82

Bérard, Christian, 72, 84
 La Plage, 69, 90

Berkman, Florence, 69–70

Berman, Eugene, 66, 73
 Retrospective at Atheneum (1941),
 123, *123*

Bliss, Lizzie, 66

Blume, Peter, 56–57, 97, 117
 photograph of, *49*
 The Italian Straw Hat, 55, *55,* **135**

Bonnard, Pierre, 90

Brancusi, Constantin
 Blond Negress, 89

Braque, Georges, 20
 Les Fâcheux, 82
 The Mantelpiece, 104
 Still Life, 63

Breton, André, 39, 42, 46, 75, 104, 117, 126

Brook, Alexandera, 97

Cagli, Corrado, 123

Calder, Alexander, 56, 100, 103, 117
 photograph of, *101*

andirons, *69*
 The Dragon, 98, **135**
 Little Blue Panel, 97, 98, 102, 143
 Mantis, 106, *106,* 143
 Mobile, 98

Calder, Louise, 101

Campigli, 123

Caravaggio
 Ecstasy of St. Francis, 122

Carpenter, Mrs. John, 63

Cézanne, Paul, 20, 64

Chagall, Marc, 66, 126
 The Circus, 126
 Autumn in the Village, **135**, *136*

Charlot, Jean, 70

Cocteau, Jean, 73

Cornell, Joseph
 Bel Echo Gruyere, *110,* **136**
 Crystallized Dream, 98
 Homage to the Romantic Ballet, *109,*
 136
 Soap Bubble Set, 106, *107,* 143
 Untitled, *109,* **136**
 Untitled (for Juan Gris), *108,* **136**

Courbet, Gustave, 20

Crane, Mrs. W. Murray, 74

Cubism, 20–23, 89, 104, 122

Dada, 40, 42

Dale, Mrs. Chester, 78

Dalí, Gala, 90–91, 104, *114,* 115

Dalí, Salvador, 40, 43–46, 57, 74–78, *79,*
 90–92, 112–15
 lecture and exhibit at Atheneum
 (1934), 91–92

photograph of, *114*

The Accommodations of Desire, 104

*Apparition of a Face and Fruit Dish
on a Beach*, 44–46, *45*, 112, 112–13, **136**

*Debris of an Automobile Giving
Birth to a Blind Horse Biting a
Telephone*, 123

Double Portrait, 127

The Endless Enigma, 112

Geodesical Portrait of Gala, 104

The Image Disappears, 127

La Persistence de la Memoire, 76,
78, *78*, 79

La Solitude, 39, 76, *76*

*Myself at the Age of Ten When I
was the Grasshoper Child*, 92

Paranoiac-astral Image, 44, *44*, 45,
92, **136**

Persistence of Memory, 74, 75, 79, 91

The Specter of Sex Appeal, 92

Specter of Vermeer, 92

Un Chien Andalou (film), 92

Davies, Arthur B., 79, 97

Protest Against Violence, *96*, **136**

Davis,. Stuart, 20, 97

Midi, *19*, *20*, **137**

de Chirico, Giorgio, 14, 35–37, 66, 69–70,
75, 79, 84, 92, 93, 106, 121, 127

The Endless Voyage, 11, 35, 36, 66,
79, 136

The Evil Genius of a King, 93

The General's Illness, 14, 35, *35*, 93,
135

La Famille de l'artiste, 75

La Lumiére fatale, 123

Le Bal set designs and costume stud-
ies, 84

Pittura Metafisica, 35

de Kooning, Willem, 50, 52–53

Standing Man, *52*, 52–53, 137

"Decalcomania," 15, 49

Delvaux

Woman with Lamps, 127

Demuth, Charles, 97

Still Life with Eggplant and Squash,
64, *64*, 143

Derain, André, 66, 68, 72

The Bagpiper, 69

Jack in the Box, 83

La Boutique Fantasque, 82

Landscape, 68

Vase with Landscape, 104

Diaghilev, Serge, 82, 83

Dickinson, Preston, 64, 97

Die Brücke (The Bridge), 14

Dix, Otto, 79

Domela, César

Abstract Construction, 100, *101*, 143

Dove, Arthur, 97

Approaching Snow Storm, 50, 51, **137**

Dreier, Katherine, 75, 97, 100, 103, 121–2

Duchamp, Marcel, 97

Revolving Glass, 121

Duchamp, Suzanne, 97

The Elements of Magic (magic show
1942), 126

Elshemius, Louis, 79

Epstein, Jacob, 98

Ernst, Jimmy, 123

Vagrant Fugue, 124

Ernst, Max, 14, 15, 17, 40, 49, 57, 75, 83,
123, 124, 126, 127

Dancers, 79

Europe after the Rain, 14, *47*, *48*, 49,
124–125

The Kiss in the Night, 26, *26*, 40, **137**

Loplop Presents, 40

Loplop with Butterflies, 40, *40*, 79,
124, 143

Sun on the Desert, 79

Evans, Walker, 72

Exhibitions. *See* Wadsworth Atheneum;
specific museum by name

Expressionism, 50, 79

Fantasy, 127

Fauvism, 20, 122

Fernandez, Louis

Still Life, 106

Figuration, 55–57

Figurative paintings, 25–31

Flechtheim, Alfred, 81

Forbes, Edward, 61

Francavilla

Venus, 87, *87*

Francis, Henry, 74

French Impressionism, 62

French paintings, exhibits at Atheneum,
63, *63*–64, 66, 68, 72–74, 90

Fresco, 70

Freud, Sigmund, 39

Fuller, Buckminster, 70

Gabo, Naum, 99, 100

exhibition at Atheneum (1938), 103

Construction on a Line in Space, 103,
103

García Lorca, Federico, 46, 112

Gauguin, Paul, 89

German Expressionism, 13, 14, 70, 121

Gérôme, Jean Léon

L'Éminence grise, 78, *78*, 79

Gleizes, Albert, 20, 23

*Imaginary Still Life, Green (Nature
Morte Imaginaire, Verdatre)*, 20, *23*,
137

Gontcharova, Nathalie, 83

Goodrich, Lloyd, 72

Goodspeed, Bobsie, 100

Goodwin, Helen, 66

Goodwin, Mrs. F. Spencer, 66

Goodwin, Mrs. J.J., 63

Goodwin, Philip, 66, 89

Goodyear, A. Conger, 74

Gorky, Arshile, 121

Graham, John, 121

Gris, Juan, 90

Les Tentations de la bergere, 83

Still Life, 65

Guerrero Galván, Jesús

The Little Nurse, 117, *118*, 144

Guggenheim, Peggy, 126

Guillaume, Paul, 90

Halpert, Mrs. Edith, 66, 97

Hartford Festival (1936), 103

Hartley, Marsden

Military, 50, *50*, 144

Harvard Society for Contemporary Art, 70

Heckel, Erich, 70

Henri, Robert, 62

Herman, Simone, *101*

Hitchcock, Henry-Russell, Jr., 61, 66, 73, 78, 104

 photograph of, *62, 112*

Hopper, Edward, 97

 exhibit *Watercolors of Edward Hopper* (1928), 65

Impressionism, 20, 122

Jacobson, Robert, *62*

James, Edward, *114*, 115

Janowitz, Sidney, 72

Johnson, Philip, 89, 99, 117–118, 126

Kandinsky, Wassily, 79, 122

 Improvisation No. 30, 78, *78*, 79

Kane, John, 97

Kantor, Morris, 79

Kelly, Leon, 123

Kirchner, Ernst Ludwig, 13, 14, 15, 17, 57, 70

 The Street (Berlin), 14

 Suburb of Berlin, *13*, 13–15, *15*, 18, ***137***

Kirstein, Lincoln, 70, 84

Klee, Paul, 14, 37, 70, 79, 81–82, 121

 Architecture, 19, 37, *39*, 53, ***137***

 Atheneum exhibition (1936), 103

 Gift for I, 90

 In the Grass, 72

 Marionettes in a Storm, 14, *81*, 82, 144

 Mr. Pep and his Horse, 82, 123

 Still-Life with Little Box, 106

Klossowski de Rola, Balthasar. *See* Balthus

Kokoschka, Oskar, 70

Kuniyoshi, Yasuo, 65, 97

Lachaise, Gaston, 98

Landscape painting, 72, 115

Laurencin, Marie, 69

 Les Biches, 83

Lawrence, D.H., 31

Le Clercq, Tanaquil, 87

Le Corbusier, 61–62, 89

 photograph of, *62*

Léger, Fernand, 90, 100, 121

 photograph of, *101*

 La Creation du Monde, 83

Lehmbruck, Wilhelm, 89, 90

 Head of a Woman, *93*, *93*, 144

Leiris, Michel, 42

Leonide, 73

Levy, Julien, 74, 75, 79, 82, 90, 92, 98, 103, 104, 106, 111, 112, *114*, 115, 123, 127

Lewis, Wyndham, 20

 Portrait of an English Woman, 20, *20*, 144

Lifar, Serge, 82–84

Lissitsky, 121

Loeb, Pierre, 112

Loy, Mina

 Faces, 79

Lynes, George Platt, 73, 75

 As a Wife Has a Cow, 75, *75*

Magritte, René, 40, 43

 Abstraction, 127

 The Fickleness of the Heart (Les Intermittences du Coeur), 87, *87*, ***137***

 The Key of Dreams, 104

 The Tempest, 43, *43*, 117

Maillol, Aristide, 26

 Girl with Top Knot, *94*, ***137***

 Pomona, 26, *27*, ***137***

 Seated Nude, 89

Malevich, 121

Man Ray, 90

Manet, 20

Mannerists, 87

Manship, Paul, 98

Mantegna, 64

Marcks, Gerhard

 Cinderella, *94*, ***137***

Marin, John, 64, 97

 Movement No. 3, Downtown, New York, 50, *50*, 144

Marini, Marino

 photograph of, *93*

 Rider, 93, *93*, *137*

 Seated Figure, *94*, ***138***

 Small Horse, *95*, ***138***

Masson, André, 75, 126

 Composition ("Les Captives"), 79

 Le Poisson, 79

Matisse, Henri, 20, 31, 32, 66, 68, 72, 81

 Le Chant du Rossignol, 82, *83*, 144

 The Gourds, 104

The Ostrich-Feather Hat, 31, *31*, ***138***

Reclining Nude, 69

The Red Sofa, 69

The Rose, 104

Still Life, 63

Matisse, Marguerite, 31

Matisse, Pierre, 75, 79–81, 89–90, 92, 106, 115, 117, 118, 123, 126

 photograph of, *114*

 Artists in Exile (exhibition 1942), 124, 125, 126

Matisse, Teeny, 114, 118

Matta (Roberto Antonio Sebastian Echauren Matta), 49, 93, 123–24, 126

 Composition (Personage Transperance), 124, *124*, 144

 No. 1204, 126

 Prescience, 48, 49, 123–124, ***138***

Mérida, Carlos, 70

Metzinger, Jean, 20

Mexican art, 70, 117

Miller, Lee, photograph of Chick Austin by, 61

Miró, Joan, 40–42, 46, 49, 66, 75, 83, 89, 117, 126

 photograph of, *114*

 Acrobatic Dancers, *41*, 42, 46, 53, ***138***

 Auto-Portrait Number 2, 123

 Composition, 26, *40*, 42, 93, *96*, ***138***

 Constellations, 46, 57

 Dream Painting, 42, 83–84, *84*, 144

 The Horse, 106

 Nature Morte, 75

 Painting, 90, *91*, 96, 144

 Portrait of Mrs. Mills in Costume of 1750, 75

 The Vase of Flowers, 106

Modernism, 32, 50, 65. *See also* Wadsworth Atheneum for specific *exhibits of modernism*

Moholy-Nagy, 121, 122

Mondrian, Piet, 32, 35, 99, 100, 102

 Abstraction, 72

 Composition in Blue and White, *32*, 35, 53, 102, ***138***

Monet, 20, 79

Moore, Henry
 Study for Battersea Park Figures, 95, **138**
Motherwell, Robert, 50
Munch, Edvard
 Aagaardstrand, 138, **138**
 Winter Landscape at Hvitsten, 8, **138**
Murray, Marian, 121, 127
Museum of Modern Art (MoMA) exhibit
 Fantastic Art Dada Surrealism (1936), 106
Neo-Romantics, 73, 74, 79, 84, 89, 90, 122, 123
New Britain Institute, 66
New York School, 52
Night Scenes, 122
Noguchi, Isamu, 98
O'Keefe, Georgia, 31, 32, 50, 79, 97
 Horse's Skull with White Rose, 79
 The Lawrence Tree, 31, 32, 32, 50, **139**
Orozco, José, 70
 The Cemetery, 123
"The Paper Ball" (costume gala 1936), 103–4
Parker, T.H., 63
Patinir, 115
Pevsner, Antoine, 99
 Bas Relief, 100, *100*, 144
 Torso, 100
Phillips, Duncan, 73
Picasso, Pablo, 20, 23, 25, 26, 27, 35, 64, 66, 72, 74, 75, 79
 exhibition at Atheneum (1931), 74
 exhibition at Atheneum (1934), 87–88, 88
 The Artist, 26, 29, **139**
 The Bather, 24, 25, 74, 89, **139**
 The Green Still Life, 104
 Le Soupir, 89
 Le Tricorne, 83
 Maternity, 63
 Old Guitarist, 87
 The Painter, 27, 28, **139**
 Seated Woman (1909), 89
 Seated Woman (1927), 89
 Self Portrait, 89

Still Life with Fish, 20, 21, 22, 23, 25, **139**
 Three Musicians, 89
 Two Eggs, 104
 Woman with a Fan, 89
 The Women of Algiers, **139**
Pollaiuolo, 64
Pollock, Jackson, 49, 52, 53–54, 57
 Number 9, 1949, 53, *53*, 55, **139**
Portraits, 104
Prendergast, Maurice B.
 Red-Headed Nude, 25, 26, **139**
Primitivism, 17–20
Proto-Realism, 79
Puteaux Cubists, 20
Putnam, Samuel, 75
Realism, 20, 55–57
Renoir, Auguste, 89
Rivera, Diego, 70, 117
 Young Girl with a Mask, 117, *118*, **139**
Romanticism, 69
Rosenberg, Paul, 89
Ross, Cary, 75
Rothko, Mark, 52
 Untitled, *54*, **139**
Rouault, Georges, 90
 Le fil prodigue, 83, *83*, 145
 The Workers, 81, *81*, 123
Rousseau, Henri, 17–18, 35, 72
 Jungle, 63
 Landscape at Pontoise, 17, *17*, **140**
Roy, Pierre, 75, 79, 82
 The Electrification of the Country, 53, 72, 79, 106, **140**
 Music, 79, 82, 106
Sachs, Paul, 66
Sage, Kay, 49, 115, 117, 126
 exhibition at Atheneum (1955), 117
 photograph of, *114*
 Quote-Unquote, *116*, 117, **140**
San Faustino, Kay. *See* Sage, Kay
Sarton, May, 126
Schempp, Theodore, 93
Schlemmer, Oskar
 The Race (Wettlauf), 118, *119*, 144
 Staircase, 117

Schmidt-Rottluff, Karl, 70
School of American Ballet, 84, 91
Seliger, Charles
 Cerebral Landscape, 139, **140**
Severini, 79
Shahn, Ben, 97
Sheeler, Charles, 65, 72
Singer, Clyde, 123
Siqueiros, David Alfaro, 70
 Shell, 126
Slater Memorial Museum (Norwich, CT)
 exhibit *Trends in Twentieth Century Painting* (1931), 78
Soby, James Thrall, 61, 68–69, 75, 89, 90, 92–93, 106, 111–112, 117, 119, 123, 125, 128
 After Picasso (book), 72
 collection of, exhibited at Atheneum, 69, 122
 Literature and Poetry in Painting Since 1850, photograph of exhibit by, 78
 photograph of, 62, 69
 photographs by, 78, 112, 114
Société Anonyme, 75, 97, 121
Spencer, Stanley
 Silent Prayer, 55–56, *56*, **140**
Steichen, Edward, 72
Stein, Gertrude, 74
 opera by, 87
 Portrait of Gertrud Stein (Tonny), 73, 74
 visit to Hartford (1935), 99, *99*
Stella, Joseph, 121
Stettheimer, Florine, 87, 97
 Beauty Contest: To the Memory of P.T. Barnum, 87, 88, **140**
Stieglitz, Alfred, 31, 50, 79
 Equivalents, 31
Still life, 111
Strand, Paul, 72
Super-Realism, 75–76
Surrealism, 26, 35–50, 52, 66, 74, 75, 78, 79, 82, 90, 92, 96, 112, 117, 122, 123, 124, 125
Surrealist Illusionism, 43–46

Surrealist Manifesto, 39, 42

Survage, Leopold, 75

Sutherland, Graham

 Palm Palisade, *140*, **140**

Sweeney, James Johnson, 75, 98

Synthetic Cubism, 20

Tamayo, Rufino, 70

Tanguy, Yves, 49, 115, 117, 123, 125, 126

 exhibition at Atheneum (1940),
 115–117

 exhibition at Atheneum (1955), 117

 photograph of, 49, 114

 Dream Landscape, 115, *115*, **140**

 Five Strangers, 125, *128*, 145

 Imprevu, 66, *66*, **140**

 La Rose des Quatres Vents, *116*, 117, **141**

 Poetic Landscape, 126

 Sans Titre, 49, *49*, 117, **141**

 Time and Again, 125

 Untitled Drawing, 117, *117*, **141**

Tchelitchew, Pavel, 73, 84, 93, 103, 123

 exhibition at Atheneum (1935), 103,
 103

 Charles Henri Ford, 103

 Chick as Ringmaster, 103–4, *105*, 145

 Enterrement du Clown, 73

Thomson, Virgil, 87

Toklas, Alice B., 99

Tonny, Kristians, 73, 74

 Portrait of Gertrud Stein, 73, 74

Ulmann, Doris, 72

Utrillo, Maurice, 72

Valentiner, W.R., 70

Van Gogh, Vincent, 89

 Self-Portrait, 63

van Vechten, Carl, 73

Vlaminck, Maurice de, 20

 River Scene with Bridge, *17*, *18*, 19, **141**

Vorticism, 20

Wadsworth Atheneum

 Abstract Art (1935), 99–100, *101*, *102*

 *American Painting and Sculpture of
 Three Centuries* (1935), 97–99

 Avery Court, photograph of, *87*, *102*

 Avery Memorial building opening
 (1934), 87

Ballets Russes collection (1933
acquisition), 82

Berman (Eugene) Retrospective
(1941), 123, *123*

Constructions in Space (Gabo exhibit
1938), 103

Dalí lecture and exhibit (1934),
91–92

*Exhibition of Contemporary
Paintings Lent by Mr. and Mrs.
James T. Soby* (1929), 69

*An Exhibition of Literature and
Poetry in Painting Since 1850* (1933),
78, 78–81, 124

first Dalí acquisition by a museum
made by, 77–78

first modern painting acquisition by,
72

Five Young French Painters (1931),
72–74

43 Portraits (1937), 104

Four Modern Artists (1930), 72

4 Painters (1936), 103

*Impressionism to Abstraction: 13
Women Painters* (1934), 96–97

*Loan Exhibition of Modern French
Paintings* (1928), *63*, 63–64

*Loan Exhibition of Modern
Paintings* (1923), 62

*A Loan Exhibition of Selected
Contemporary French Painting*
(1929), 66, 68

Man Ray exhibition (1934), 90

memorial exhibit for Austin (1958),
128

*In Memoriam: An Exhibition of
Paintings Under $1000* (1942), 125–6

*Modern French Paintings Drawings
and Sculptures* (1934), 90

Modern German Art (1930), 70

Modern Mexican Art (1930), 70

Newer Super-Realism (1931), 74–77,
75

Night Scenes (1939), 122

office of Chick Austin, 89, *90*, 122

Painters in Attendance (1942), 126

Painters of Fantasy (1942), 127

The Painters of Still Life (1938), 104

Paintings by Giorgio de Chirico, 69

Paul J. Sachs Collection of Drawings
(1928), 64

Paul Klee (1936), 103

Picasso exhibition (1931), 74

Picasso retrospective (1934), 87–88,
88

praise from Le Corbusier, 61–62

Soby's collection on exhibition
(1939), 122

*Some New Forms of Beauty,
1909–1936* (Société Anonyme exhibit
1939), 121–2

Stein lecture (1935), 99, *99*

Tanguy and Sage exhibition (1955),
117

Tanguy exhibition (1940), 115–117

Tchelitchew exhibition (1935), 103,
103

Watercolors of Edward Hopper
(1928), 65

Walker, John, III, 70

Walter, Marie-Thérèse, 27

Warburg, Edward, 70

Watercolors, 65, 123

Watkins, Franklin, 123

Weber, Max, 97

 Three Figures, 50, *51*, 145

Weston, Edward, 72

Wildenstein, Felix, 74, 75

Zadkine, Ossip

 Interior with Two Nudes, 65, *65*, 145

Zorach, 98

Numbers refer to Fig. numbers used in this catalogue.
All black and white photographs are from the Wadsworth Atheneum Archives,
with the exception of Fig. 52 and Fig. 57, which are reproduced by kind permission of the MoMA archives